PhotoAnnual 2004 Graphis Mission Statement: *Graphis* is committed to presenting exceptional work in international design, advertising, illustration and photography. Since 1944, we have presented individuals and companies in the visual communications industry who have consistently demonstrated excellence and determination in overcoming economic, cultural and creative hurdles to produce true brilliance.

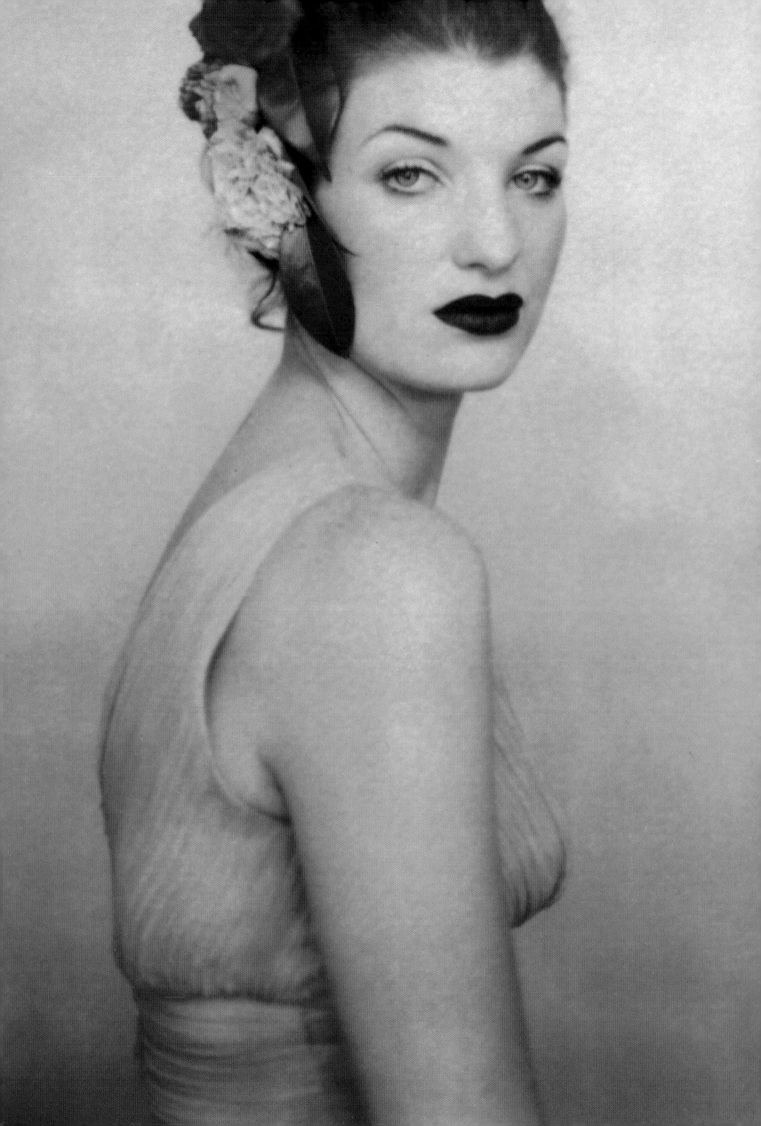

PhotoAnnual2004

CEO & Creative Director: B. Martin Pedersen

Editor: Michael Porciello

Art Director: Lauren Prigozen
Design & Production: Luis Diaz, Jennifer Kinon and Andrea Vélez
Design Interns: Sanaâ Akkach, Julian Jaramillo, and Esteban Salgado

Published by Graphis Inc.

This book is dedicated to
Herb Ritts and Sue Bennett

Debra McClinton, pg 36 (left page), Michael McRae, pg 133 (next page)

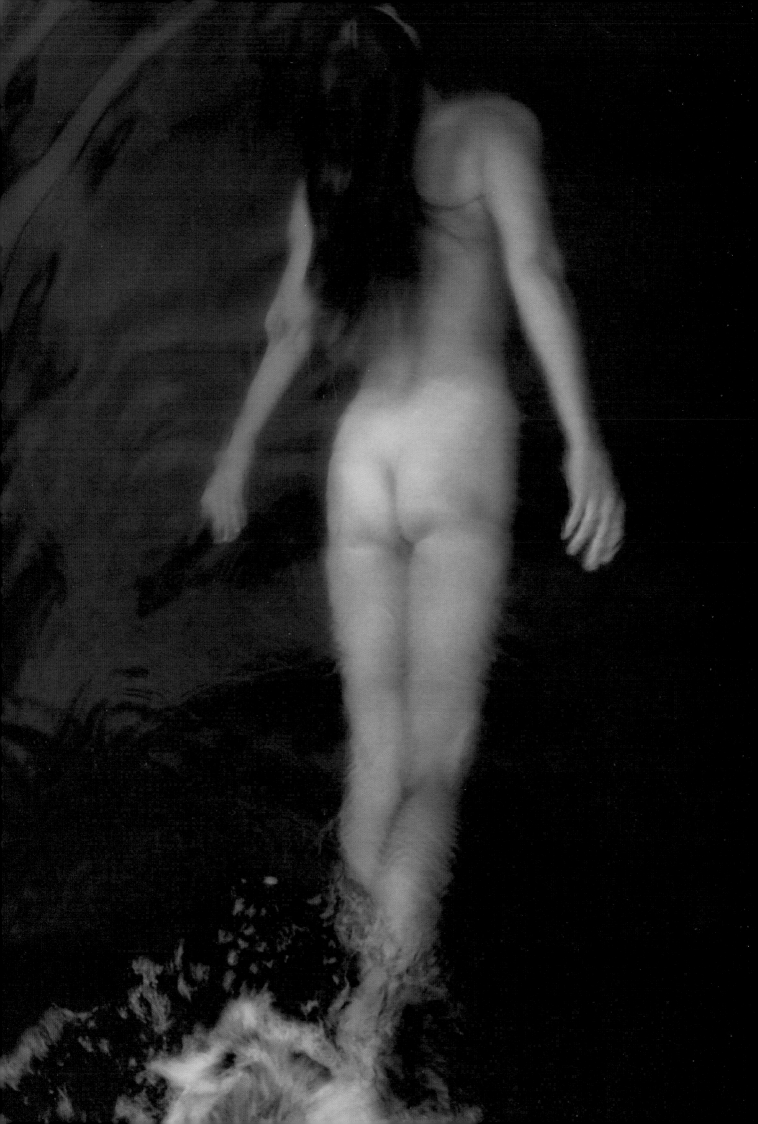

ContentsInhaltSommaire

Remarks: We extend our heartfelt thanks to contributors throughout the world who have made it possible to publish a wide and international spectrum of the best work in this field. Entry instructions for all Graphis Books may be requested from: **Graphis Inc.**, 307 Fifth Avenue, Tenth Floor, New York, New York 10016, or visit our Web site at www.graphis.com.

Anmerkungen: Unser Dank gilt den Einsendern aus aller Welt, die es uns ermöglicht haben, ein breites, internationales Spektrum der besten Arbeiten zu veröffentlichen. Teilnahmebedingungen für die Graphis-Bücher sind erhältlich bei: **Graphis Inc.**, 307 Fifth Avenue, Tenth Floor, New York, New York 10016. Besuchen Sie uns im World Wide Web, www.graphis.com.

Remerciements: Nous remercions les participants du monde entier qui ont rendu possible la publication de cet ouvrage offrant un panorama complet des meilleurs travaux. Les modalités d'inscription peuvent être obtenues auprès de: **Graphis Inc.**, 307 Fifth Avenue, Tenth Floor, New York, New York 10016. Rendez-nous visite sur notre site web: www.graphis.com.

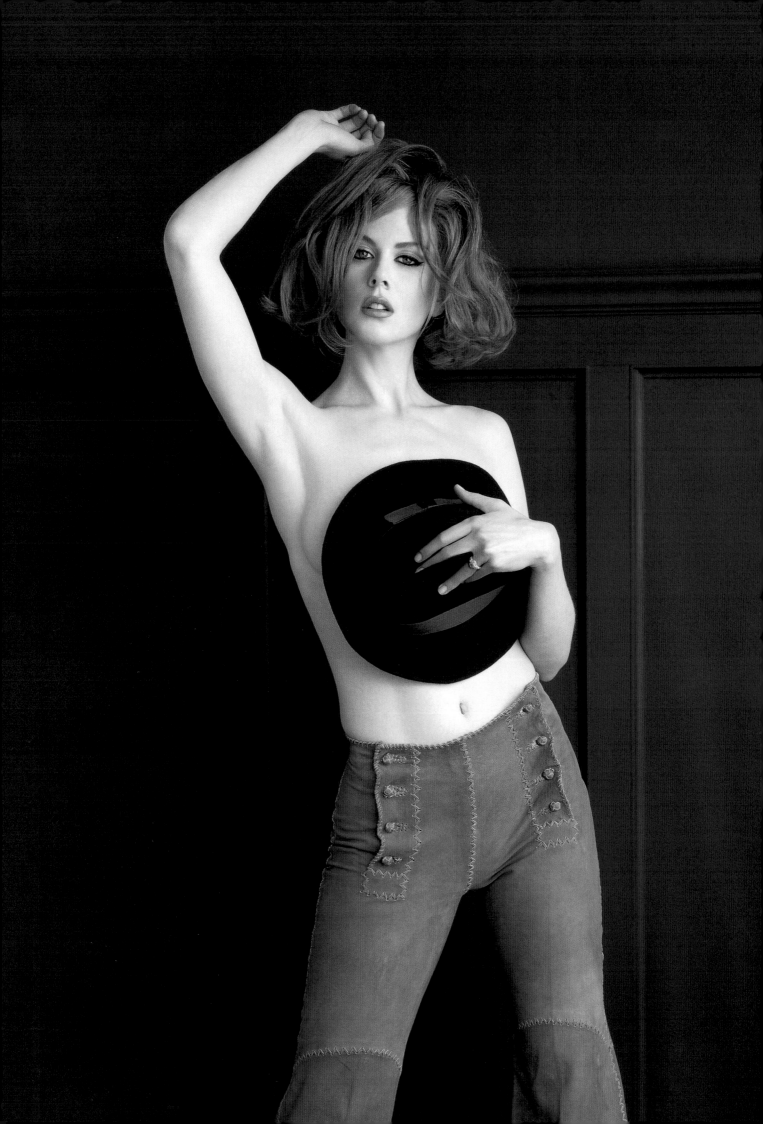

Herb Ritts (1952 - 2002)

Photographer Herb Ritts passed away December 26, 2002. It is to his memory that we dedicate this volume. ■ As fine art, photography, design, advertising, marketing, fashion and film become increasingly intertwined there is no better case for all-abiding artistry than Ritts' celebrity work, the best known chapter in his venerable folio. Photographs from the celebrity oeuvre were regularly published in Vogue, Vanity Fair and Rolling Stone. Ritts himself became an icon while capturing the likes of Madonna, Jack Nicholson, Elizabeth Taylor and, in his final session, Ben Affleck. ■ His celebrity work is remarkable and embracing because the photograph is even more enduring and magnanimous than its subject. The imagery is consistently simple; it is concise, spare and usually black and white. The style is complexly human; it is sensitive, intimate and sensual. The narrative is totally available; it is simultaneously read and felt. Something of the man consistently comes through in his work. Ritts is repeatedly and affectionately cited as a source of light, comfort and kindness. His ability to illuminate the already luminous adds value to them and to us. It brings celebrity and the rest of the population together in an amazing feat of artistry and ultimately marketing. ■ Ritts was a natural; he arrived to photography whole. Toward the end of the 1970s he began taking adult-education classes in photography. But it was a set of photos from a road trip with friends, among them Hollywood newcomer Richard Gere, that fueled – literally from the garage of a petrol station – Ritts' rise to success. ■ In addition to the celebrity work, Ritts regularly photographed fashion and pursued in-depth studies of the human form. He photographed personalities famous beyond American pop culture including the Dalai Lama. And, in 1996, he disconnected entirely to photograph the Maasai people of East Africa. A recurring theme in each of these varied milieus is his profound appreciation for the rich textures of the human body. With an almost tactile appeal, Ritts' images explore the body when it is touched and when it touches. ■ Ritts did not reconcile himself to still images. He also directed music videos that won top honors from MTV. To his credit are Chris Isaak's "Wicked Game," Madonna's "Cherish," Janet Jackson's "Love Will Never Do (Without You)," and, most recently, 'Nsync's "Gone." ■ In the exhibition catalog for the "Work" show in Boston(1996), Ingrid Sischy observes that to create a Ritts image "you have to be savvy on all fronts ... you have to be a diplomat, a psychologist, a playmate and a great persuader ... Because he has such a natural grasp of [all this], as well as of all the technical aspects, Ritts can pull off the equivalent of miracles – photo-graphs that become icons." And now, as the lines between art and design, photography and advertising, film and video, continue to blur we even better appreciate the "miracle" of Herb Ritts' enduring artistry.

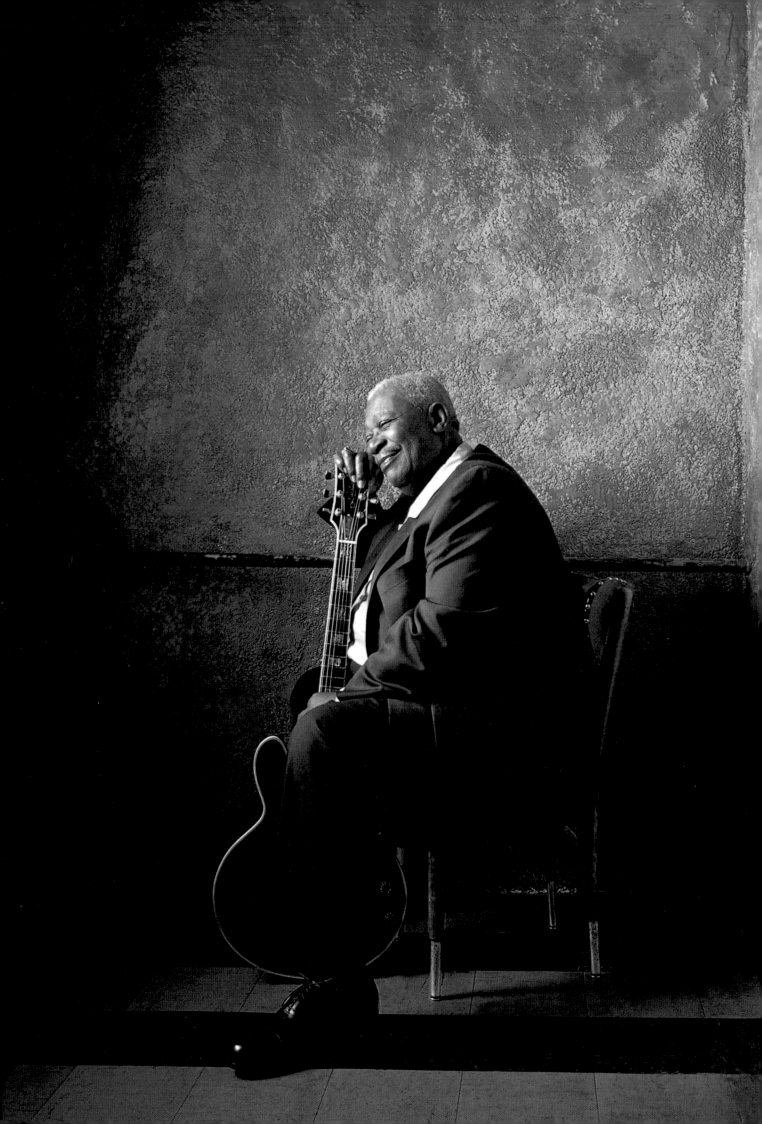

Sue Bennett (1948 - 2003)

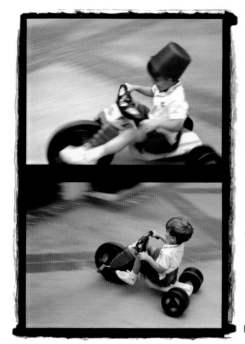 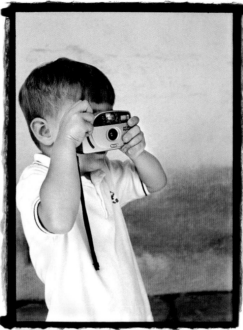 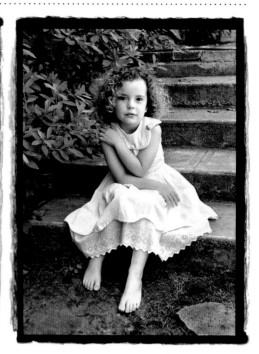

What can I say about Sue Bennett? … that I have known her for nearly 30 years … that we shared out lives together for the last 23 years …that during that time Bennett was my partner, my friend, my collogue, and the great love of my life … that Sue Bennett died in a single car roll over accident while on her way to Palm Springs for a morning appointment on the first day of May 2003. ▪ That Bennett's death has affected hundreds of people, most of all her family, her mother, brother, nephews, great nieces and great nephew. That I miss her and so do her many, many loved friends and colleagues. Bennett was happiest when she was making pictures — either for a client or for herself. I often observed that when working with commercial clients Sue always made the picture the client really needed — not necessarily the picture they thought they wanted. ▪ Bennett leaves us with her example of how to live and work. ▪ What can I say about Sue Bennett? "Sue Bennett — You got eyes." ▪ I first met Sue Bennett in 1976. She was driving a school bus daily between Sedona and Flagstaff AZ, along 45 miles of narrow canyon roads and steep switchbacks. The students she drove each day affectionately called their bus the "Red Rock Rocket." Sue was named "Capitan." ▪ After she delivered her students, she went to Northern Arizona University to complete her second degree in Photojournalism. She had already completed a Political Science Degree from University of Southern California. ▪ While still a student Sue interned and freelanced for newspapers and utility companies. As soon as she graduated, she went to work photographing and writing stories for Arizona's Department of Tourism. Then she moved on to Mountain Bell as a staff photographer. ▪ Sue started to freelance in 1980 moved her studio to Flagstaff in 1983. She then built and moved into her current studio in 1992. Each year she learned more, improving her skills as a photographer and ultimately following a career path from photojournalist to highly respected advertising photographer. ▪ Her studio manager, Keiji Iwai and marketing manager, Kelsy Opdahl continue to manage Sue's studio, managing and licensing photos from Sue's stock files and administering photos and usages from the shoots Sue completed just prior to her death. ▪ The photographs we chose to show here are some of Sue's favorites. Sue was not quick to show her work, nor brag, even about important and successful commercial jobs. On the other hand when asked to show photos of what she was doing lately, she would quickly produce a little black box of photos of her great nieces and nephew. Her copies of these photos were scattered by the wind around the site were Sue's car crashed. ▪ A scholarship fund has been created in Sue Bennett's memory to help young aspiring commercial photographers achieve their education. If you wish to donate to the fund, checks can be made payable to Art Center 100 and mailed to the following address: Art Center 100, 1700 Lida Street, Pasadena CA 91103, Attn: Mattie Comer, Sue Bennett Scholarship Fund ▪ Dedication by John Running

Q&A with Sheila Metzner

Sheila Metzner's unique photographic style has positioned her as a contemporary master in the worlds of fine art, fashion, portraiture, still life and landscape photography. Born in Brooklyn, in 1939, she attended Pratt Institute, where she majored in Visual Communications, and was then hired by the Doyle Dane Bernbach advertising agency as its first female art director. She took pictures all the while, amassing them slowly over the next thirteen years, while raising five children. One of these photographs was included in a famous and controversial exhibition at the Museum of Modern Art—Mirrors and Windows: American Photography since 1960—and became the dark horse hit of the exhibition. Gallery shows and commercial clients soon followed. Metzner's fine art photographs are featured in numerous private and museum collections—among others The Metropolitan Museum of Art, The International Center of Photography, the Agfa and Polaroid Collections. She has published four monographs: Objects of Desire, which won the Amerian Society of Magazine Photographers Ansel Adams Award for Book Photography; Sheila Metzner's Color, Inherit the Earth (landscapes) and Form and Fashion (images culled from twenty years of fine-art and fashion work).

What photographs or series of photographs is your proudest achievement?

The series I feel most strongly about are my New York 2000 series, Olympics 2002, the Samburu, Flowers, Nudes, Metal Objects, and Landscapes.

Have all the pictures been taken?

The pictures are never all taken—I think about them all the time and continue to add to all of the series whenever I can. For example, I'm hoping to go to Athens for the Summer 2004 Olympics.

Who is your past/present mentor (influence)?

My mentor was a photographer named Aaron Rose. He taught me that the print was as important as the image. That every inch of what is within the frame must be considered. That photography is a "way" and a

"teaching" and not to be intimidated by criticism on my path. That photography is painting with light. That the camera is only a tool. You make the pictures.

What part of your work do you find most demanding?

Raising money for personal projects and making the time to work on these studies in depth.

What creative philosophy do you communicate to a student audience? a professional audience? a client?

To a student audience I communicate that you are an individual with your own unique genetic past, nationality, parental and environmental influences (books, movies, friends…) and your work should reflect all of these things in order to make it your own. I was taught by my mentor not to show my work until I had a body of work that was unique to me, and I worked for seven years before I had 22 photographs that I felt I could show.

To a professional I communicate the importance of work being archival. I like to show the range of my work and talk about what influenced each series: the great photographers, painters, artisans, master builders, filmmakers and authors who have inspired me.

To a client I communicate that the most important thing is that I don't want to repeat myself—that I want to do something I've never done before: travel to a new place, photograph new people, new subjects. The essence of the project and the challenge and power come from solving their particular problem.

How do you predict the future of traditional photography given the new emergence of digital technology?

I don't see digital imaging as photography yet—it is a new form that has no tradition, but I suppose will inevitably one day have its own tradition and influence on photography and film. Digital technology has been useful for me as a documentation tool, for cataloguing images on the computer and for presentation purposes. My fine-art prints are either Fresson, platinum or silver gelatin, and these are the most archival processes available, which I believe is the area digital technology is most lacking.

The role of the photojournalist is to bear truthful witness to the moment. How can the photojournalist validify his credibility if the "truth value" of images is subverted by digital processing?

If the definition of a photojournalist is "one who bears witness to the moment" then one who subverts their document with digital enhancement, has to be called something else.

Does photography have a moral dimension?

For me, photography has a significant moral dimension. A photograph seen by a viewer can inspire or influence that viewer to a great degree. Images reflect the photographers' view of life, through nudity, sex, violence, beauty. The photographer creates a world which can be truthful, mythical, sensual, etc…Choices are made; good vs. evil, levels of pleasure or pain…

What are the implications of the Web for the photographer's ability to maintain commercial or artistic control of their images?

The Web's greatest feature is the number of people who can see and become inspired by the work displayed. This kind of exposure is just one of those risks worth taking.

Over the last two decades, more and more of the images we see depend on color. Is there a future for black and white imagery?

I think color photography and black and white photography are essentially different media. Steichen, at the end of his life, was extremely interested in color and stated "color photography can be considered as a technique that enriches the value of the photograph as visual information and documentation, but in the domain of abstract photography I believe it can be regarded as an entirely new medium." And Man Ray once said, "I paint what I cannot photograph and I photograph what I cannot paint." For me, I use black and white when I cannot use color and I use color when I cannot use black and white.

In many artistic works, photos gain their meaning in a series, project or concept. Is there a future for the single image as a significant communication?

Many years ago, when I visited John Szarkowski at the Museum of Modern Art, he looked through my first portfolio and his comment was, "Try to get it all on one picture." This is still the basis of my work. In every series, it is essential that any one image in that series be able to stand on its own.

Throughout photography's history, fine art photography has sought to separate itself from commercial and industrial applications (most recently fashion/advertising). Is that separation valid, or even possible today?

The separation of fine art from commercial and industrial applications is valid and always possible. There is no doubt that some commercial photography is artful and could, in special instances, be called "art." But the artist in his soul works for himself, not for a client. His aim is limited only by his own limitations, and not by the client's restrictions. There are no boundaries—the artist is free.

People now see photographs occupying the same space in museums that paintings do. What is the current relationship between painting (and other arts) and photography and how does this influence photographic practice?

The difference between painting and photography, apart from the tools: paint and brush vs. camera, is that the photographer's subject is Life, which must be in front of the camera. The painter can work from his mind and memory, and can invent life. The photograph, as Julia Margaret Cameron signed her prints, is "From Life."

Aside from photography, what is your favorite pastime?

I love to read, to look out the window, to ride horses, to lie in the sun, to swim, to arrange flowers, to do yoga, to spend time with my family and friends, to cook, to watch movies, to travel, to be a passenger in a car, train or airplane.

Where do you see yourself going in the future, and what are you presently striving for and perfecting?

I work in the present. Virginia Woolf wrote, "For what more terrifying revelation can there be than that it is the present moment? That we survive the shock at all is only possible because the past shelters us on one side, the future on another." I live as though there is no future. It doesn't exist until it becomes the present. My striving has been the same since I was young—for peace, love, truth and beauty.

Any final words on photography?

My high school motto: Be true to your work, and your work will be true to you, and back to Steichen, who wrote, "Having carried out the promise I made to Alfred Steiglitz, when I was twenty-one, that I would always stick to photography, it is with pleasure that today…I warmly salute—with a 'Good Luck and Keep at it!'—the present young generation of photographers."

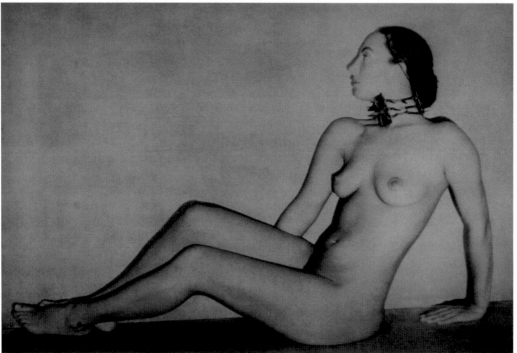

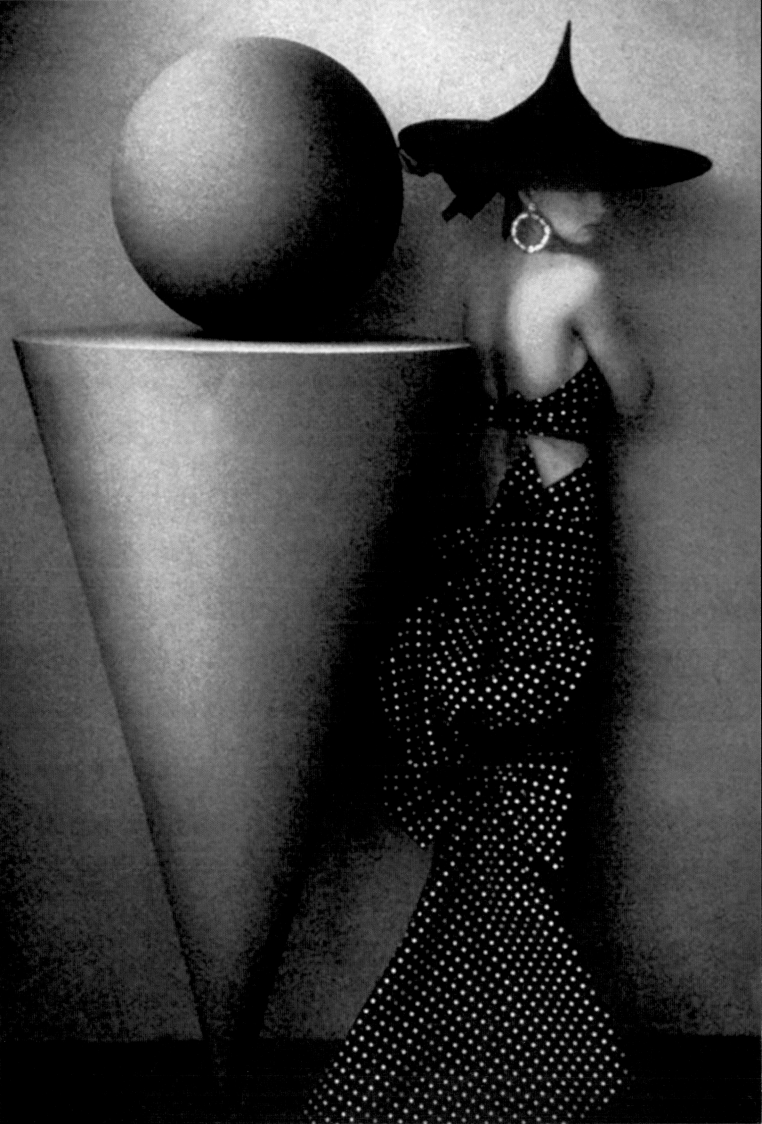

Q&A with Les Stone

 Bio for Les Stone: I was Born 1959 in NYC. I am a Graduate of Hampshire College in Amherst Massachusetts with a degree in Photography. I worked in NYC as an assistant to many corporate photographers and worked for three years as a staff photographer for the Metropolitan Transportation Authority in NYC. However, my "photographic heart" was always in the news. During my time at the MTA, I would save my money and take my vacation time and go to any "hot spot" around the world such as Haiti and Panama and photograph the news events. In 1989 I got lucky and photographed the beating of the president and vice president of Panama by the Paramilitary thugs of Manuel Noriega, pictures that were seen around the world. Since that time I have worked for countless magazines around the world covering news events and feature stories. At present I continue to work as a freelance photographer, contributing to such publications as National Geographic traveler, National Geographic Adventure magazine and the New York Times Sophisticated Traveler. I currently live on a mountain in the Catskills, located in New York state.

What photographs or series of photographs is your proudest achievement?

That's a difficult one. I would have to say that there are two: Vietnam, the 25th anniversary of the war in 2000, including a piece on the effects of Agent Orange on the Vietnamese 25 years later. And Haiti, during the bad years (they're all bad years), Voodoo being the series that I like the most.

Have all the pictures been taken?

No, I believe that all the pictures have not been taken, or at least that putting a personal stamp on a subject will always change the story. There may always be room for an original style, work that does not copy anything previous.

This may be wishful thinking, because I know when I look at the year-end work or go back to old year-end magazines I see very similar subjects and styles recycled again and again. The only thing I think that is new always is hard news, wars, natural disasters, etc.

Who is your past/present mentor (influence)?

I thought long about this. I can't really say I have followed anybody, or been mentored by anyone. If it's a matter of who I would like to be able to match talents with in my wildest dreams I'd have to say Eugene Richards. I say this because I think that he is probably the most original and easily the most committed of contemporary documentary photographers. I don't think that any other photographer today can come close. There is one other man: Antonin Kratochvil. He also has an extremely original style and is wickedly talented. There is a great difference between dilettantes and the real thing, these guys are the real thing.

What part of your work do you find most demanding?

I think it is the business side of photography that I find the most demanding. I'm not talking about billing, etc. I'm talking about the climate among editors, photographers and the large corporations that are emerging as the bulls in the china shop. In my recent experience, I've found that financial considerations have become all important. Photographers are given very little choice these days, young photographers have "buy out" contracts with their agencies, meaning they will not own their work, and the magazines pay the lowest amount possible for pictures while paying lip service to how much they support the photographer. Photojournalism is in danger of becoming just another commodity for sale in the marketplace.

What creative philosophy do you communicate to a student audience? a professional audience? a client?

Can't answer that one.

How do you predict the future of traditional photography given the new emergence of digital technology?

Traditional photography will always have a place in fine art, but as far as photojournalism is concerned, digital will almost completely replace it.

Even digital photography is now being used for fine art. I think that any new innovation is good and will find its place. I was a long time hold-out, but have come around to seeing the benefits and possibilities of digital.

The role of the photojournalist is to bear truthful witness to the moment. How can the photojournalist validify his credibility if the "truth value" of images is subverted by digital processing?

First of all I think it is somewhat pompous to talk about Photojournalism being able to bear "truthful witness to the moment" As soon as you interject the photographer into the moment you have changed it. The only truthful witness may be the security camera, which captures the moment without judgment and interpretation. In other words there is no "truth," only interpretation. Read 15 history books about the same subject and they will have 15 different "truths." As far as digital technology changing truth, I think that with vigilance and honor there can be a "policing" of accuracy in images. We just have to be much more careful in how much we trust photographers and editors, and take nothing for granted.

Does photography have a moral dimension?

Strange question. I think it depends on the photographer. I think that everybody's personality is different. These days, I think that many photographers are worker bees—some really care about what they do and some just want to "be there." There are some photographers that continue the tradition and mission of giving up much of their lives to show the world the horror. When I started out I really thought that I could change the world, I'm not so sure now. I also think that some people should ask themselves if ego and potential fame are more important than morality.

What are the implications of the Web for the photographer's ability to maintain commercial or artistic control of their images?

There is still such a thing as a lawsuit. Stealing other peoples creative vision is a crime.

Over the last two decades, more and more of the images we see depend on color. Is there a future for black and white imagery?

There will always be black and white. I am always asking the client to shoot in B+W.

In many artistic works, photos gain their meaning in a series, project or concept. Is there a future for the single image as a significant communication?

Of course, the single image is important, that single snapshot of the moment that changes history is without question rare but will always be without competition from video or any other medium.

Throughout photography's history, fine art photography has sought to separate itself from commercial and industrial applications

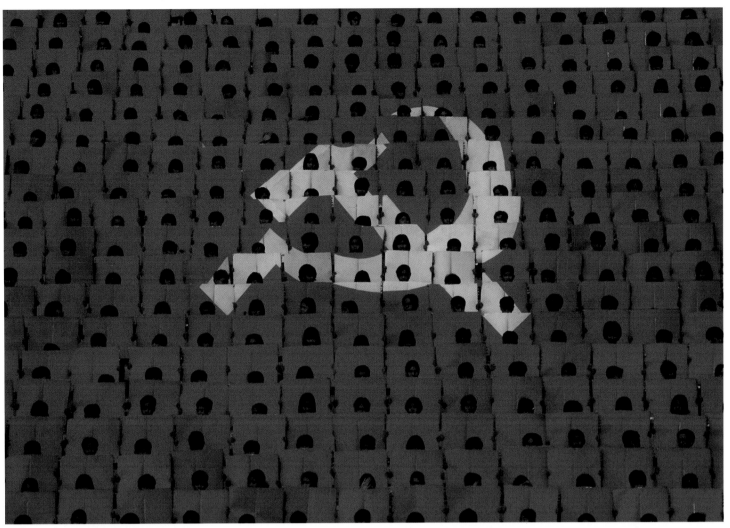

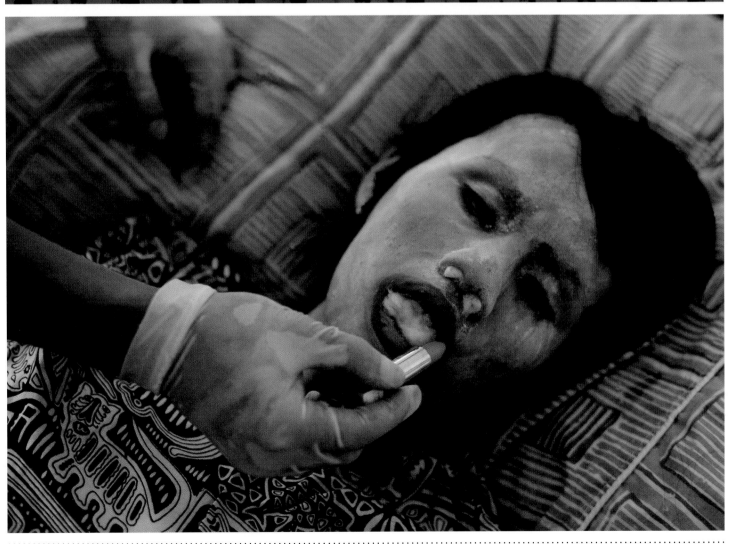

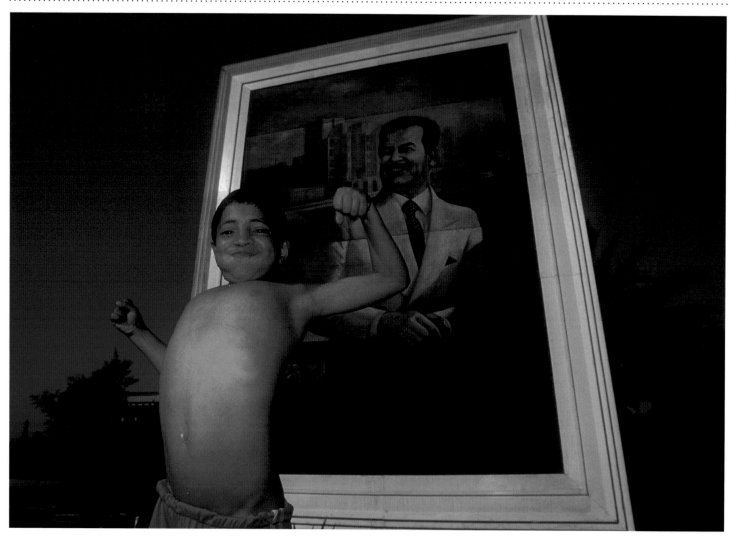

(most recently fashion and advertising). Is that separation valid, or even possible today?

I can only answer this question from a photojournalists point of view. The art world is extremely snotty, treating photojournalism as an inferior vision. Only the lucky few are anointed. In my view the world is upside down and it should be the other way around. Fine art and photojournalism are one and the same, I put as much creativity, hard work, and vision into a "Photojournalistic" picture as someone who works on a concept.

People now see photographs occupying the same space in museums that paintings do. What is the current relationship between painting (and other arts) and photography and how does this influence photographic practice?

I think that photography has always been side by side with painting, Since the beginning it has been interchangeable, not only because one is always borrowing ideas from the other but because photography and painting are equal in their ability to move a person to tears and ecstasy.

Aside from photography, what is your favorite pastime?

I like to renovate old houses and gardening.

Where do you see yourself going in the future, and what are you presently striving for and perfecting?

I have no idea where I'm going in the present or the future. Surviving in this crazy world is the best I can do.

Any final words on photography?

Last words: never lose sight of what you drove you to photograph in the first place, try not to be cynical, and keep photographing no matter what happens.

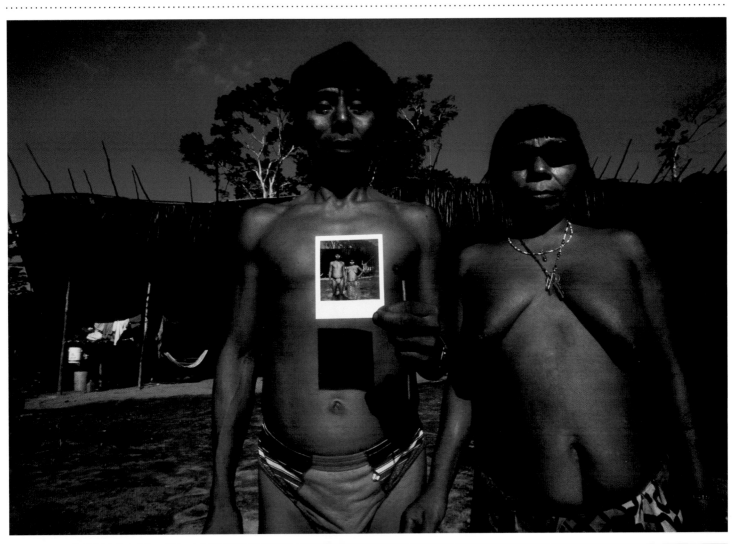
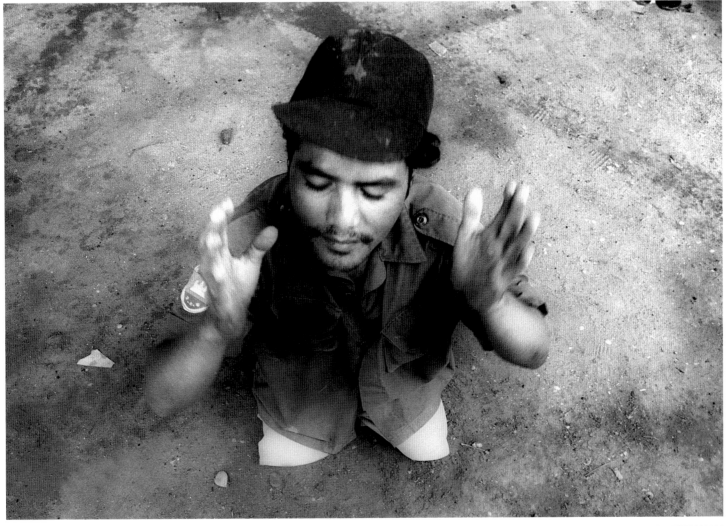

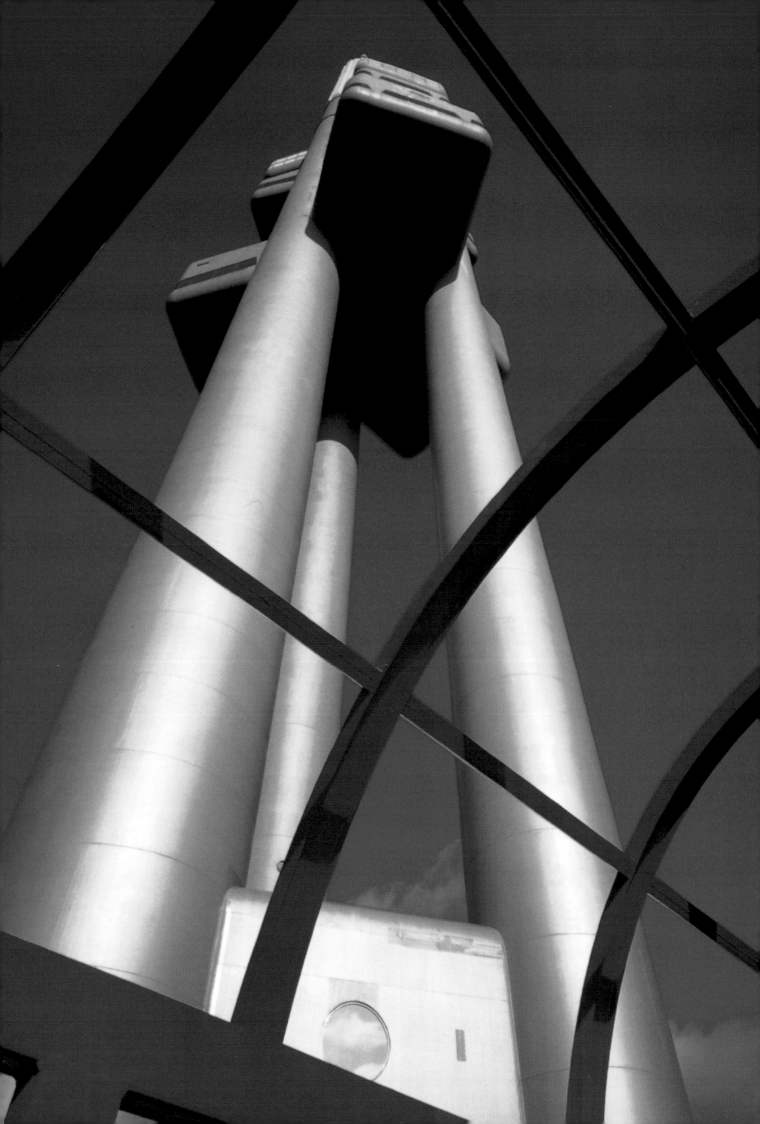

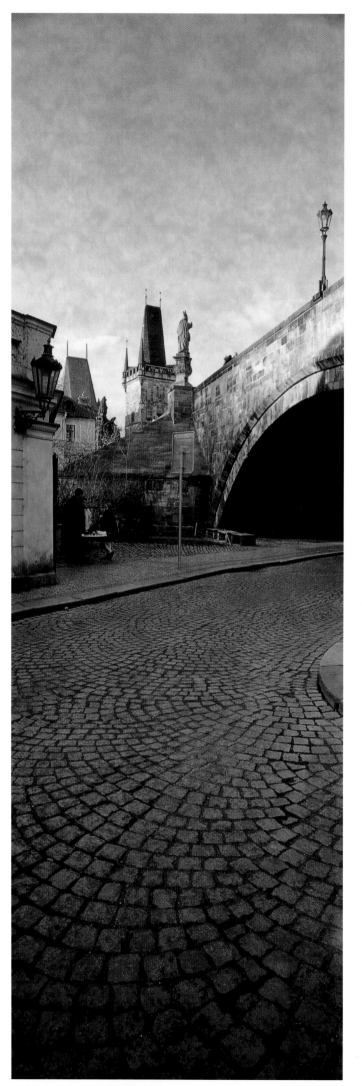

Phil Bekker (opening page), Peter A. Sellar (this page)

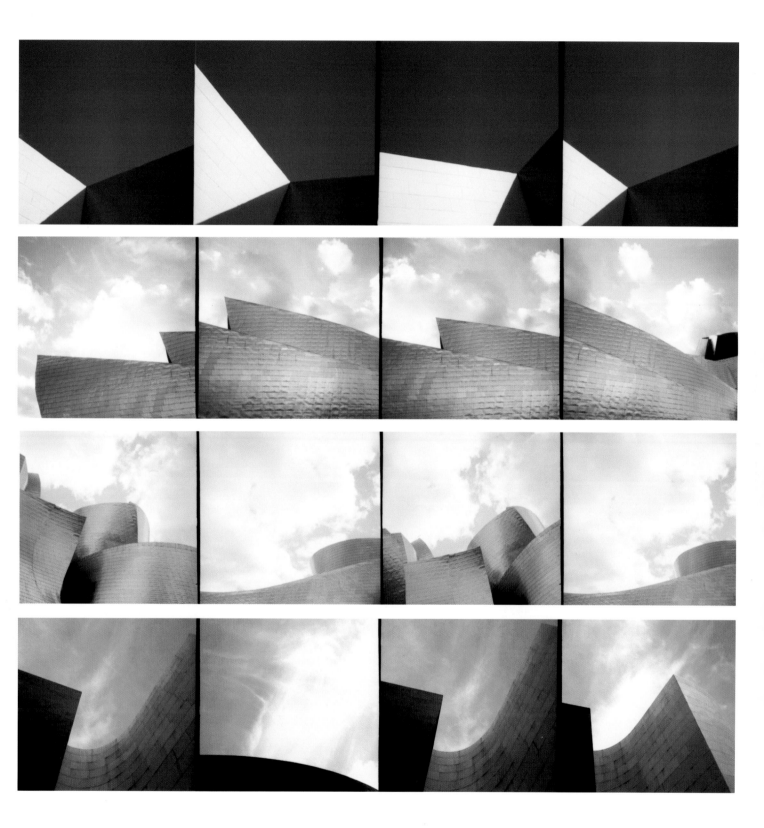

Art Brewer

FIRE · STATION · NO · 6 ·

TRUCK · CO · NO · 3 ·

ENGINE · CO · NO · 6 ·

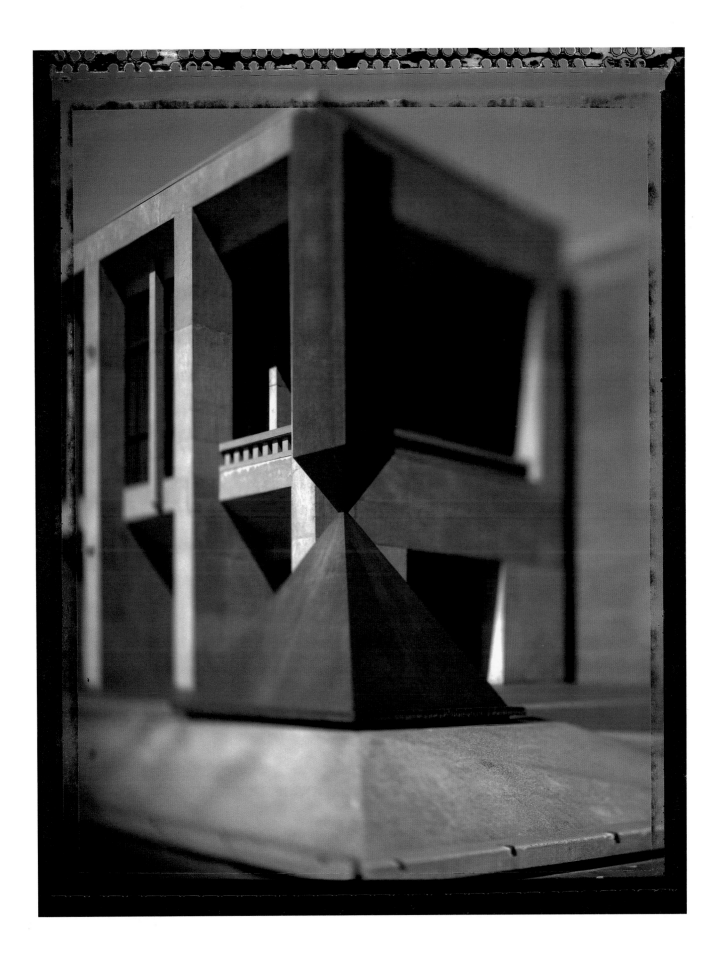

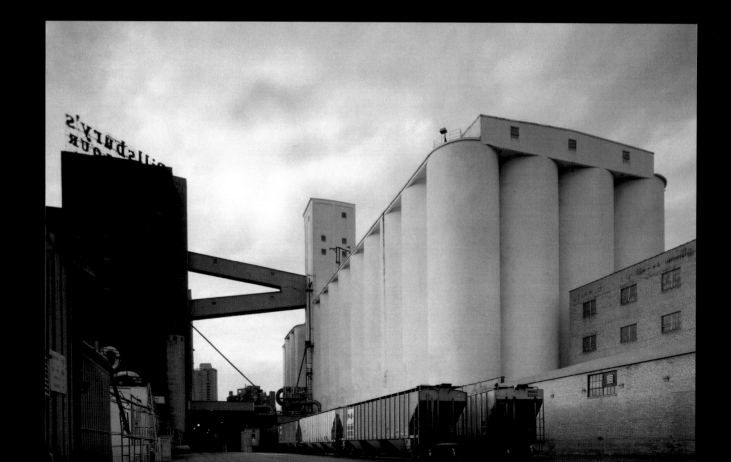

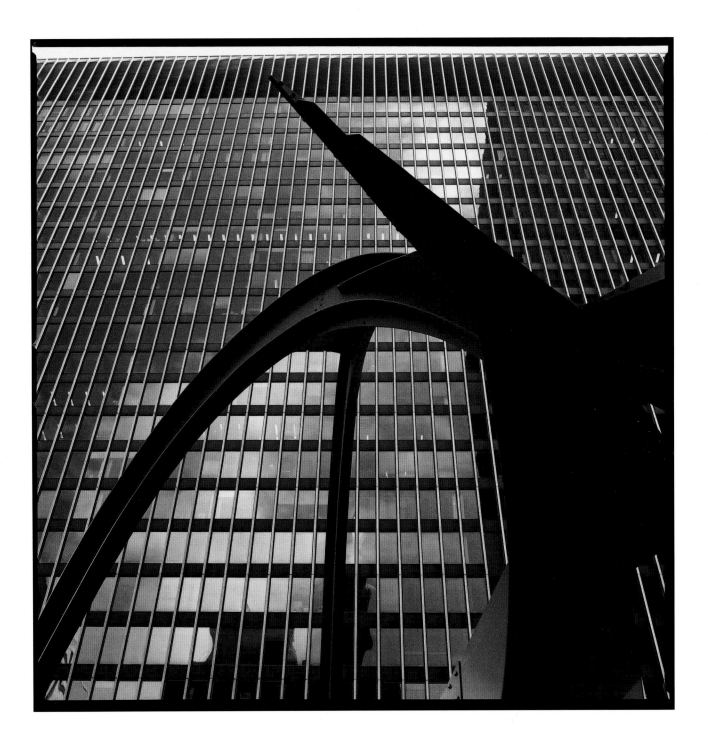

Paul Elledge

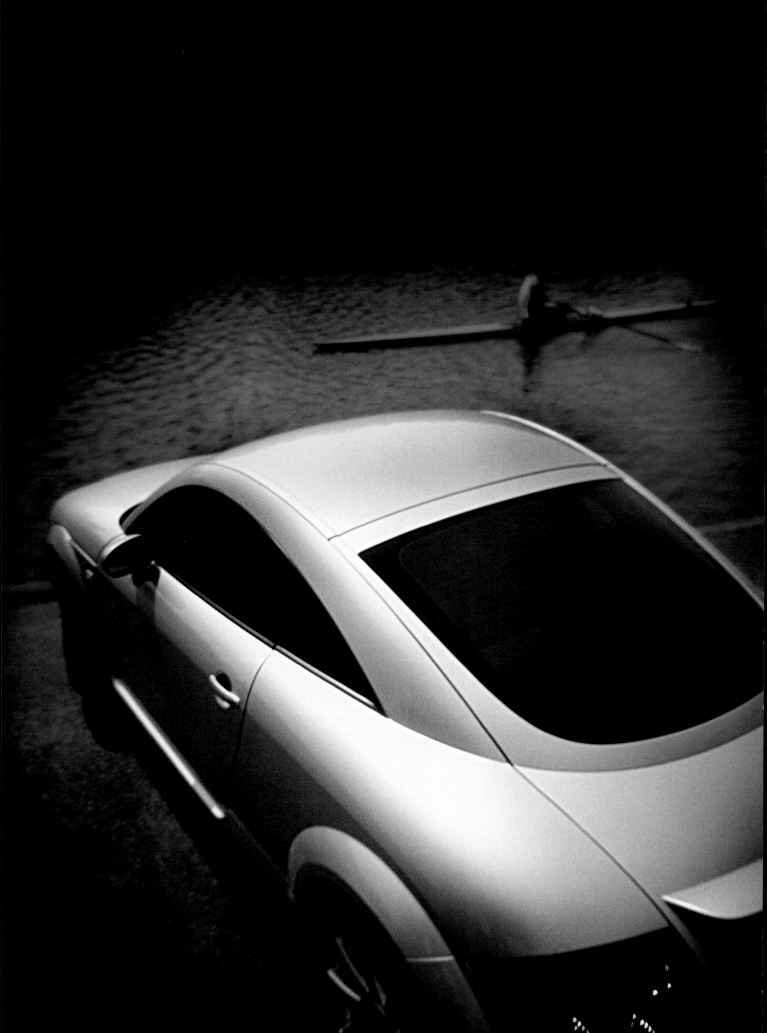

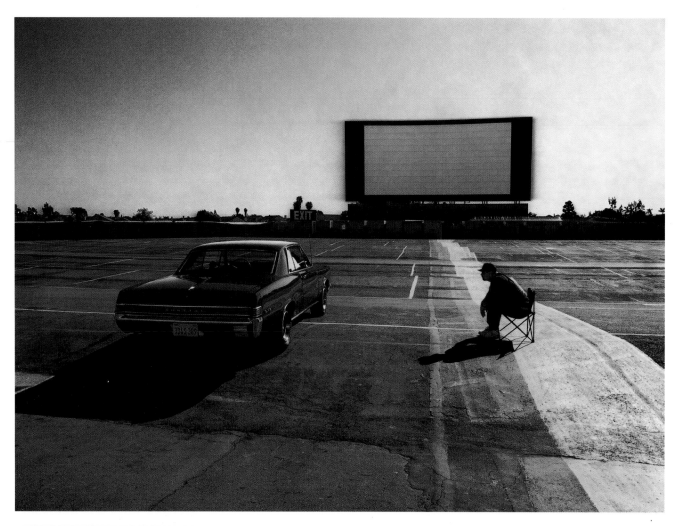

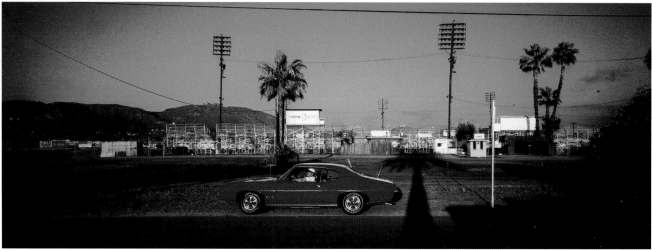

Lars Topelmann (opening page), Marshall Harrigton (this spread)

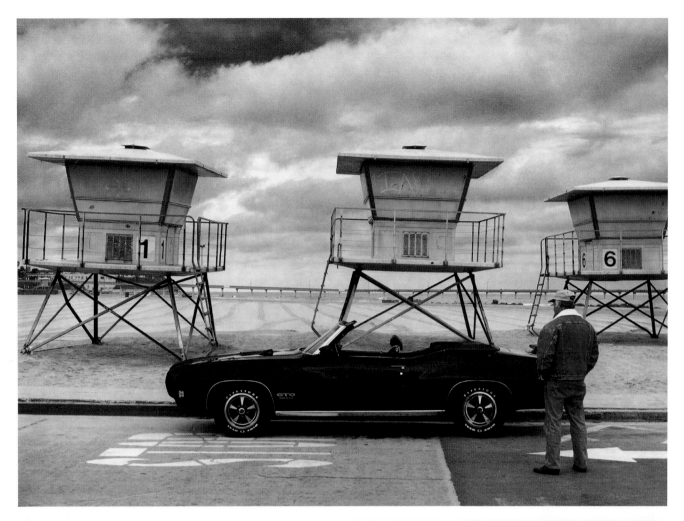

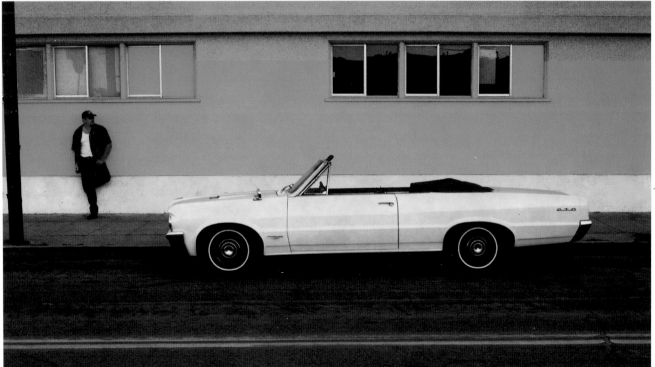

Craig Cutler

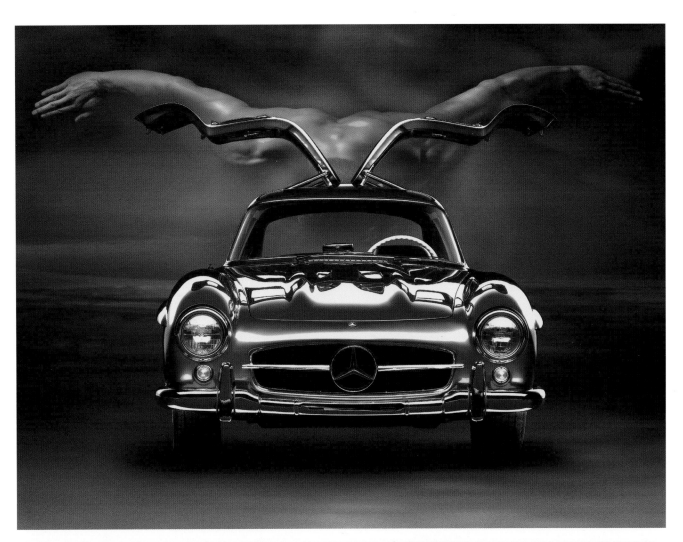

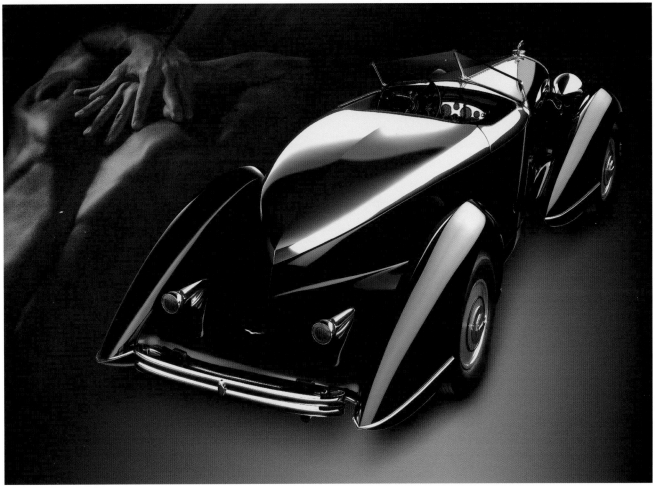

Mark Leonhard and Derek Blagg

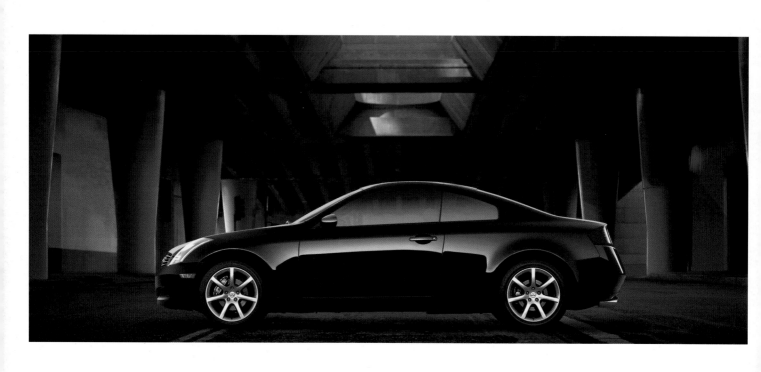

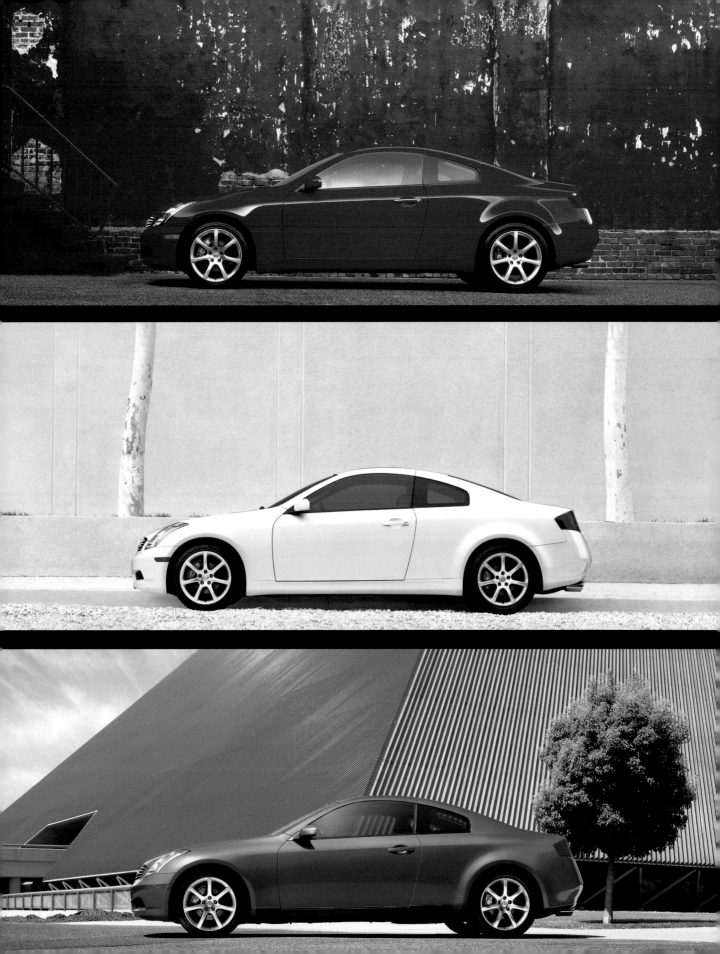

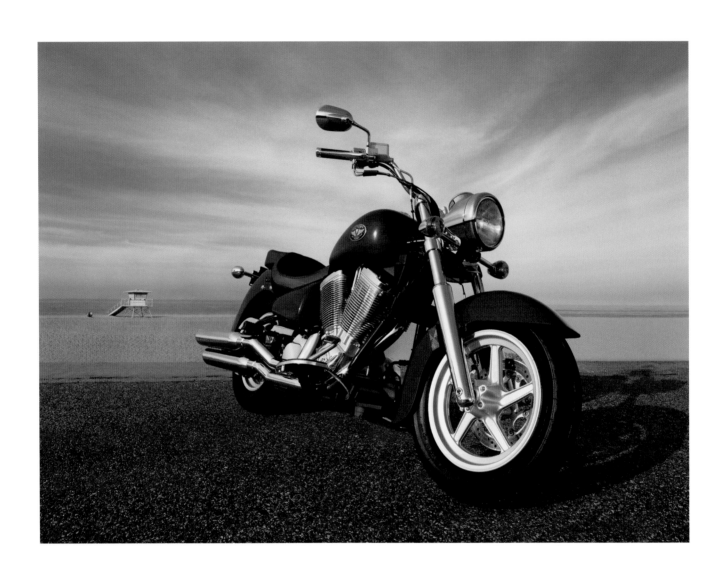

Per Breiehagen

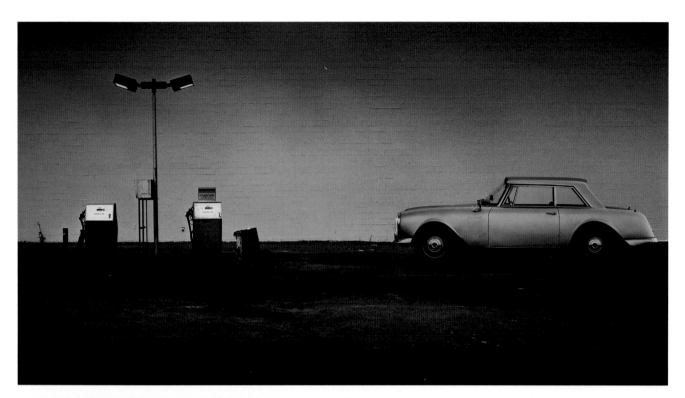

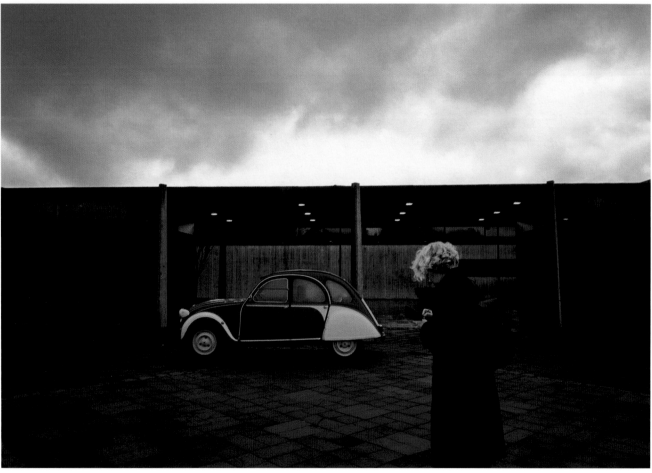

Dirk Kartsen

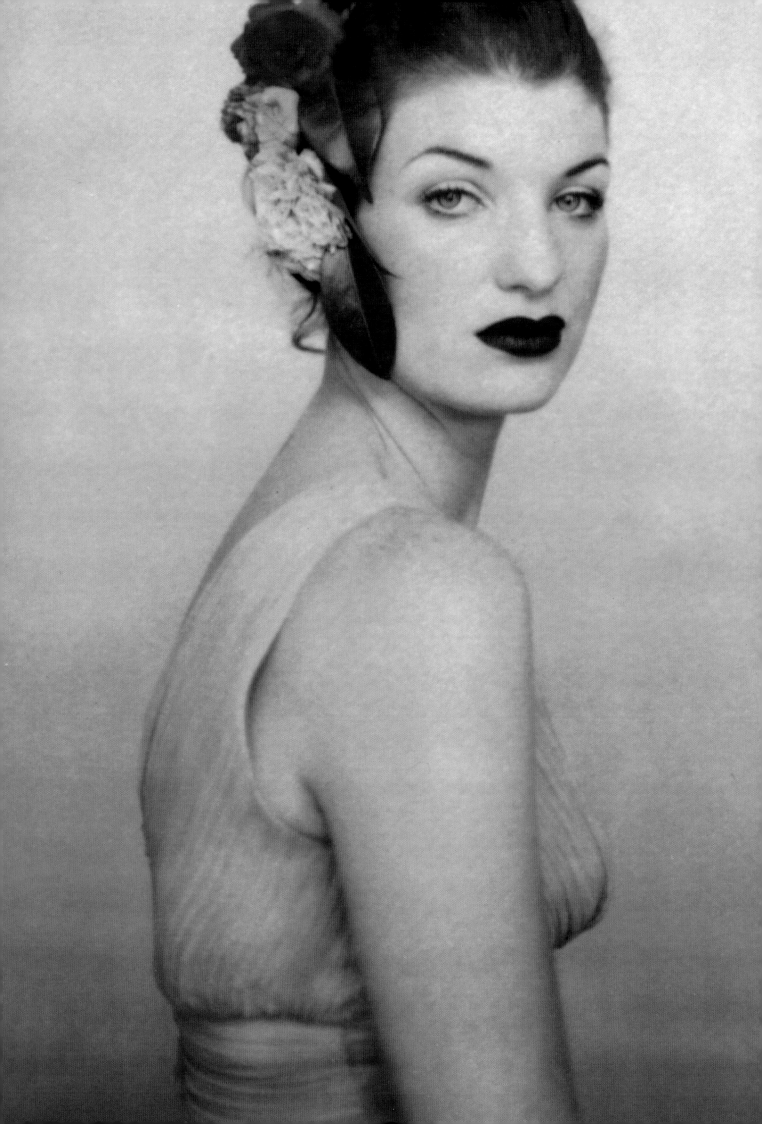

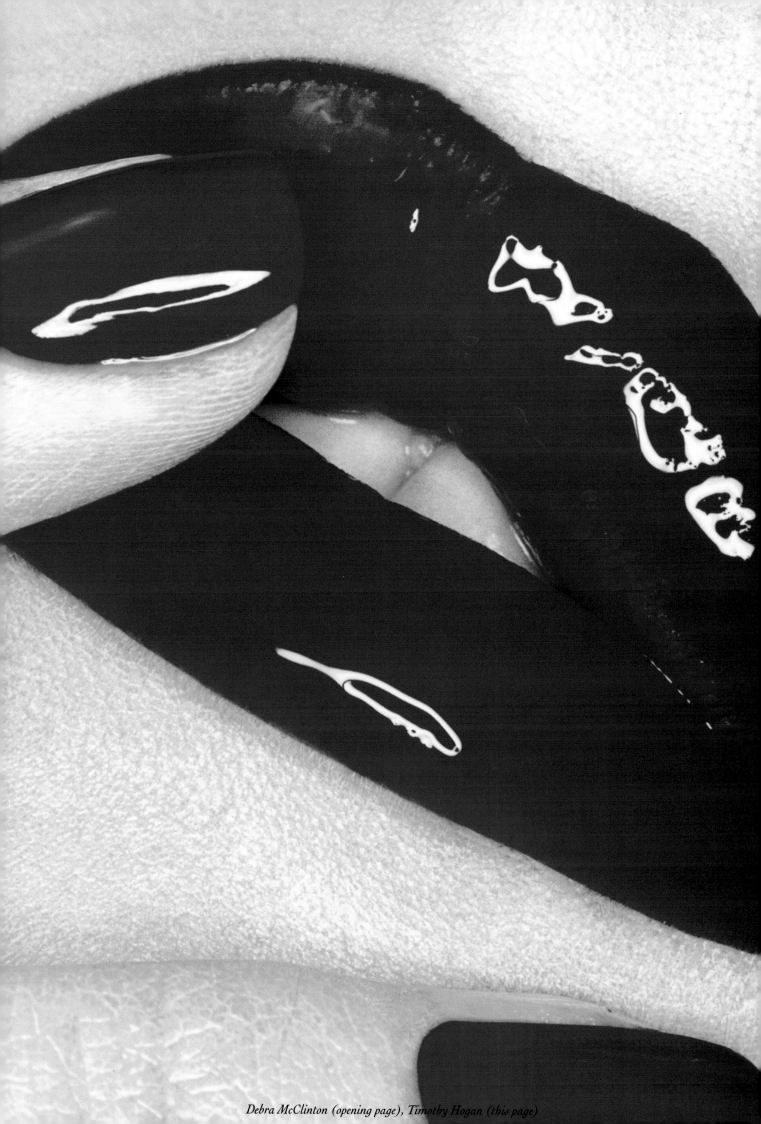

Debra McClinton (opening page), Timothy Hogan (this page)

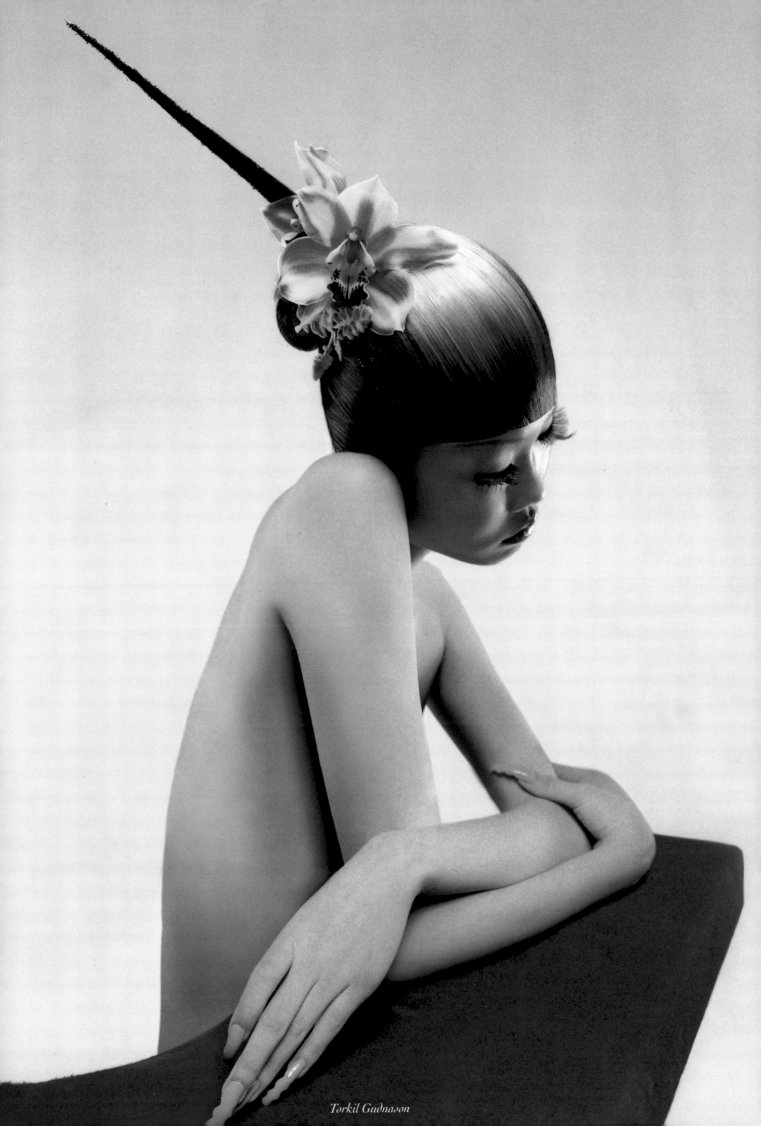

Torkil Gudnason

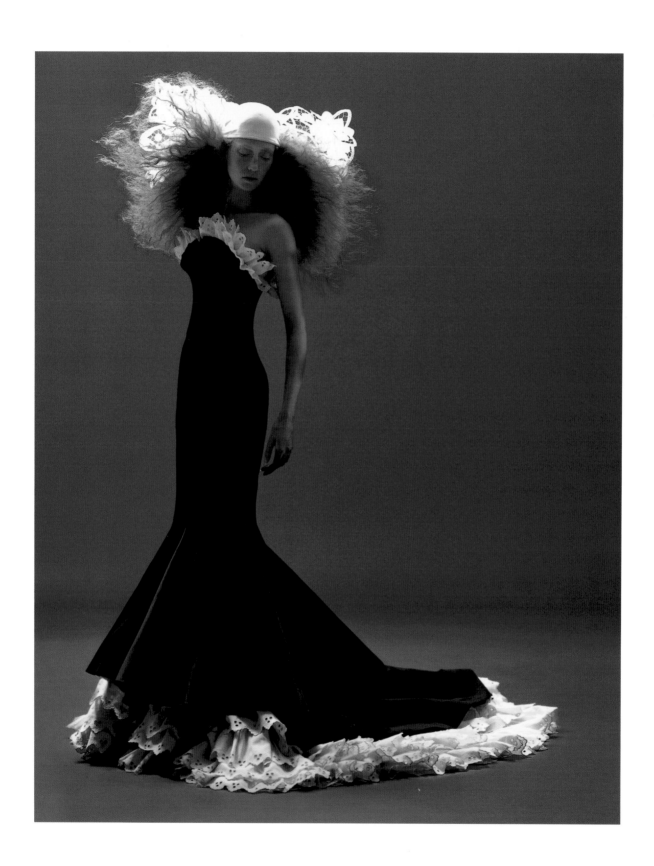

Bill Diodato (this spread)

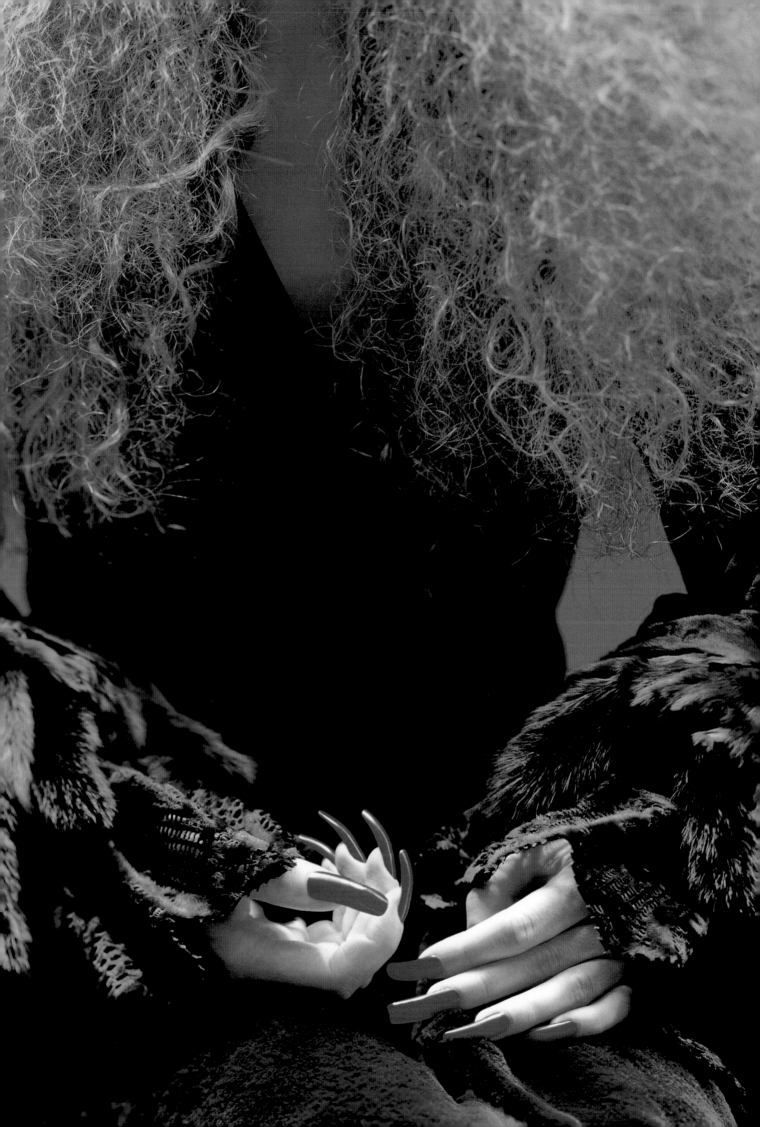

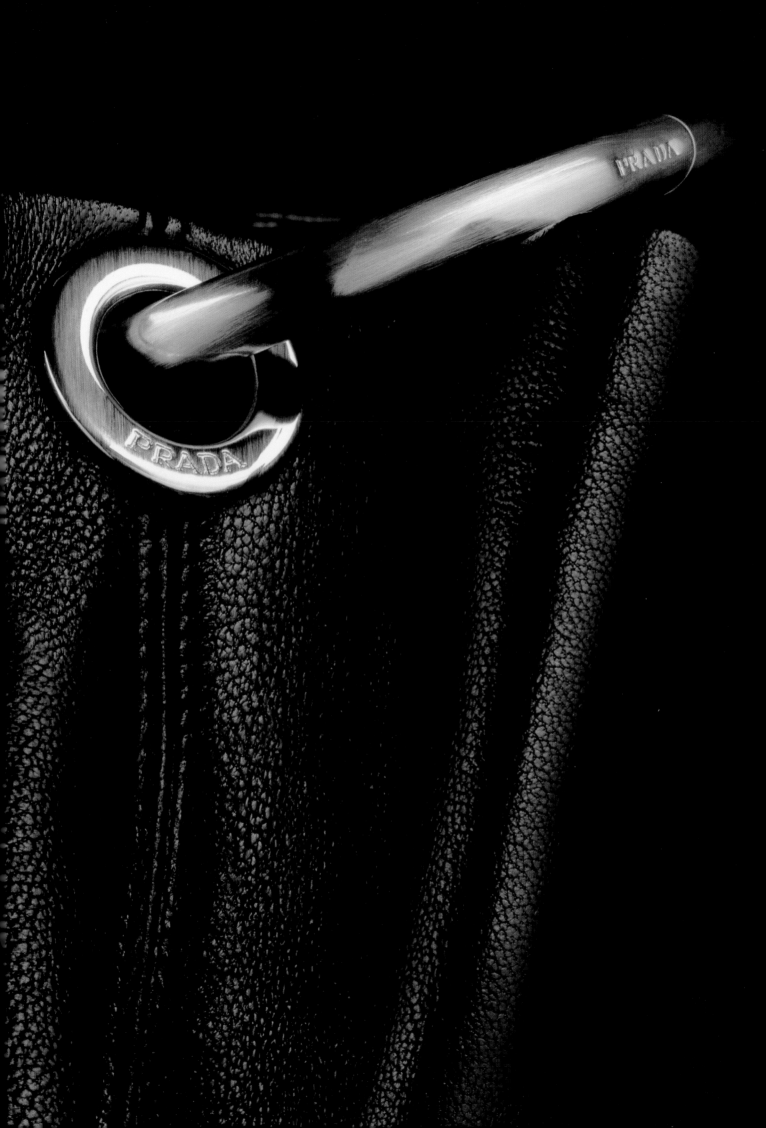

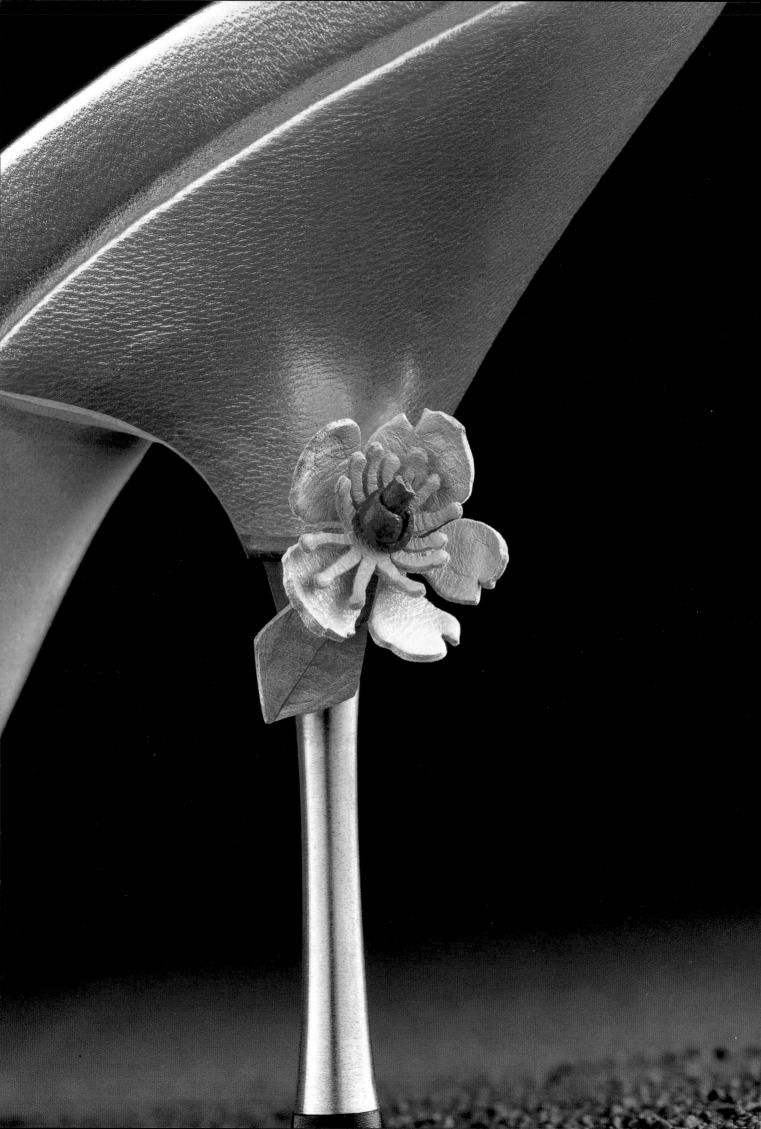

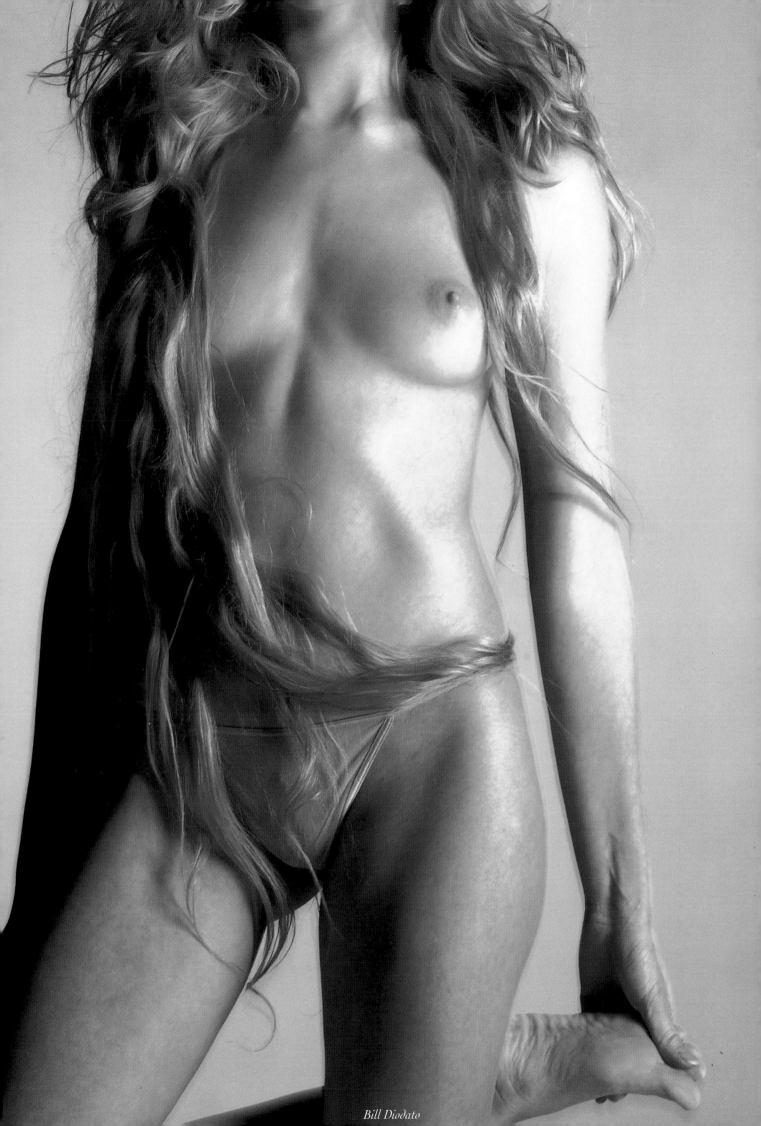

Bill Diodato

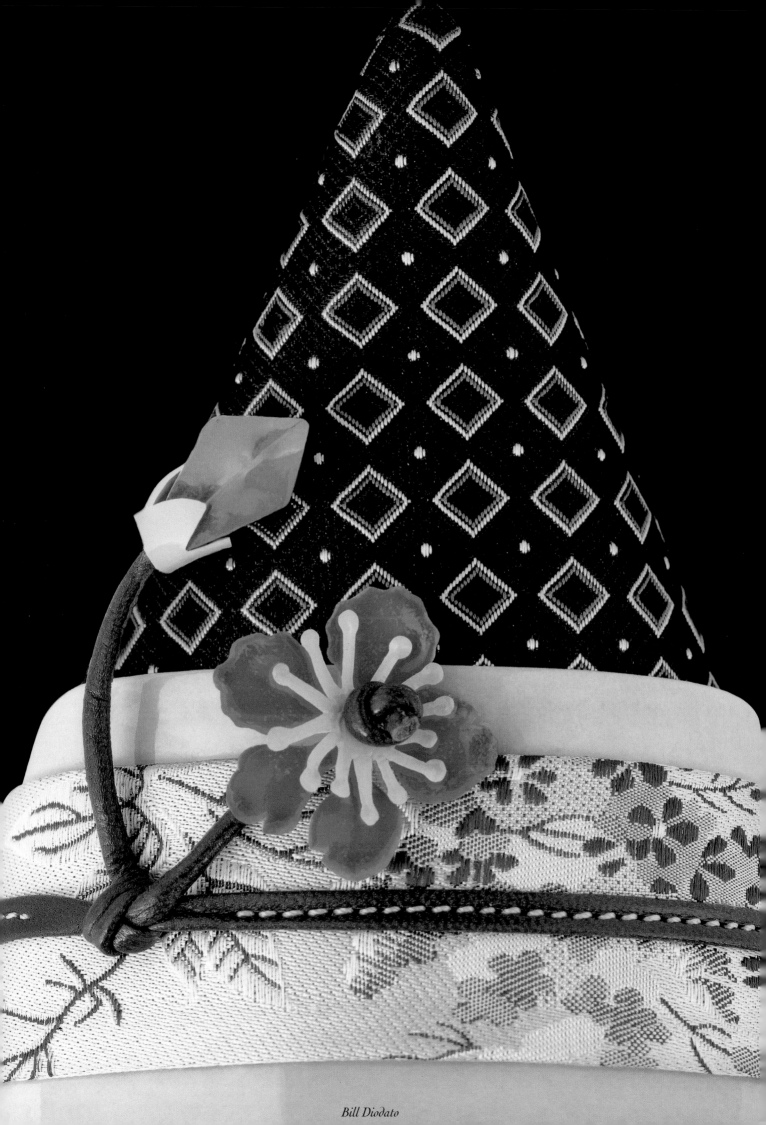

Bill Diodato

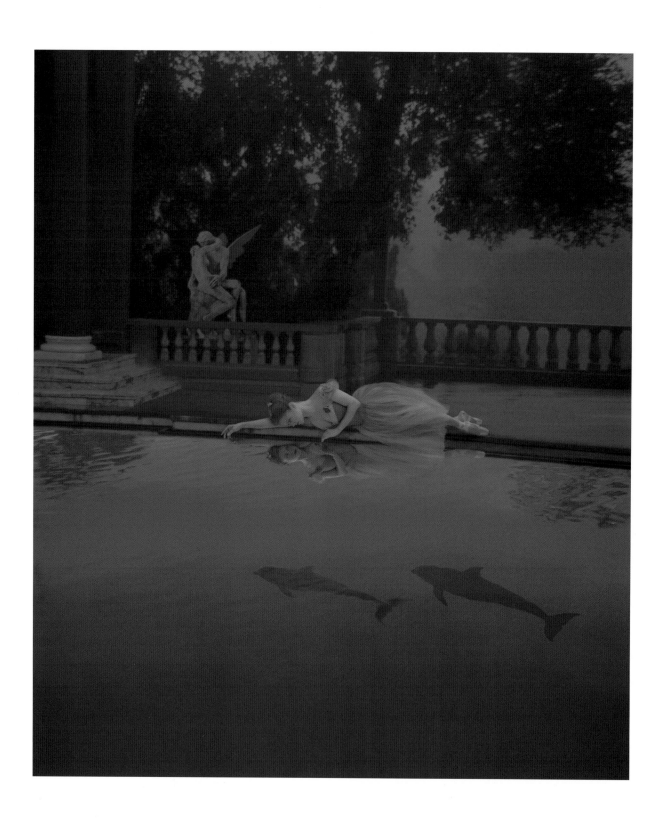

Parish Kohanim (this page), Haig (right page)

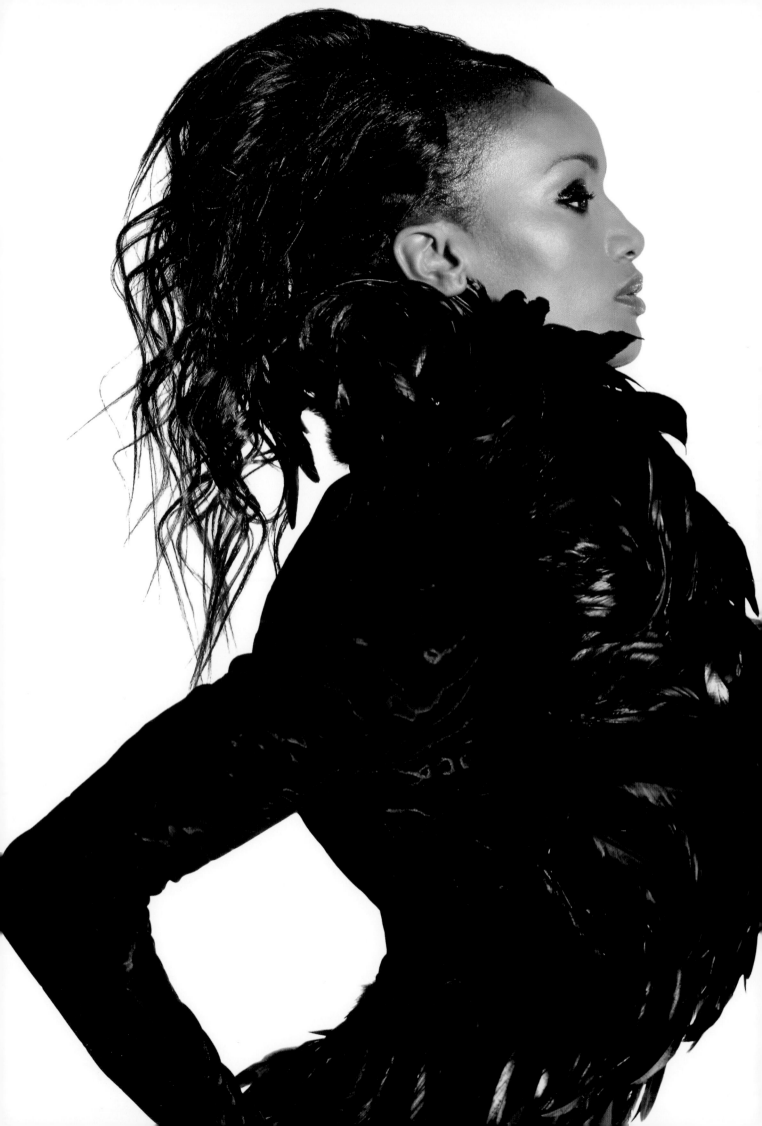

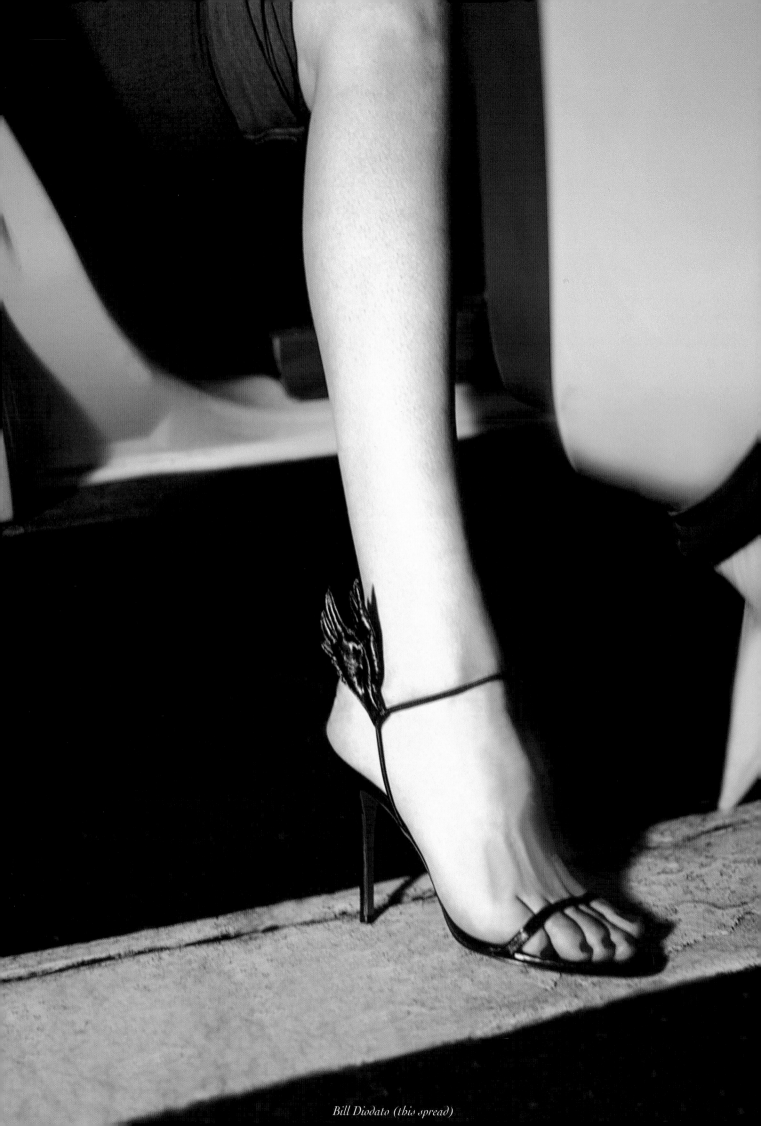

Bill Diodato (this spread)

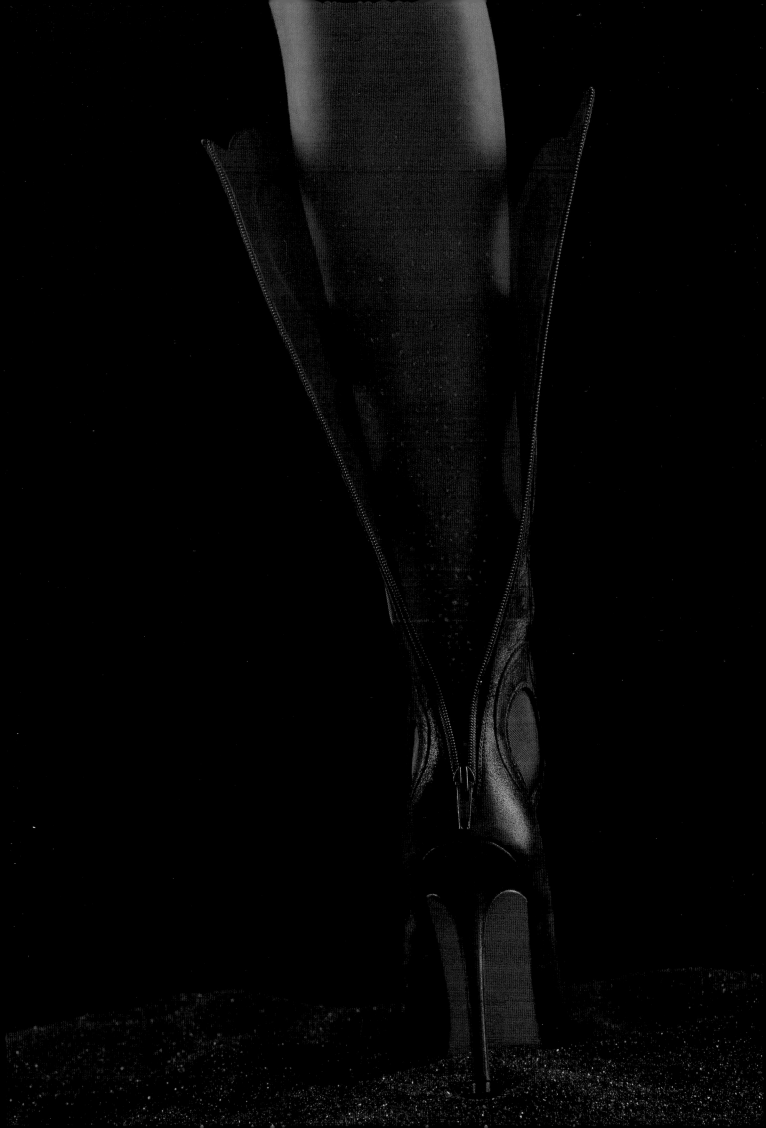

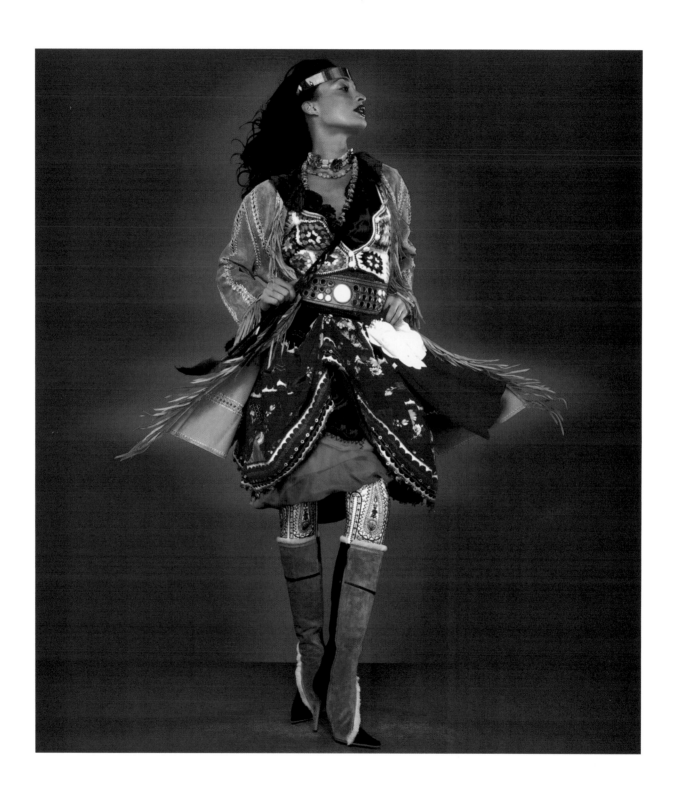

Howard Schatz (this spread)

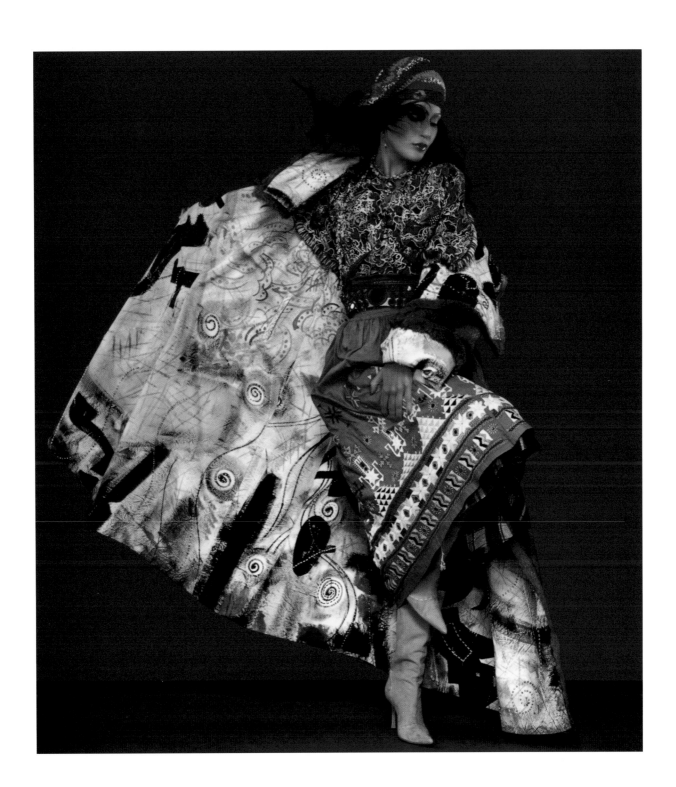

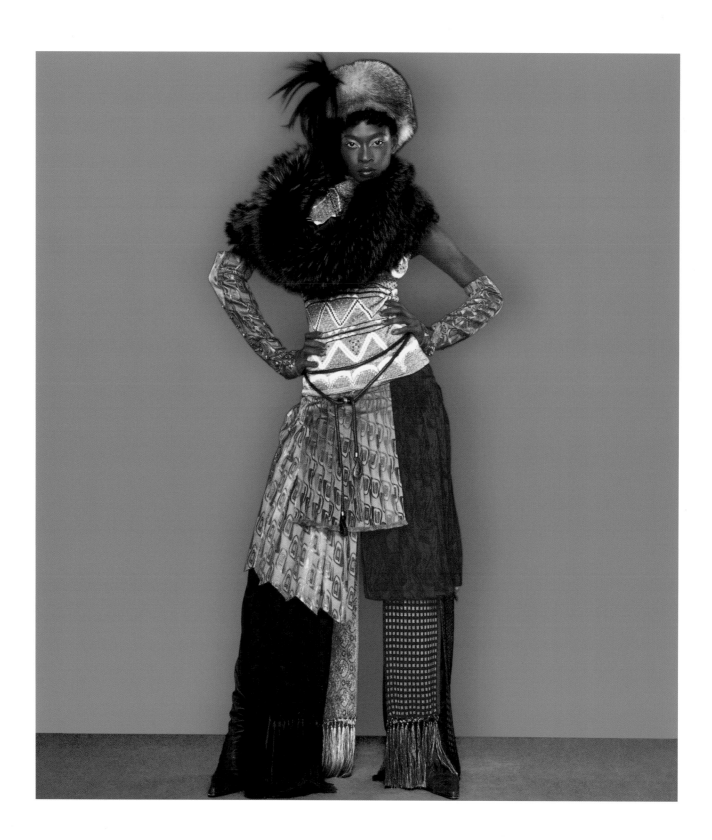

Howard Schatz (this spread)

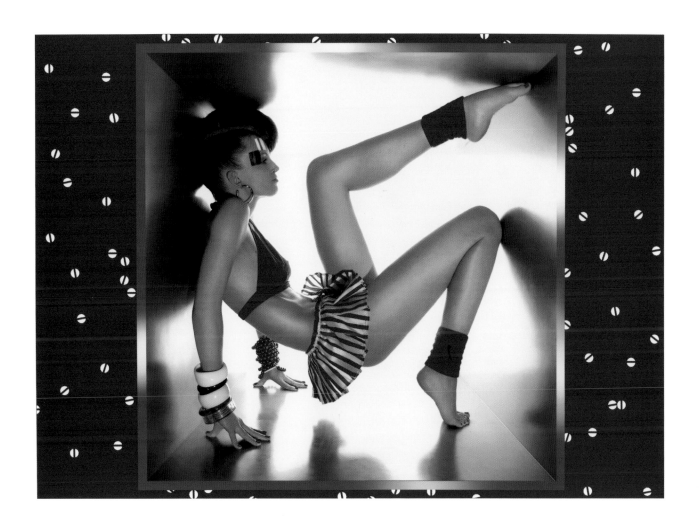

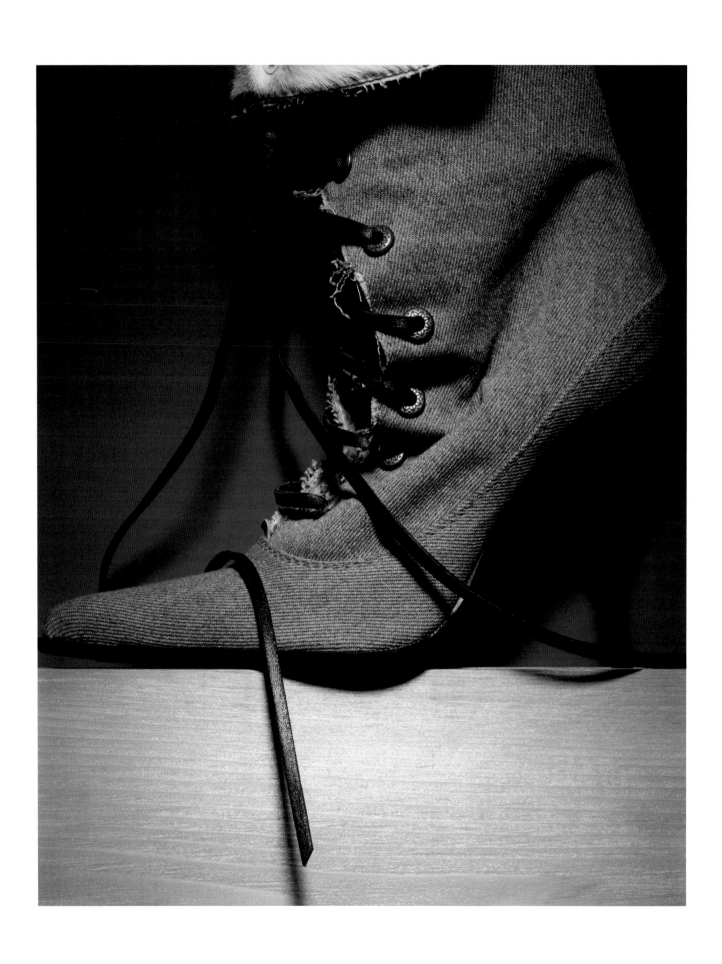

Kenji Toma (this page), Peter Dazeley (left page)

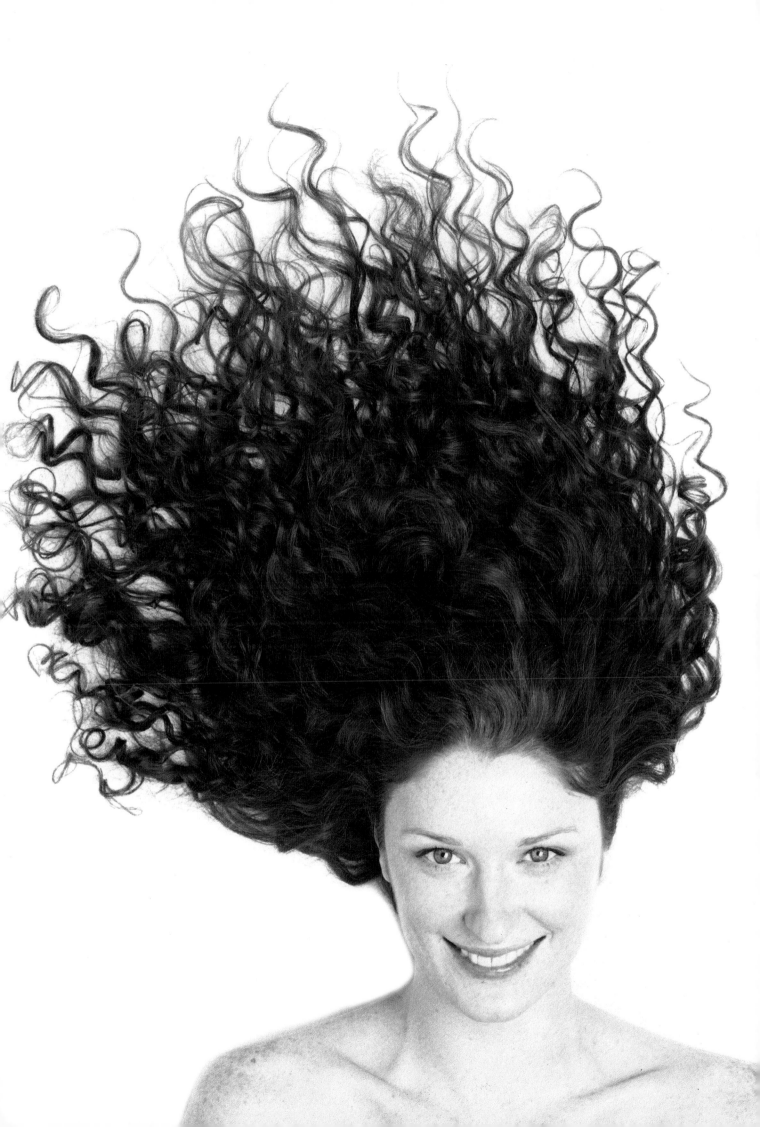

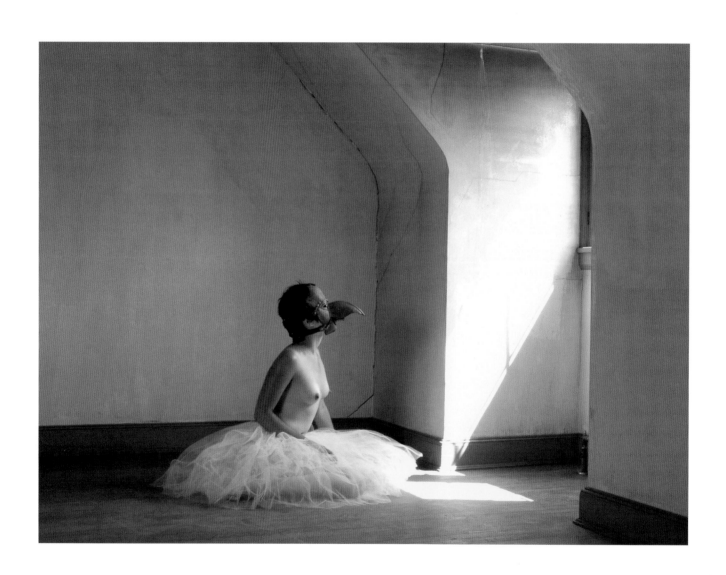

Don Carsten

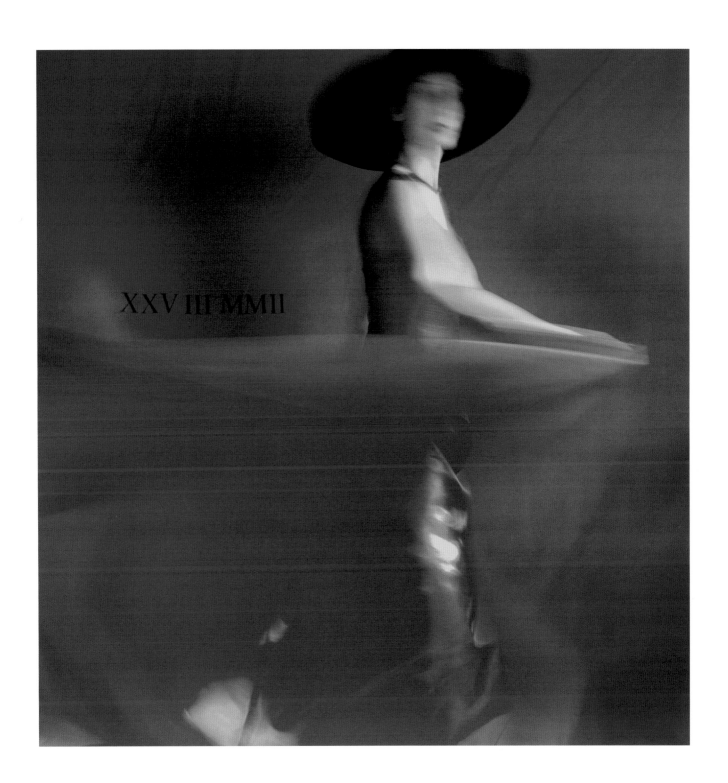

XXV III MMII

Rodney Smith

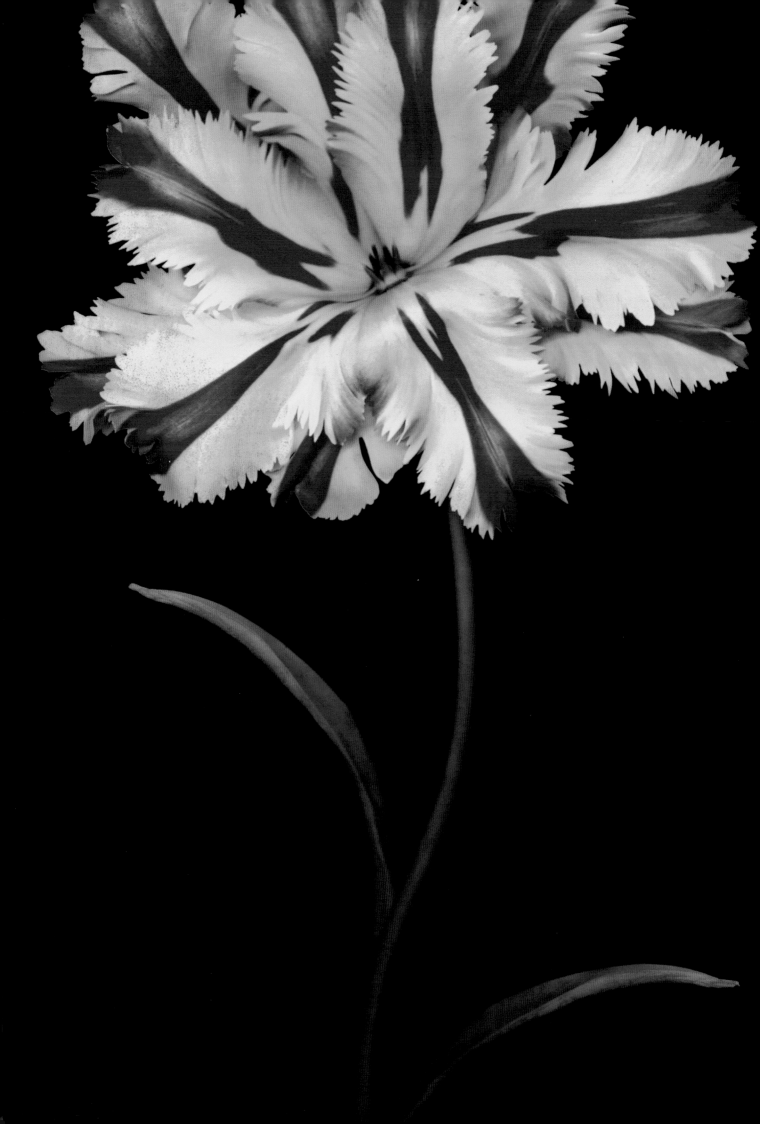

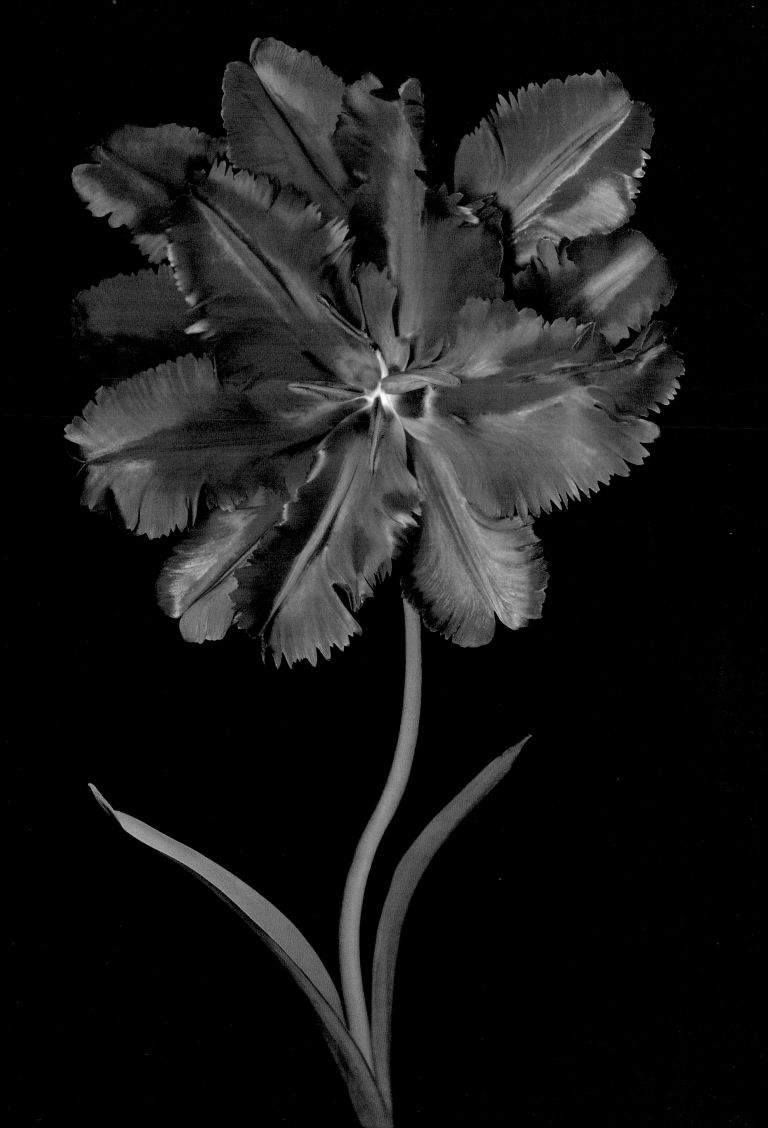

joSon (opening page and left page), Doris Mitsch (this page)

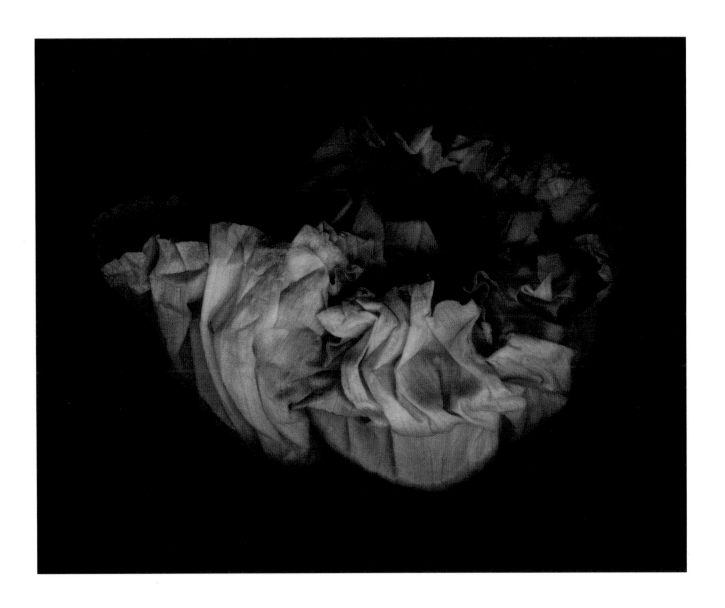

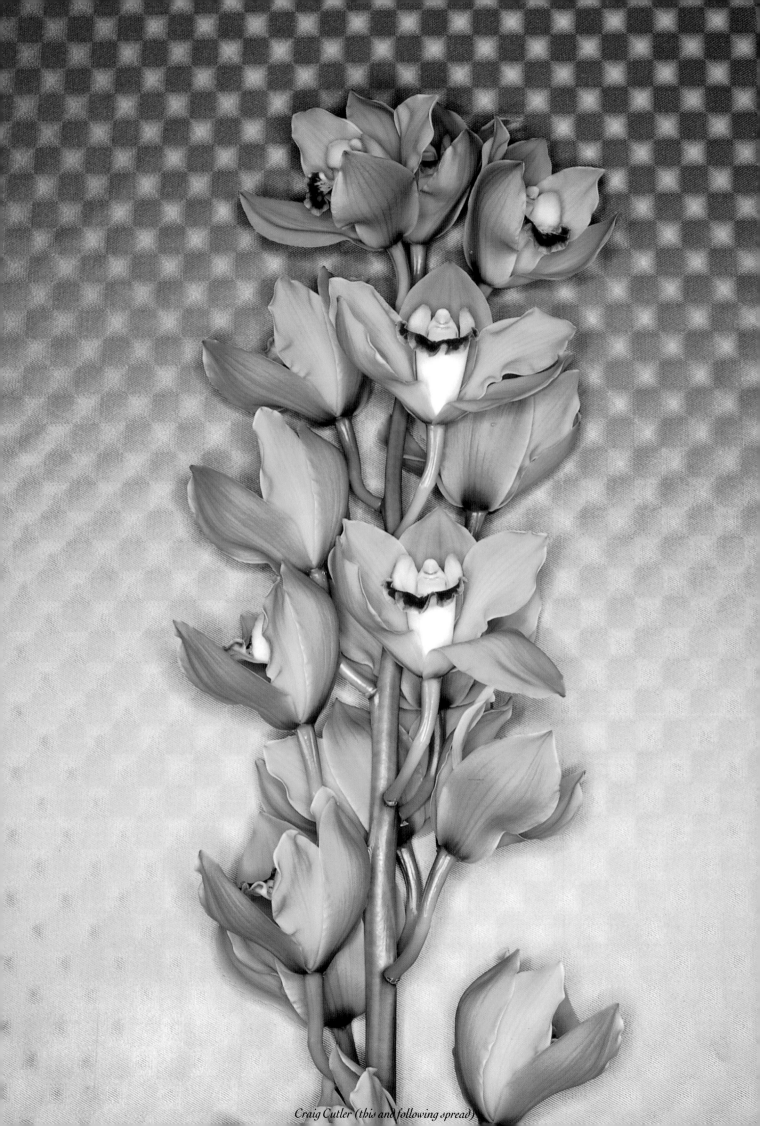

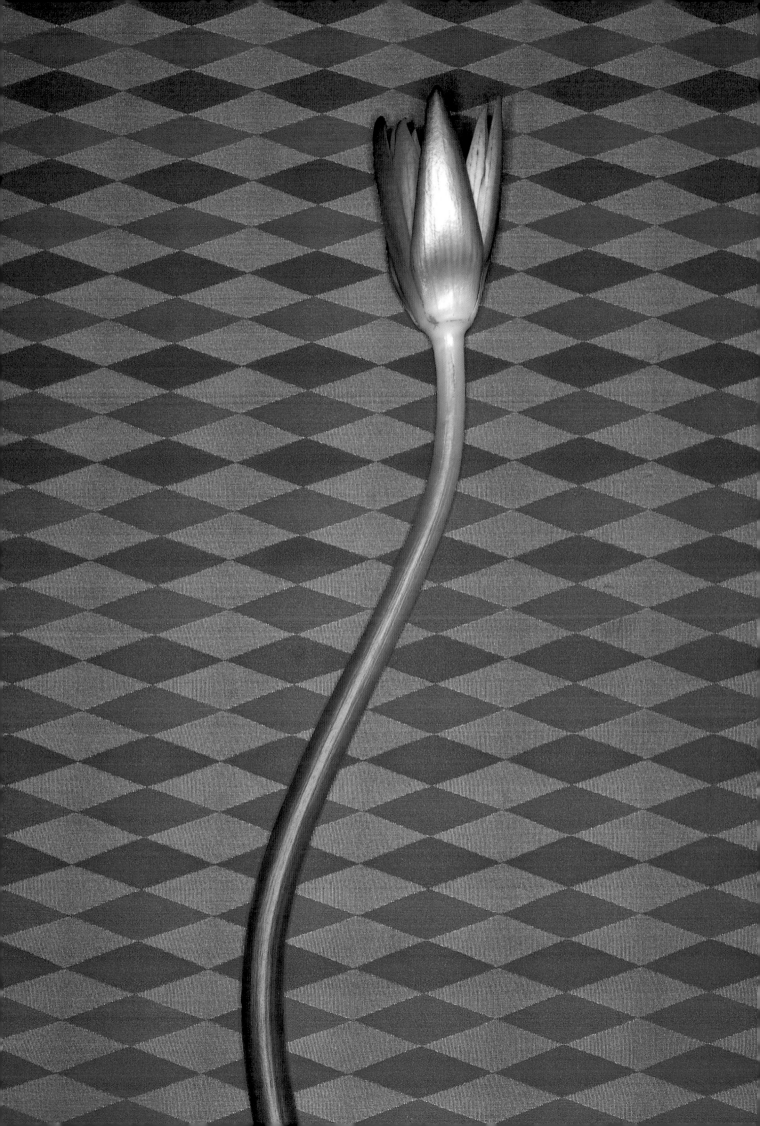

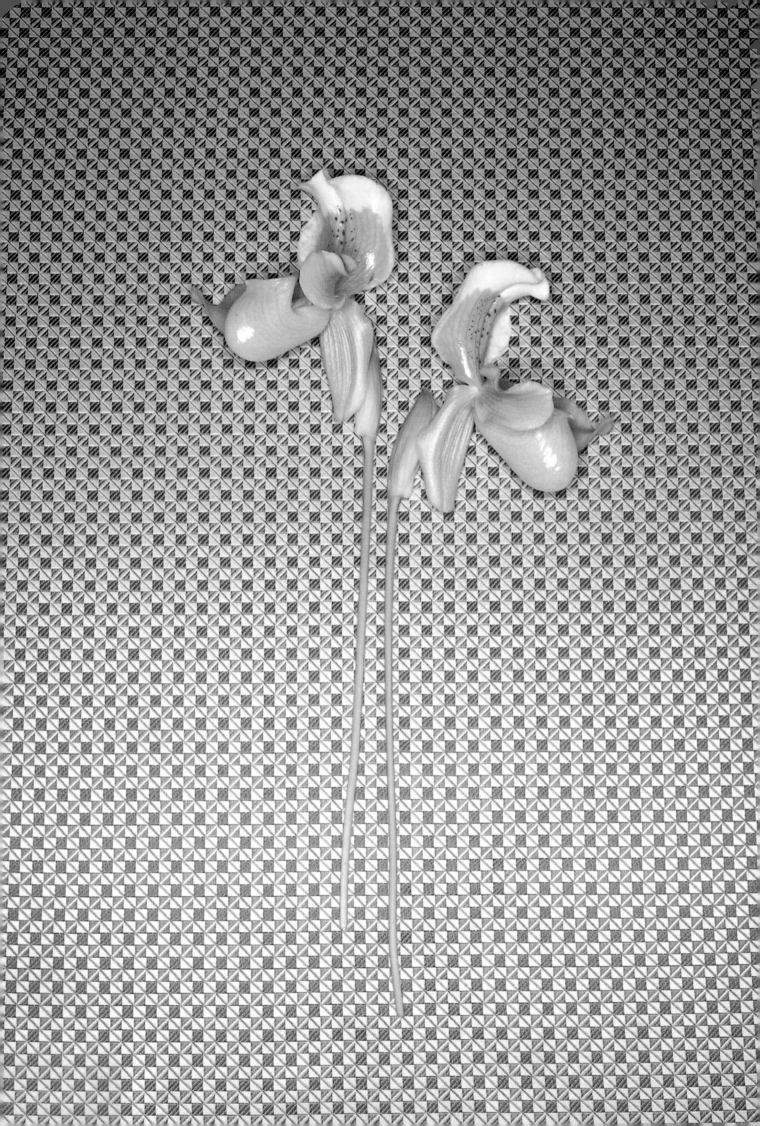

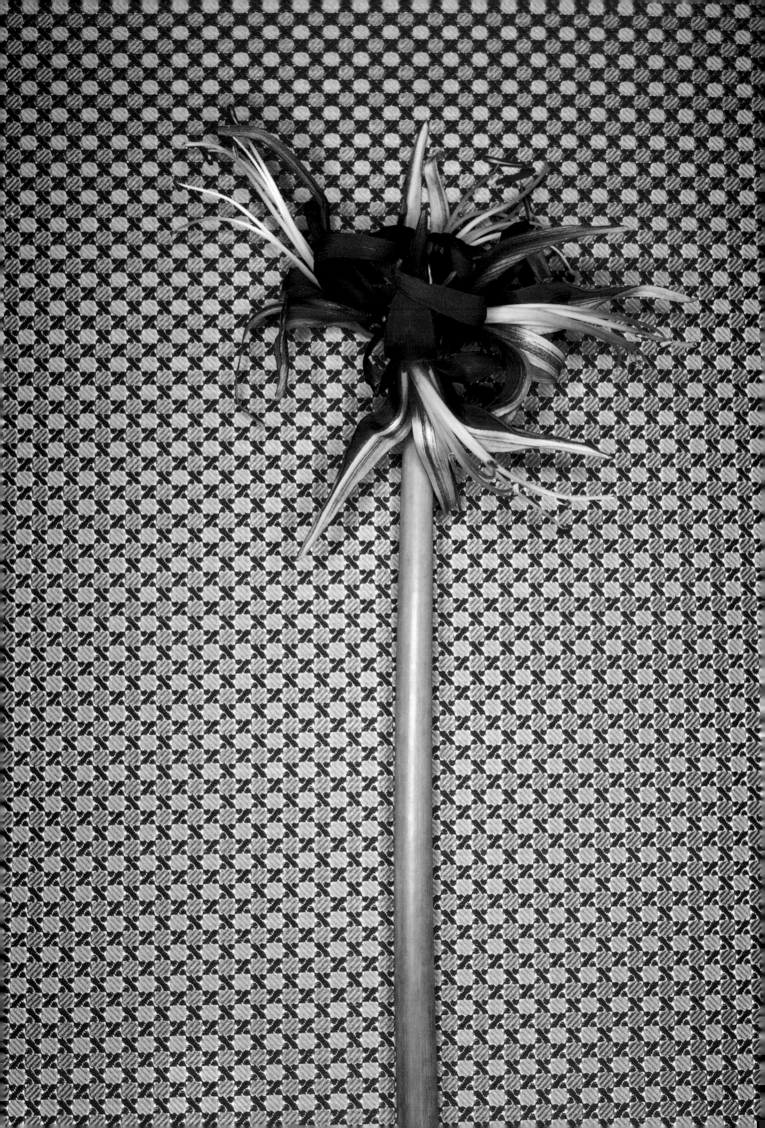

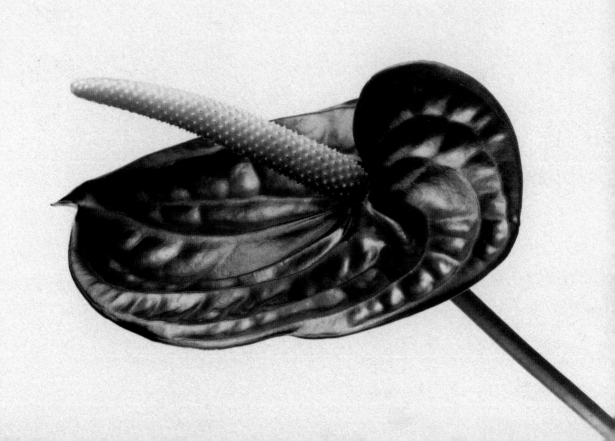

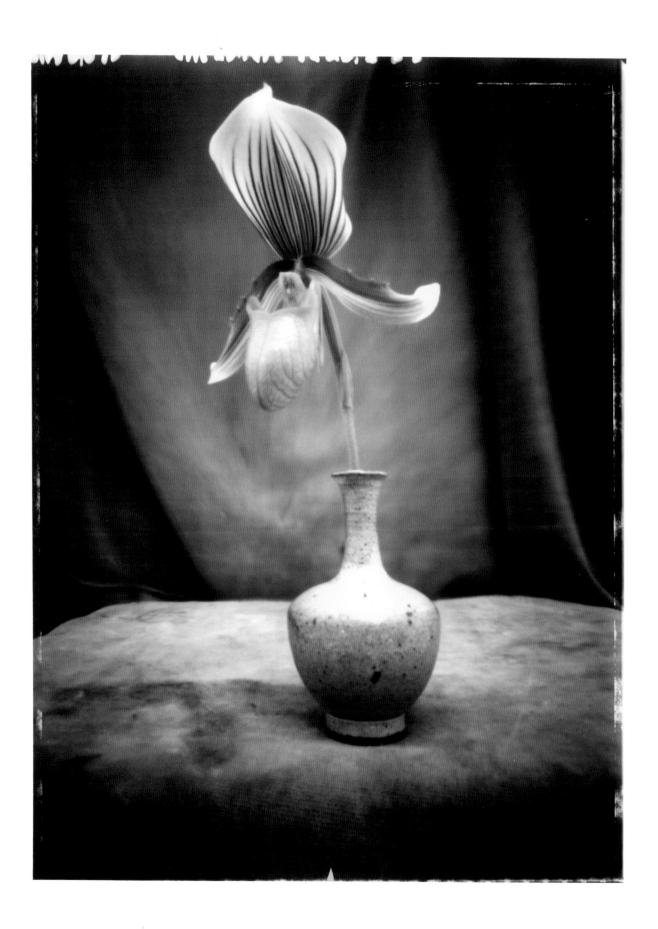

Dopy Doplon

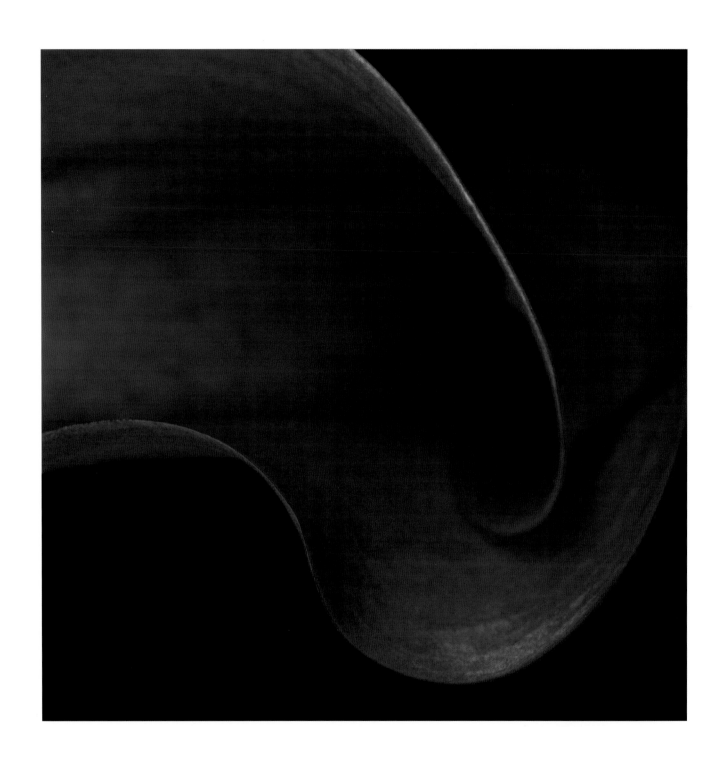

Doris Mitsch (this spread)

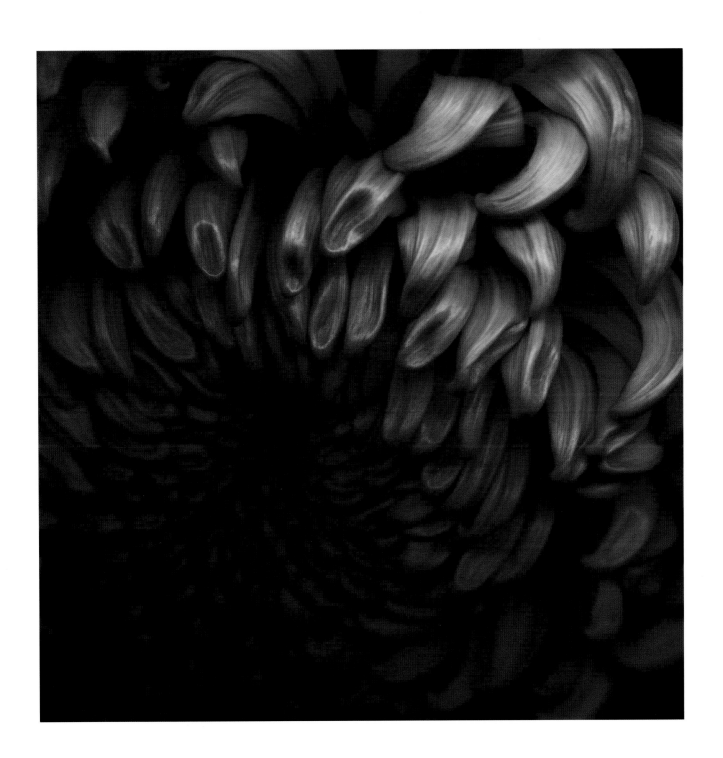

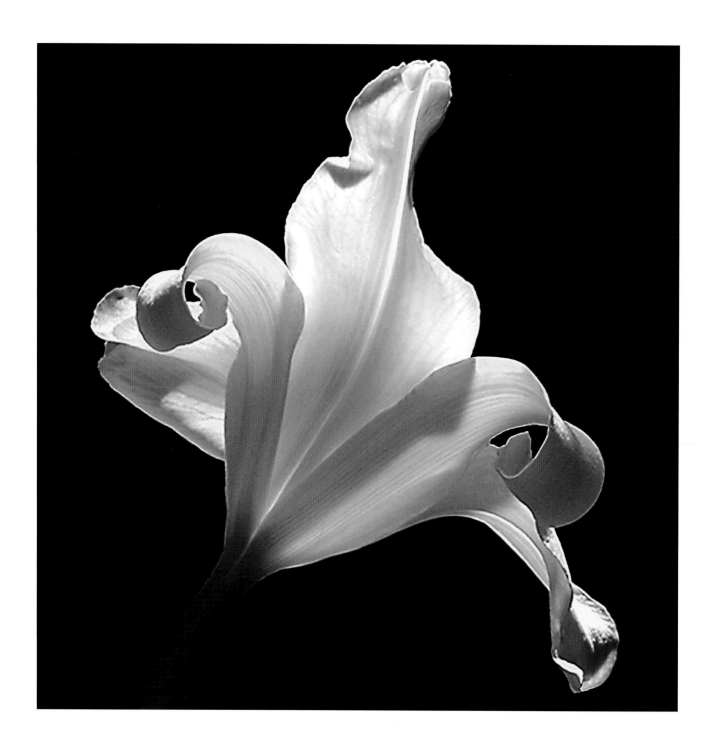

Harry Sargous

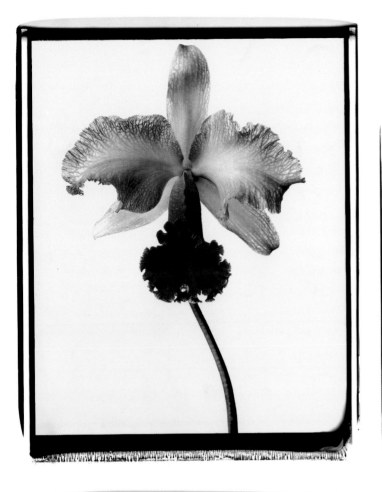

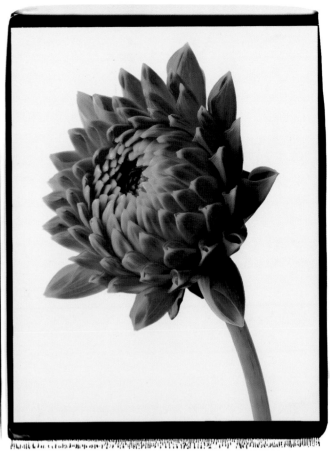

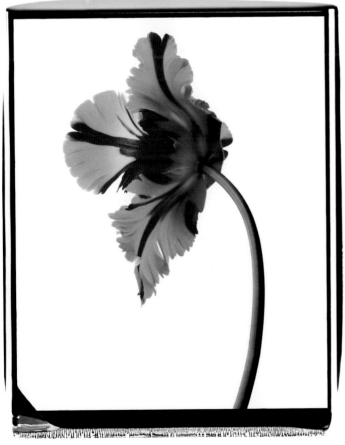

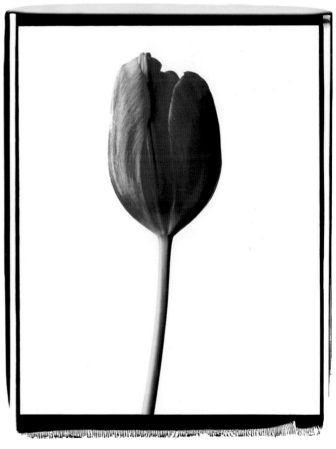

Mark Laita

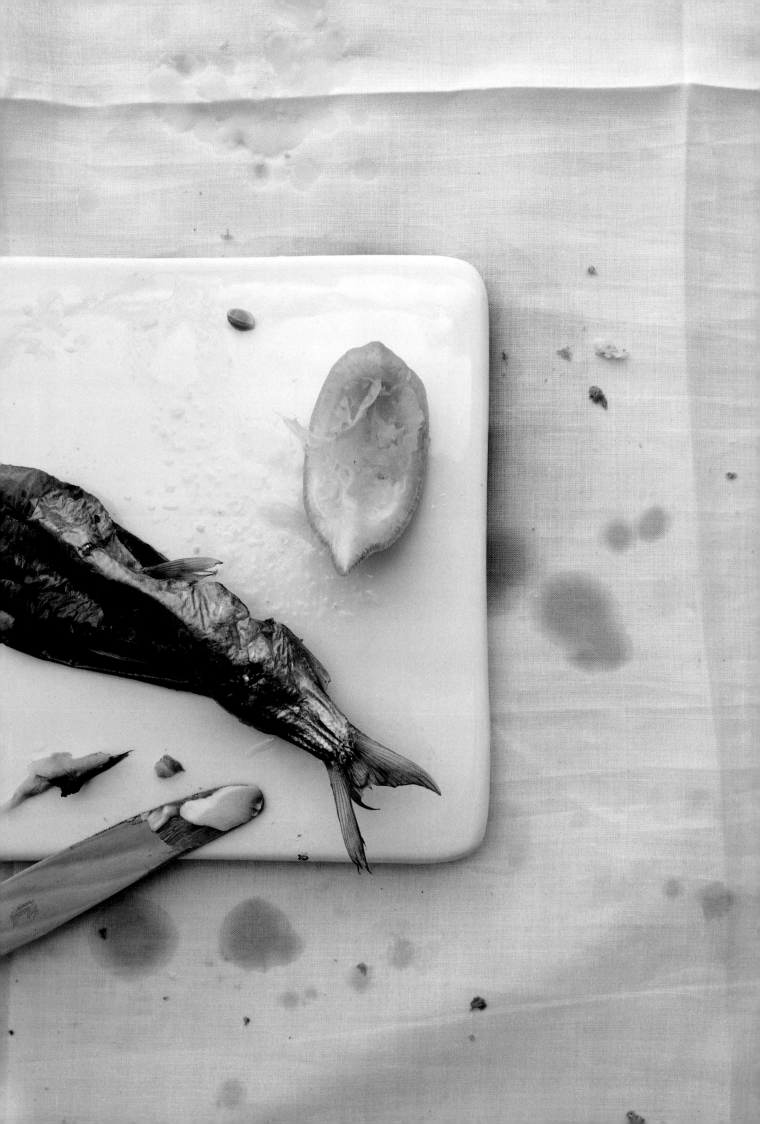

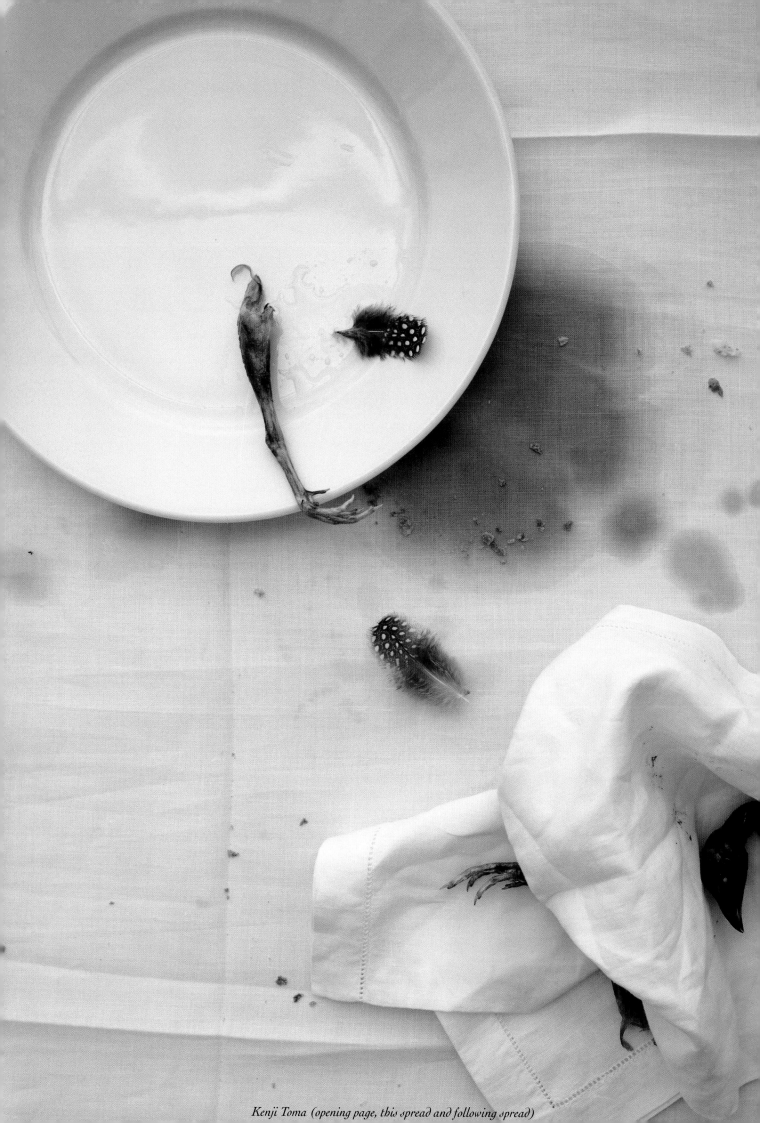

Kenji Toma (opening page, this spread and following spread)

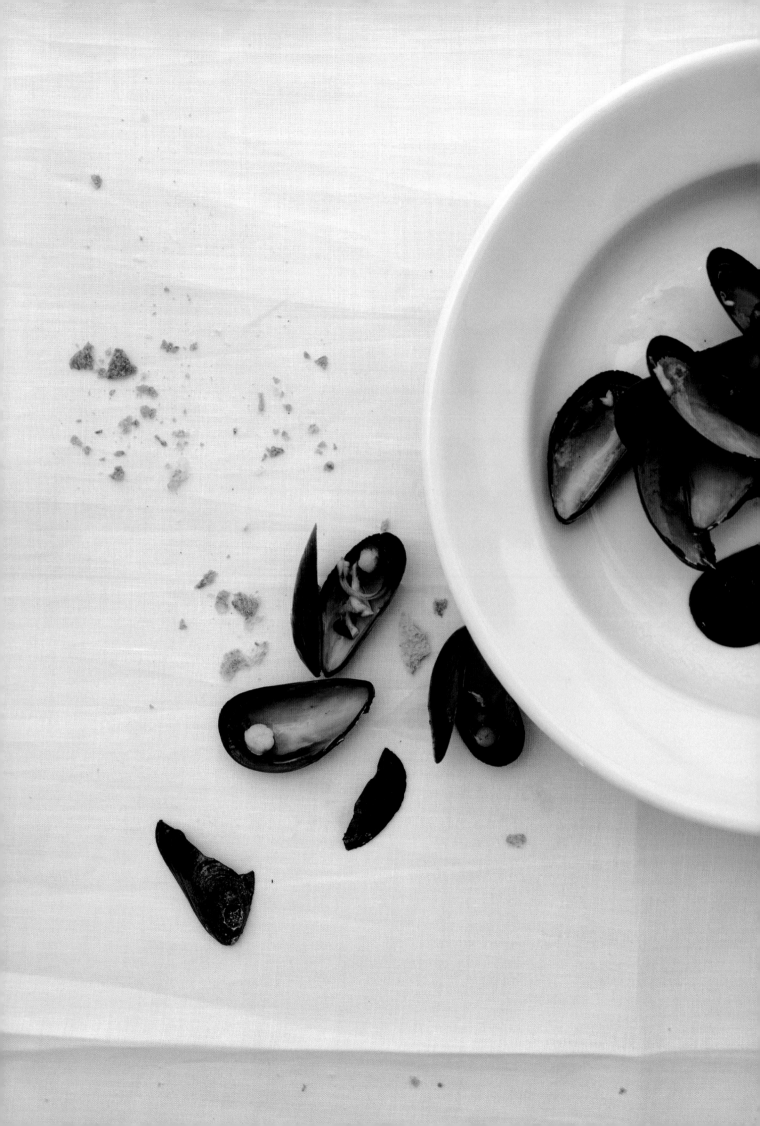

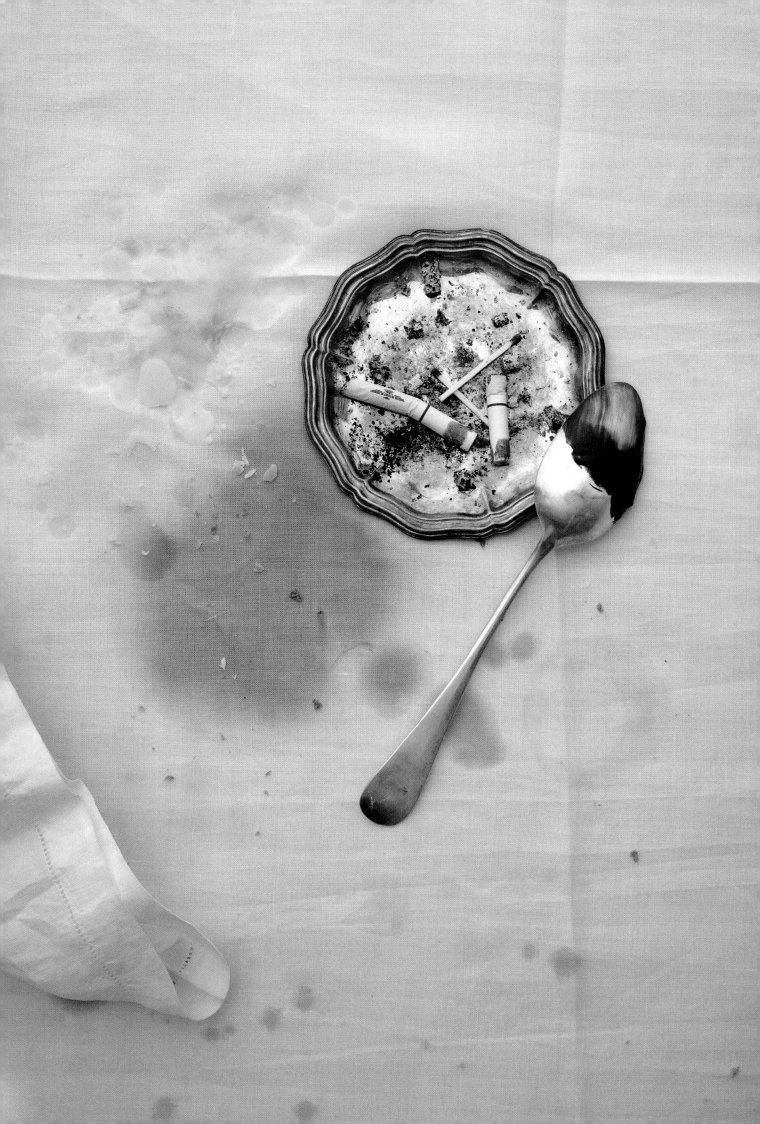

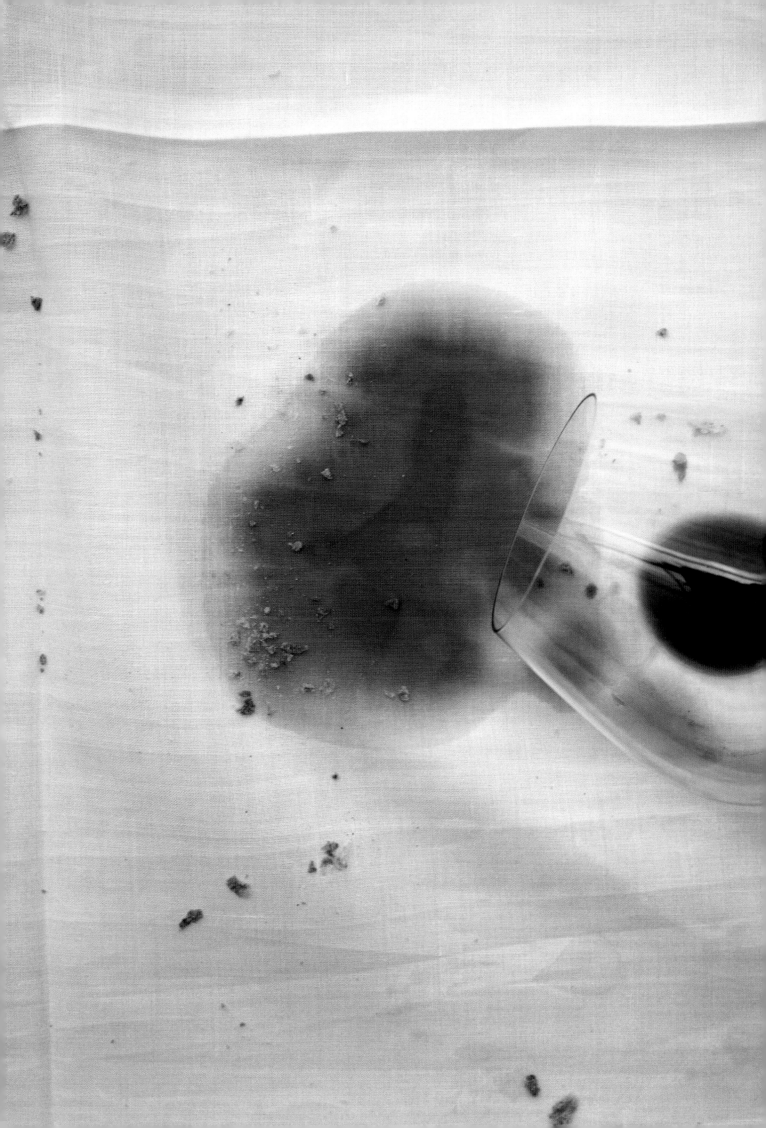

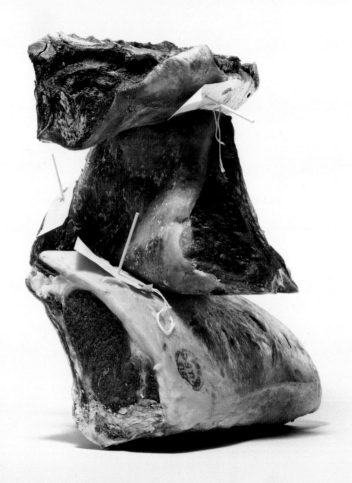

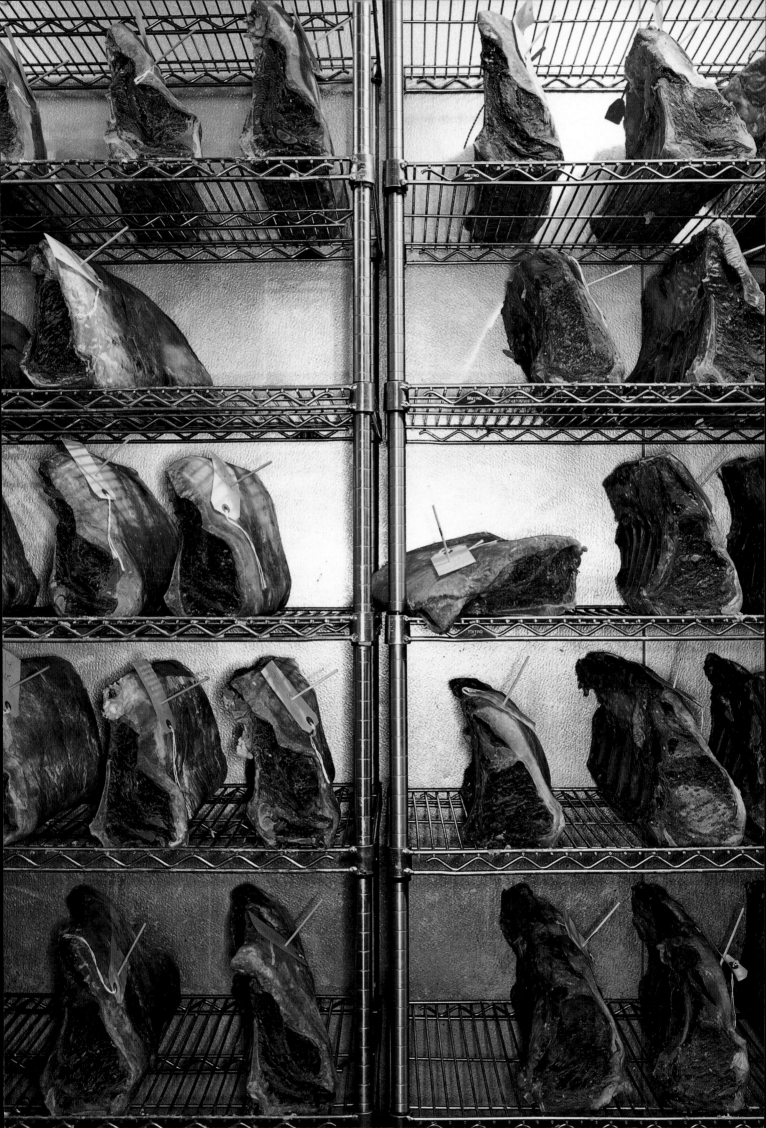

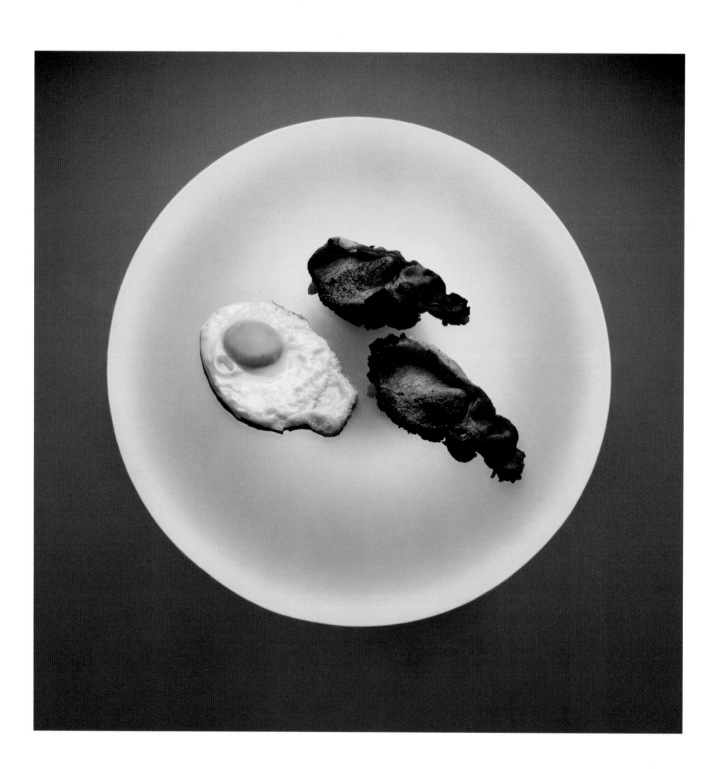

Jonathan Knowles (this spread)

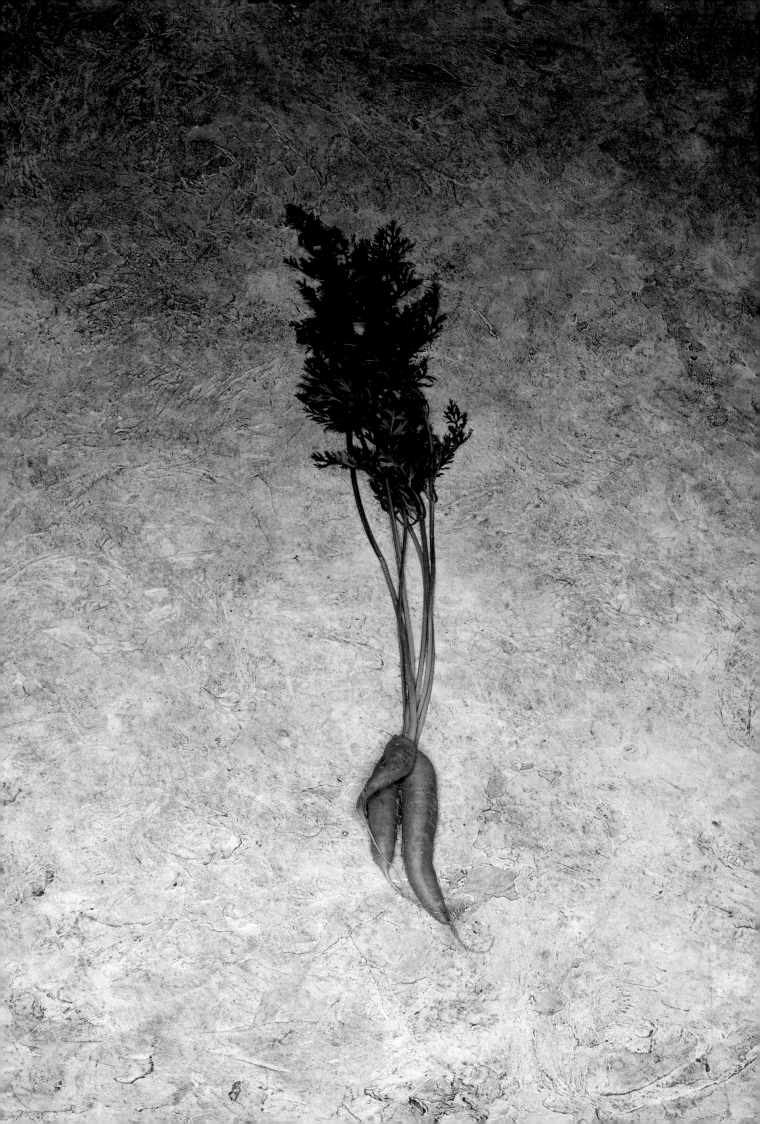

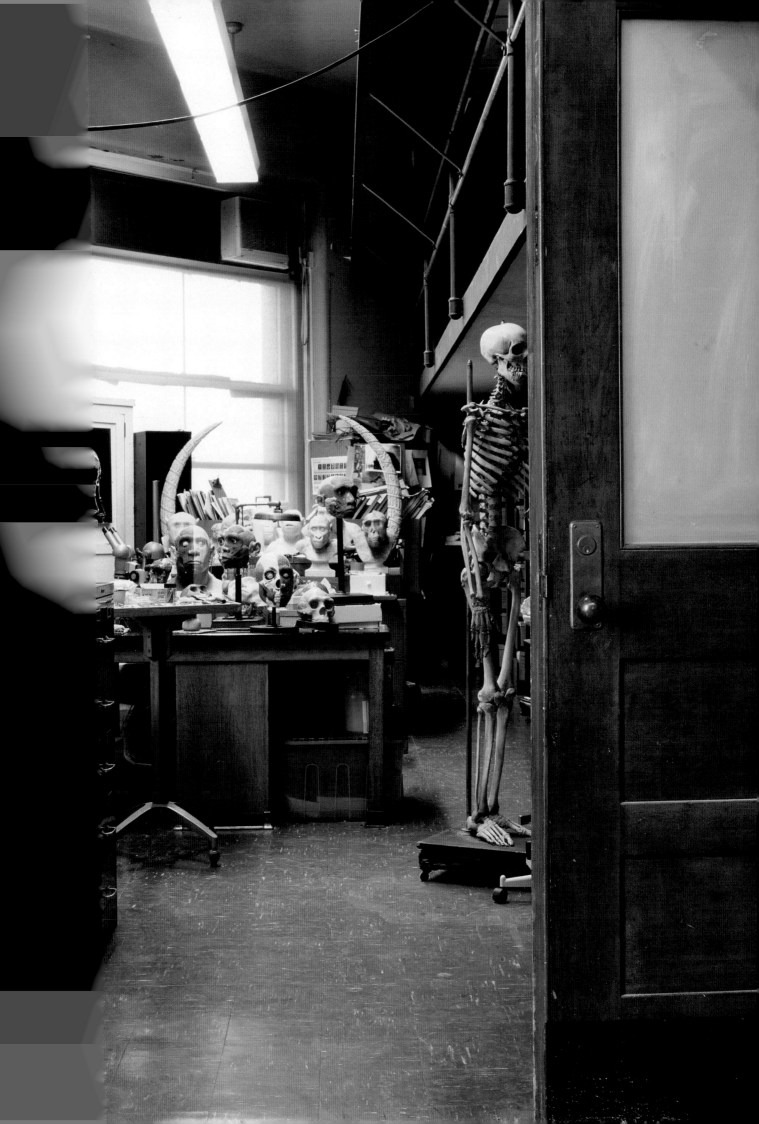

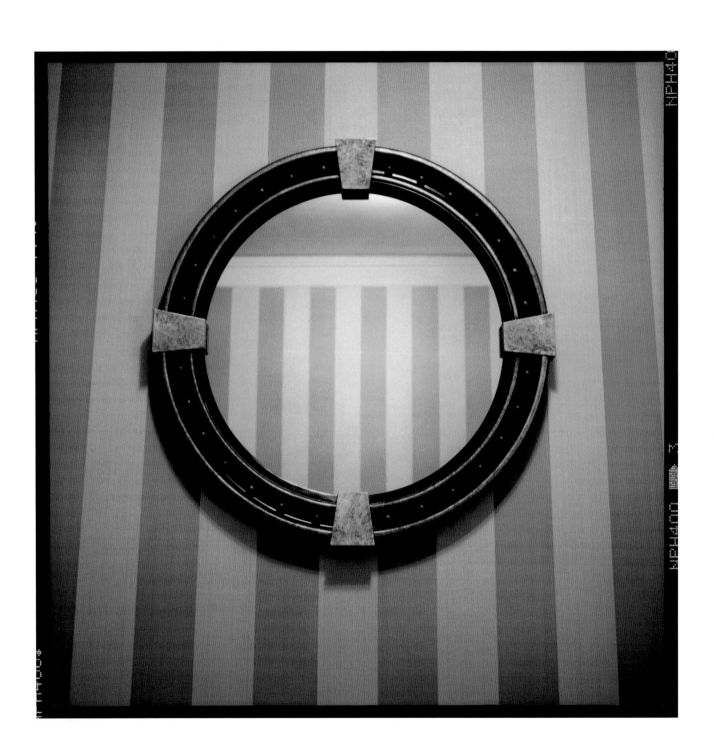

Craig Cutler (opening page), James Salzano (this page)

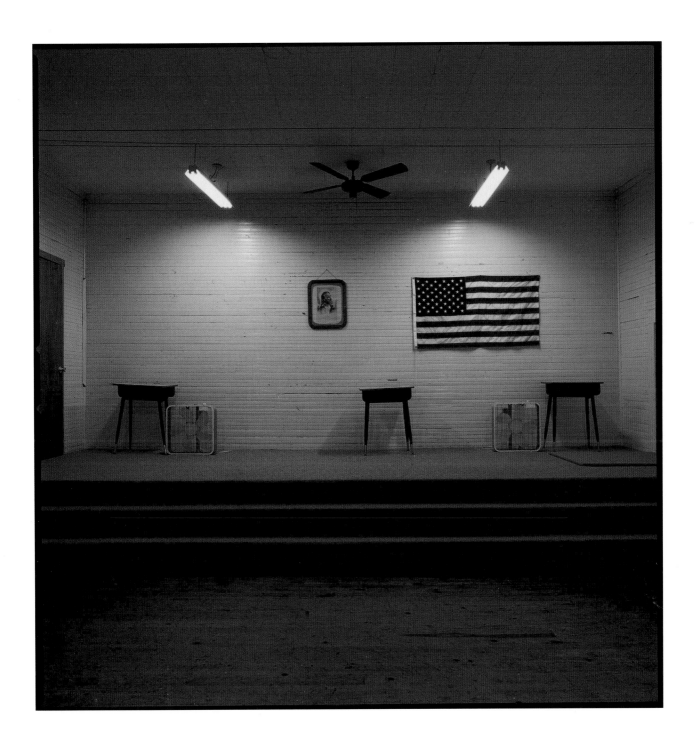

Michael O'Brien

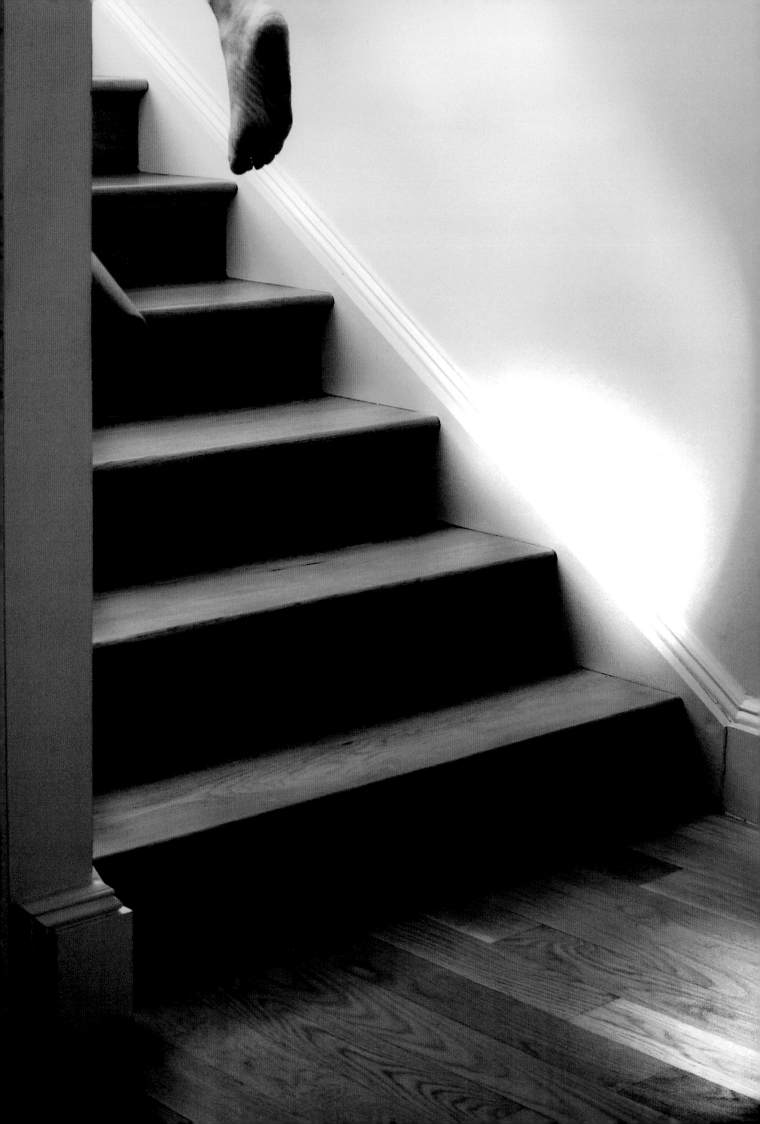

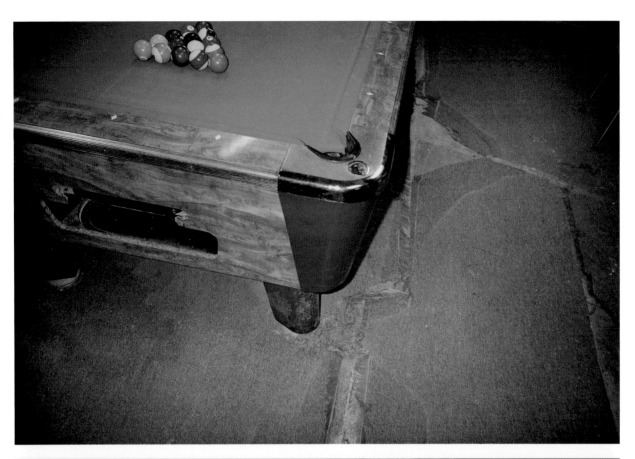

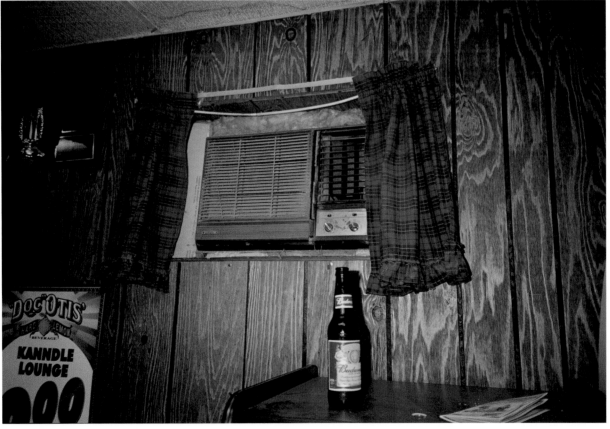

Phil Marco (left page), Lars Topelman (this page)

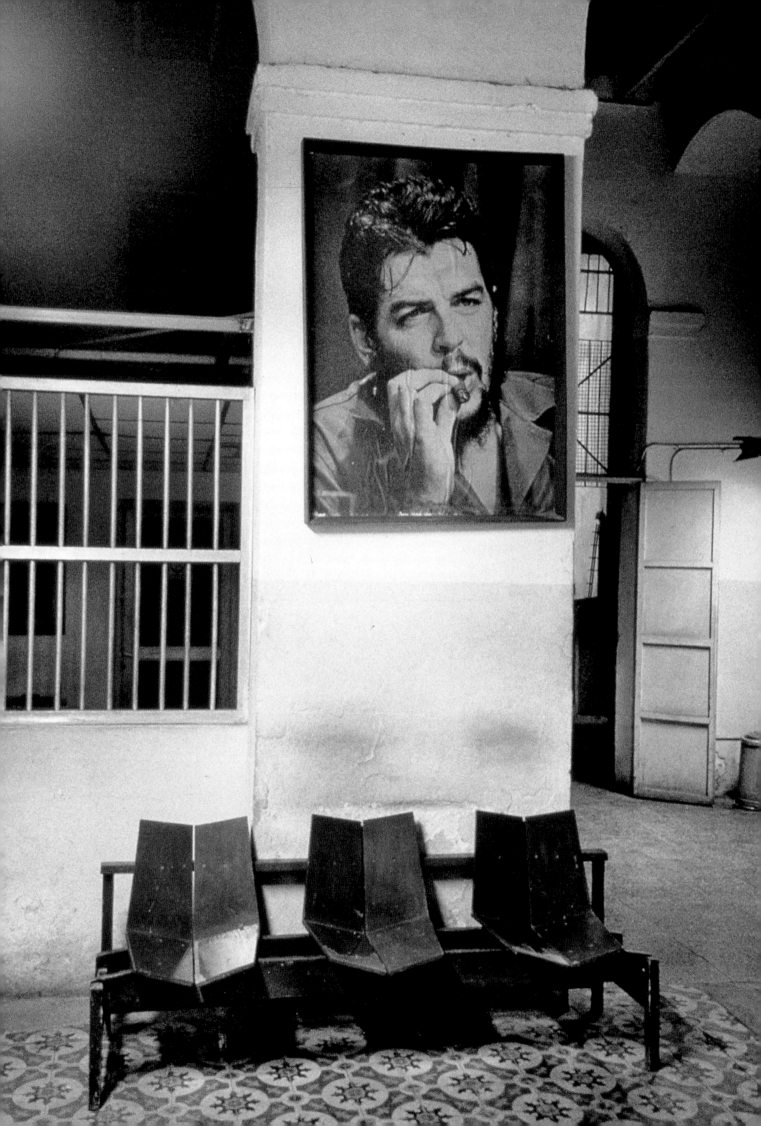

Journalism

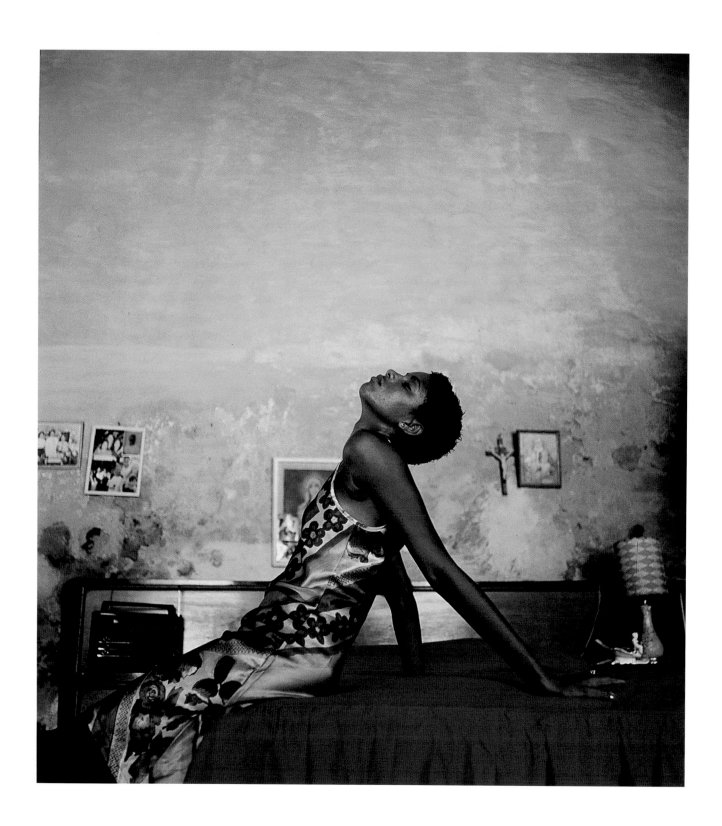

George Simhoni (opening page), David Allan Brandt (this spread)

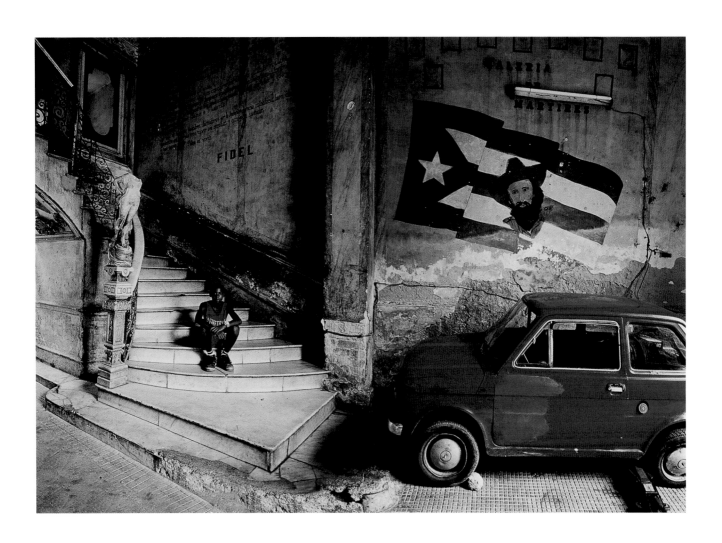

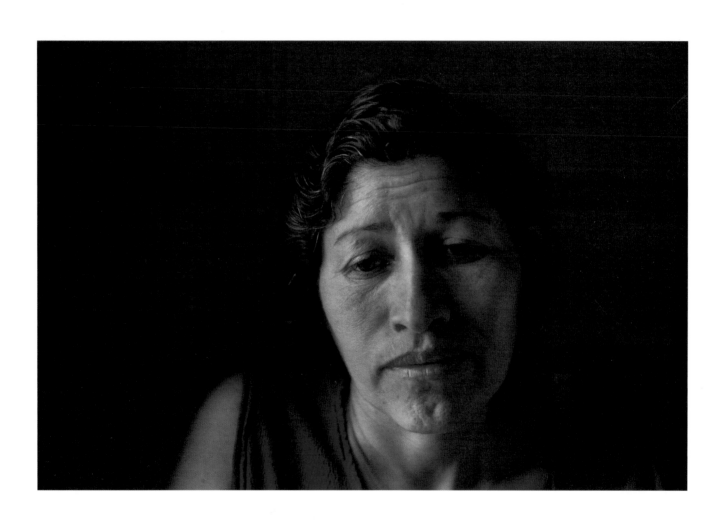

Jamey Stillings (this spread)

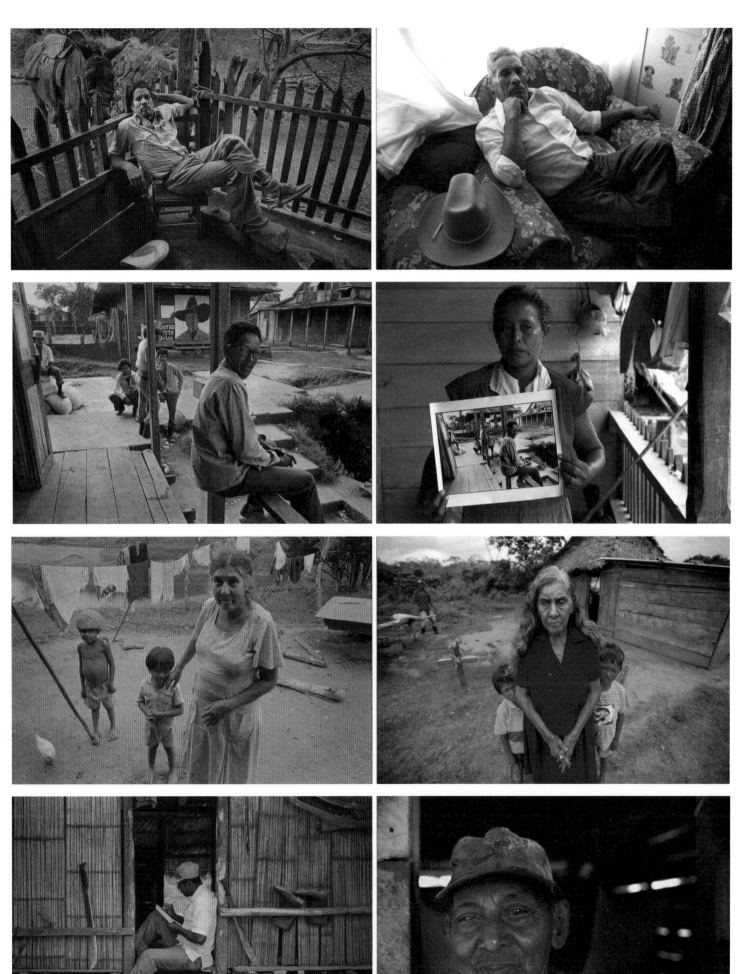

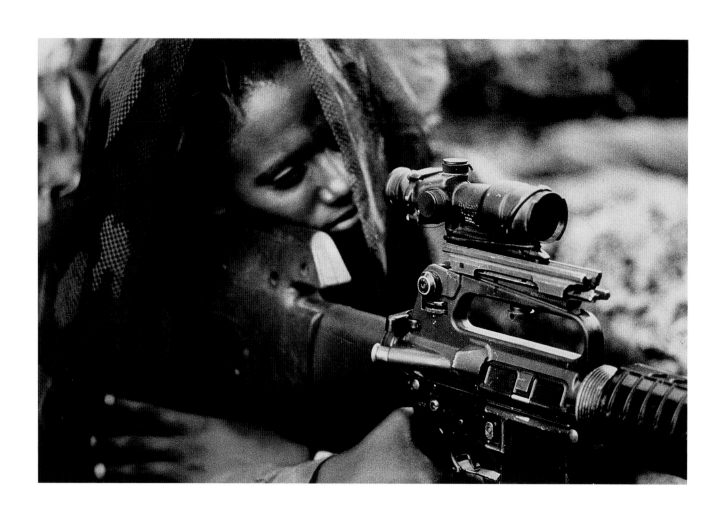

Beverly Abramson

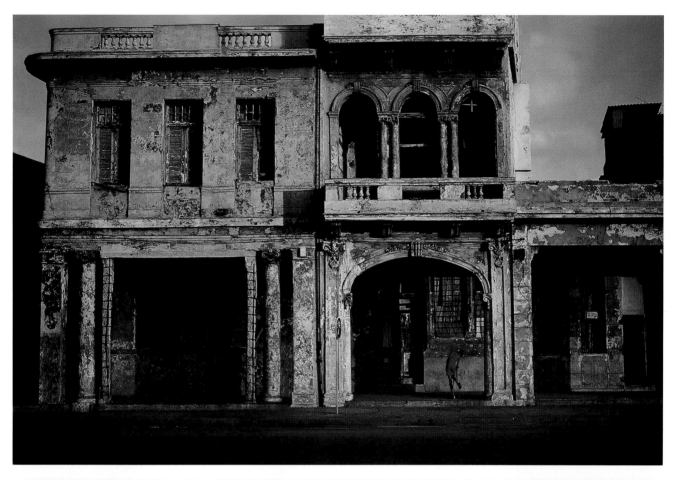

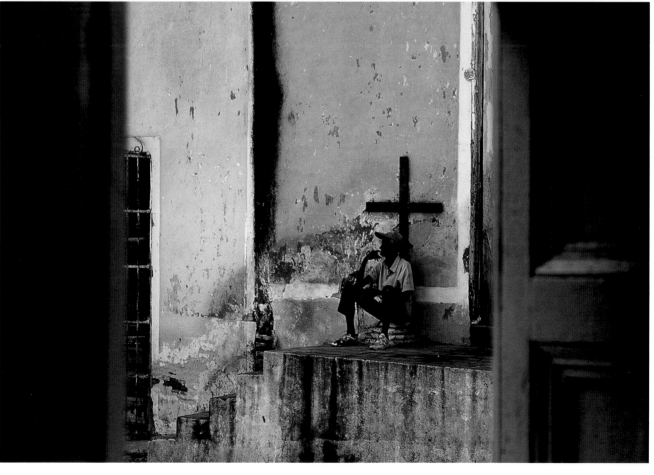

David Allan Brandt

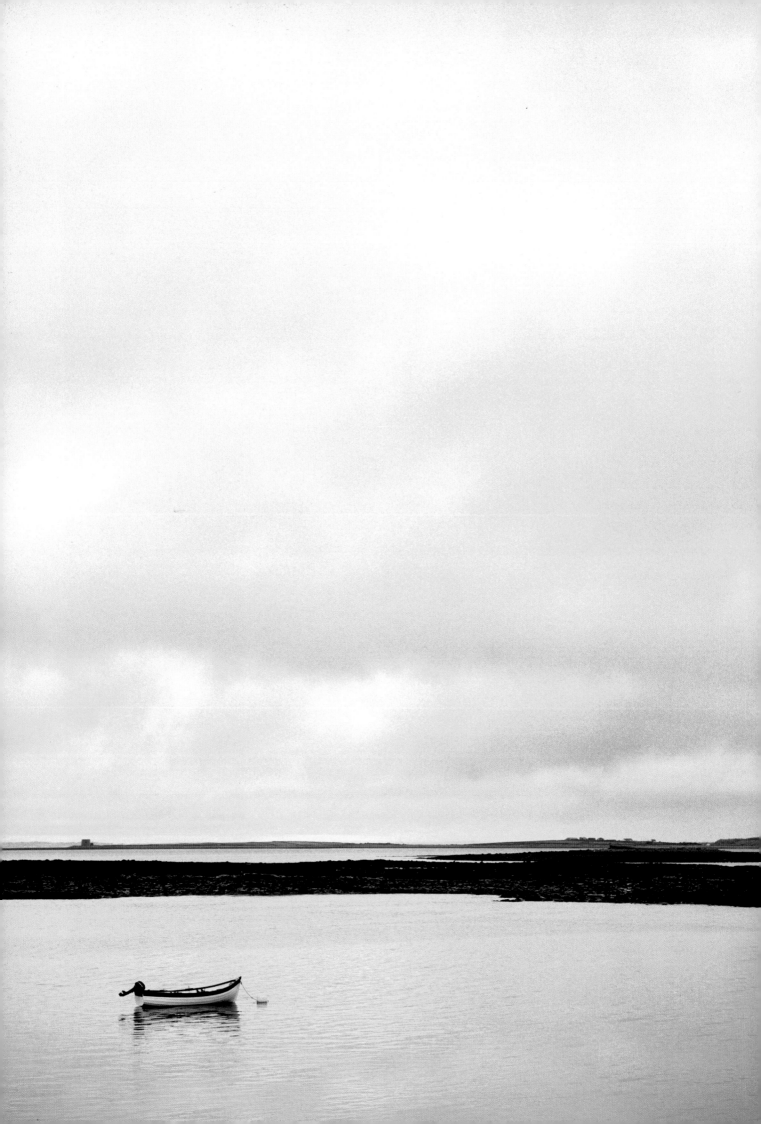

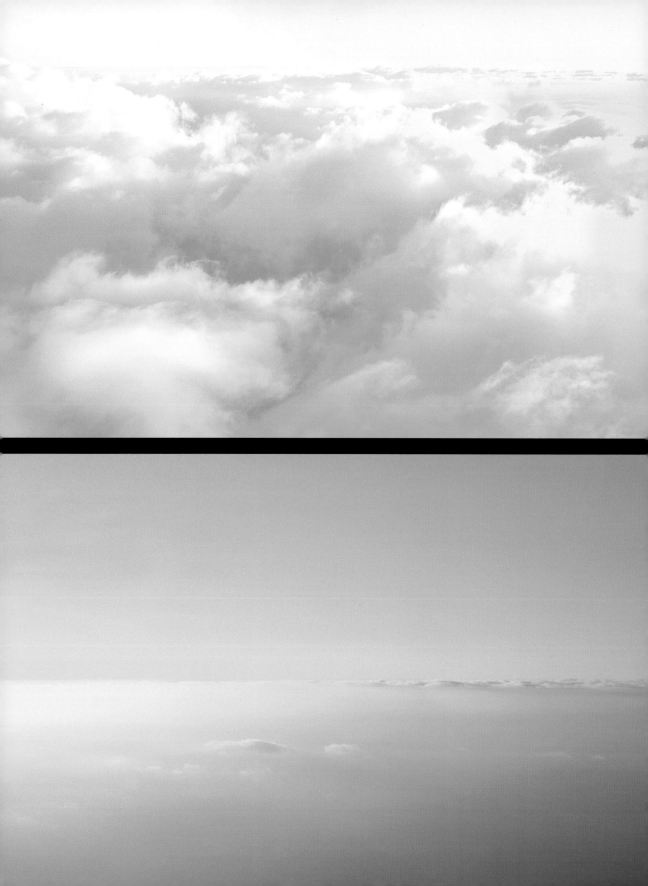

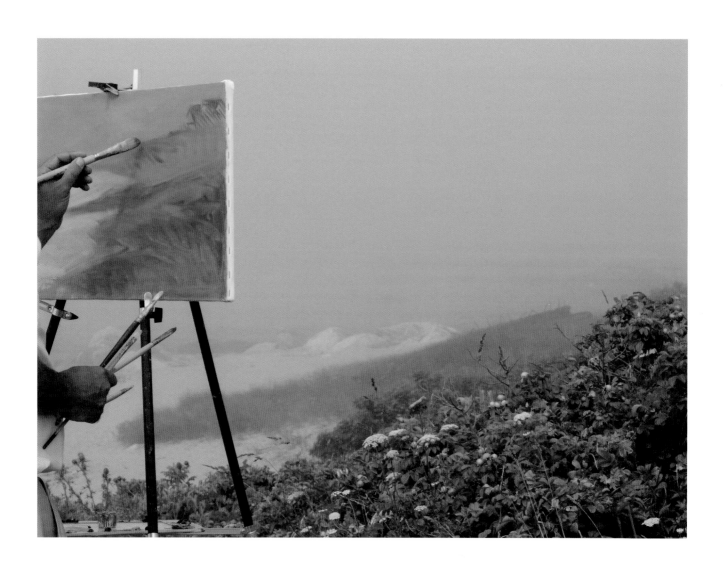

Avrohm Melnik

Art Brewer

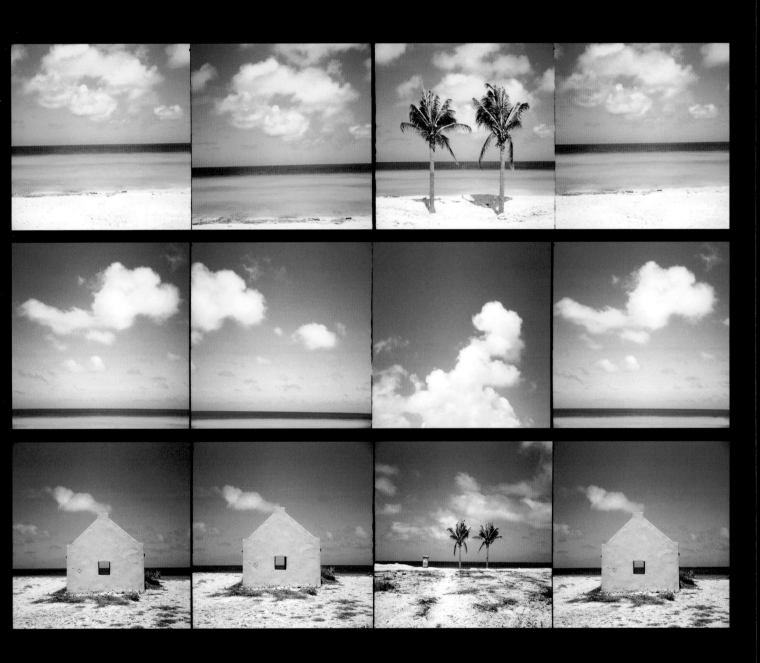

Claudia Goetzelmann

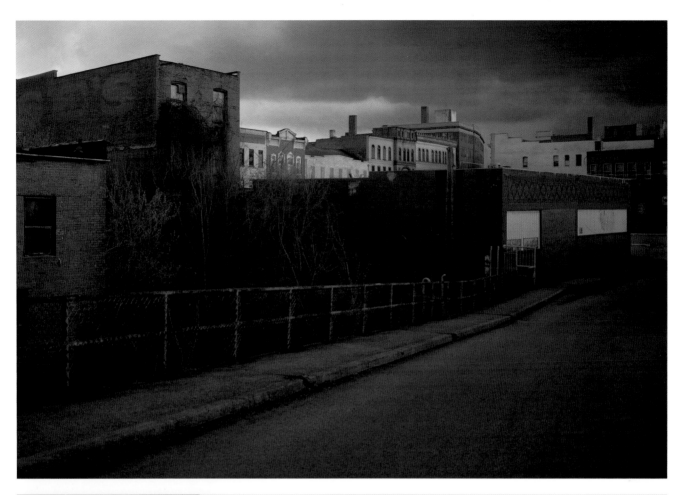

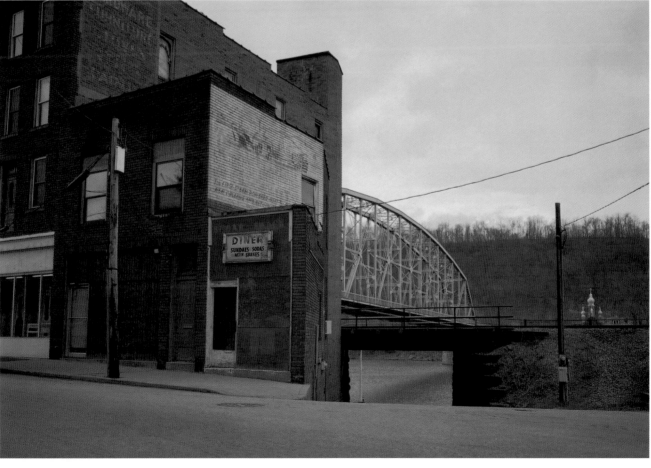

Scott Montgomery

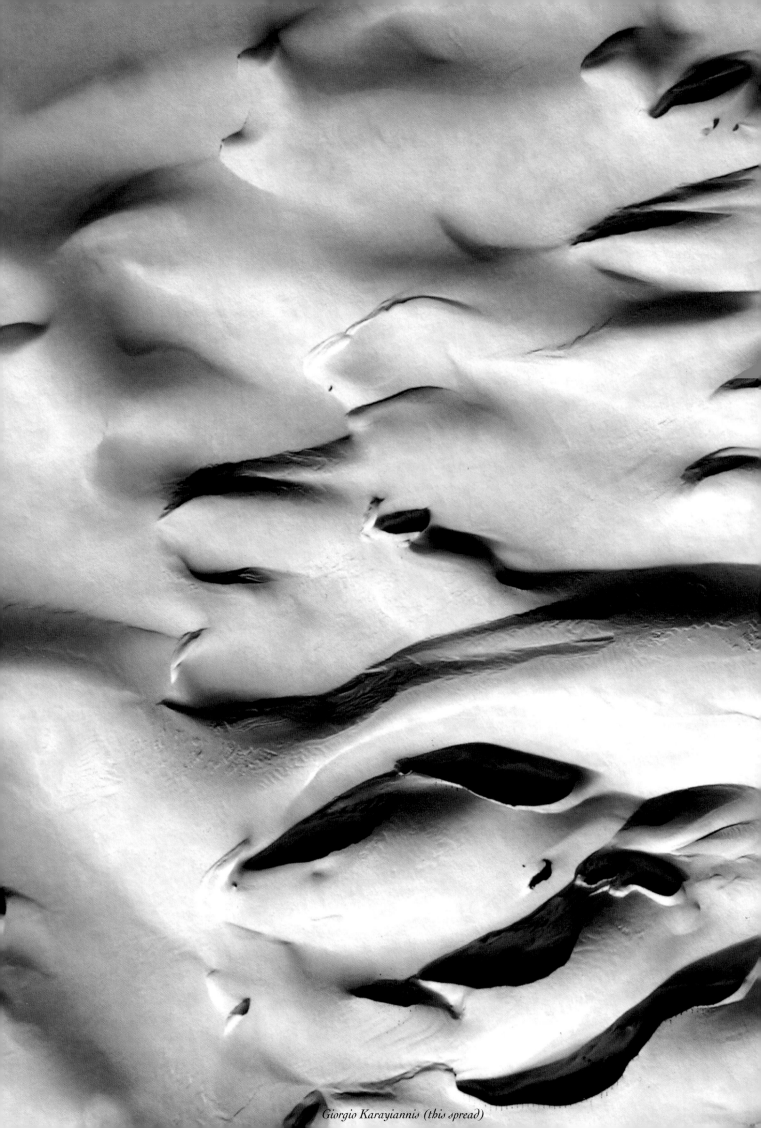

Giorgio Karayiannis (this spread)

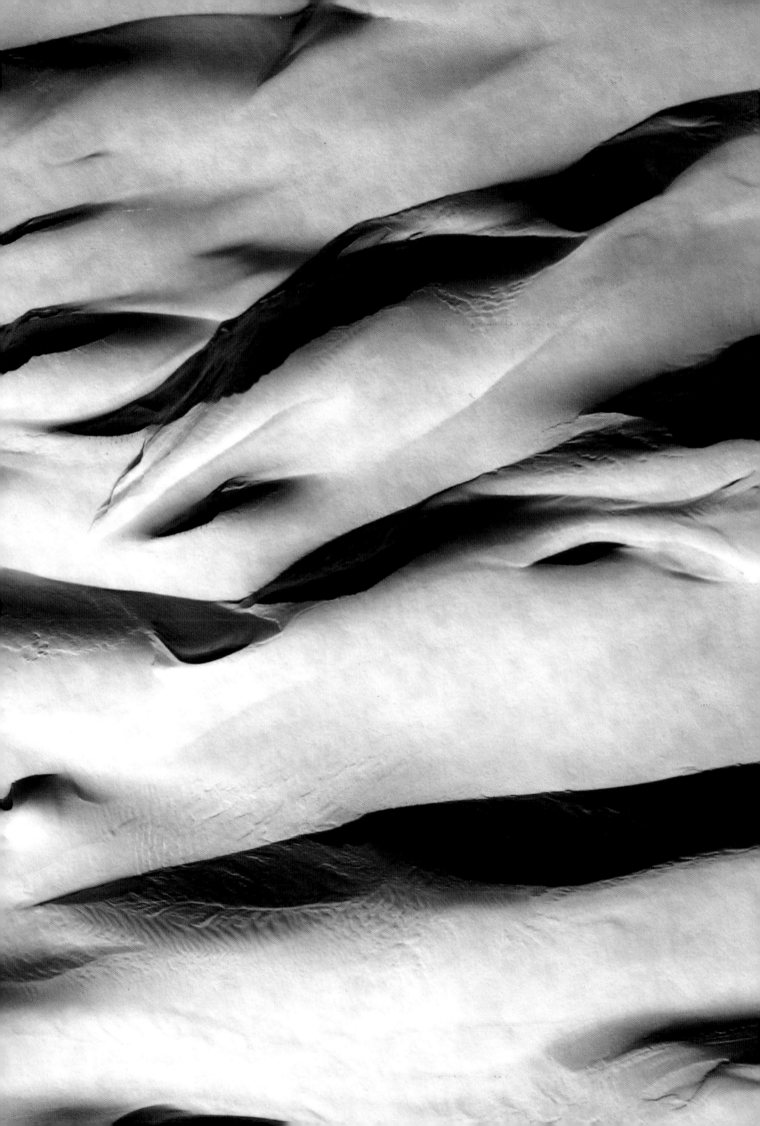

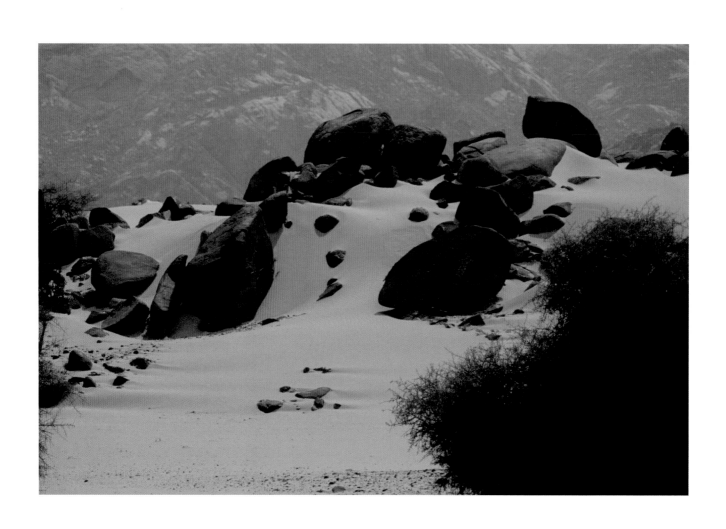

Charter Weeks (this spread)

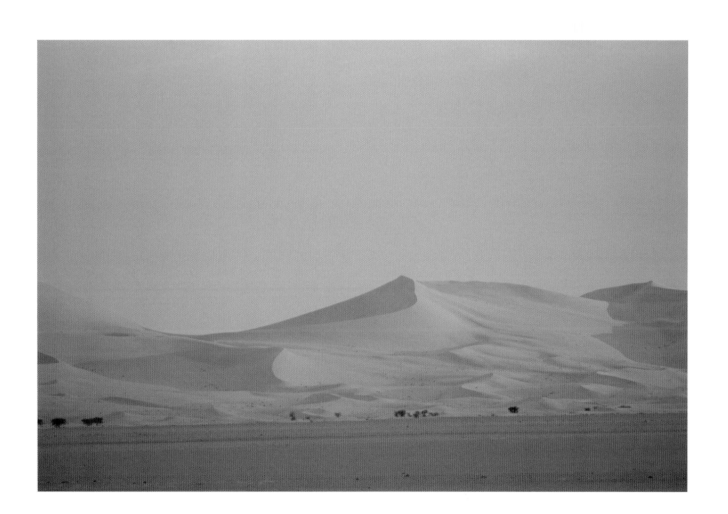

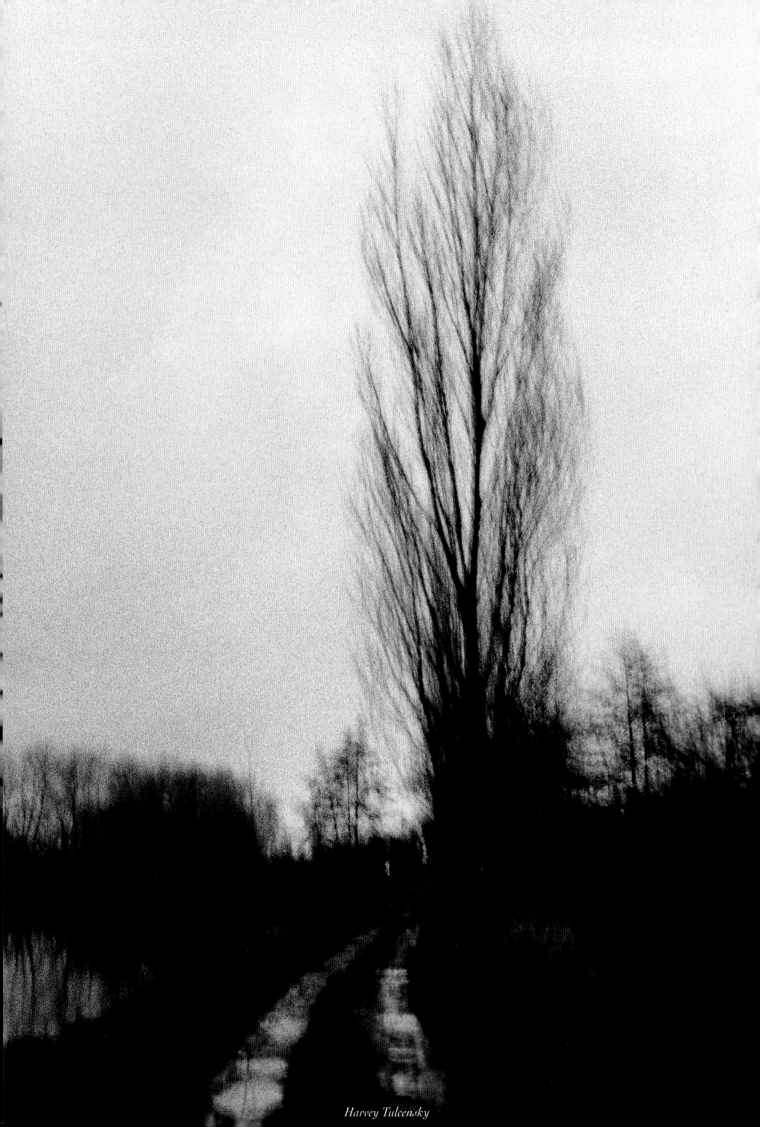

Harvey Tulcensky

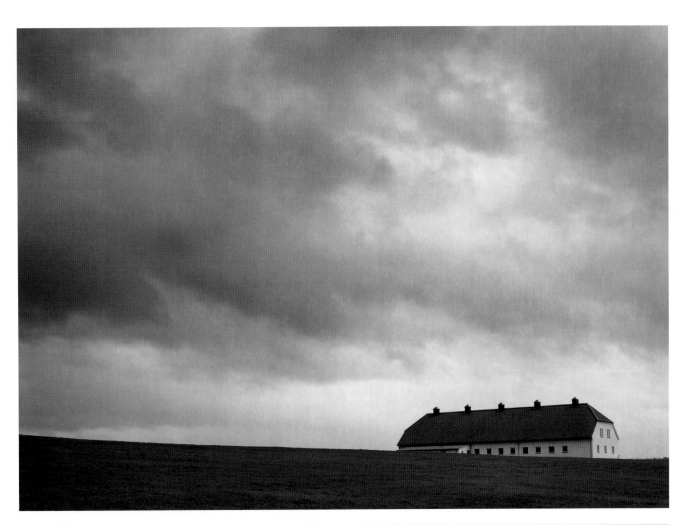

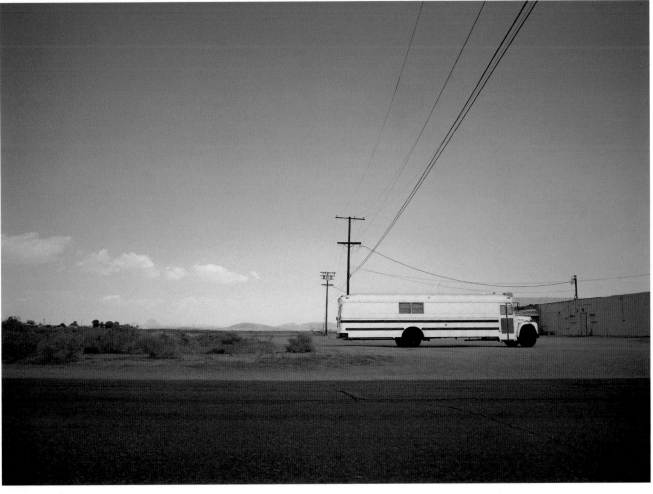

Scott Montgomery

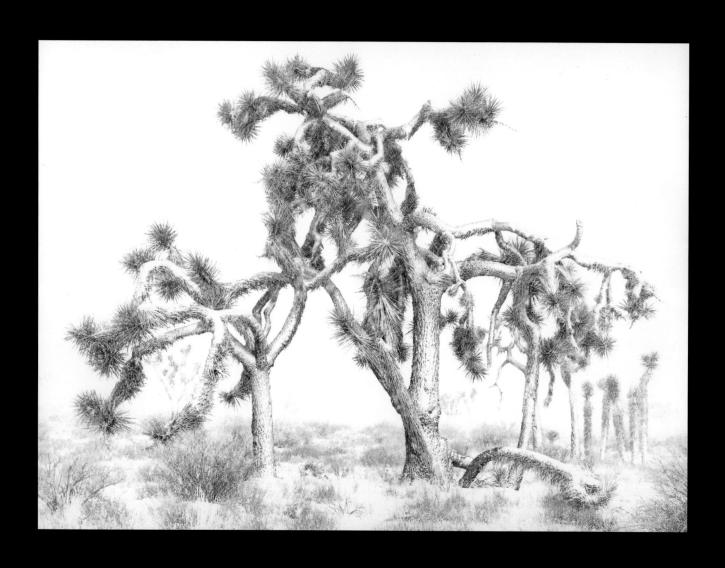

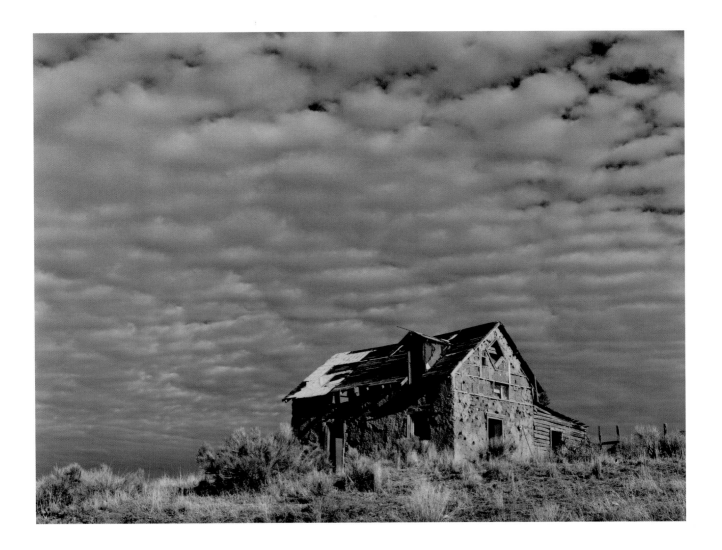

Kent Barker

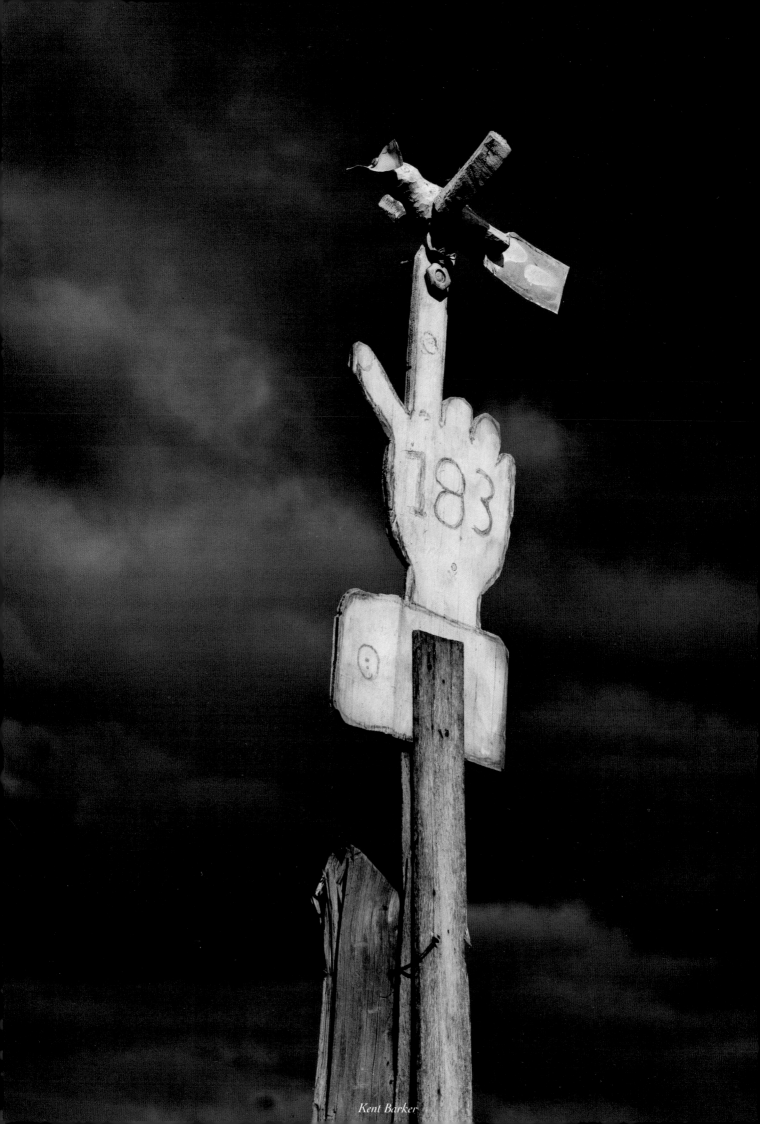

Kent Barker

Jody Dole

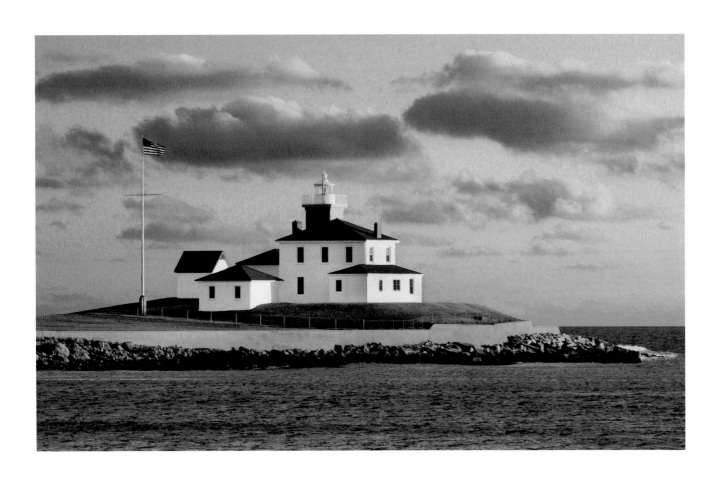

Jody Dole

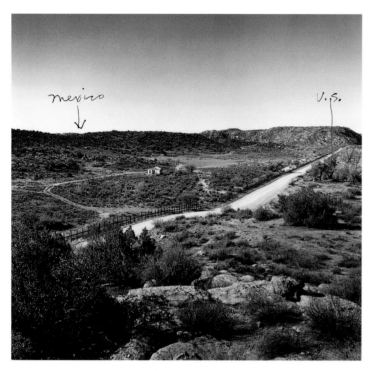

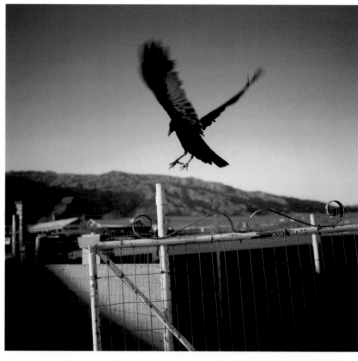

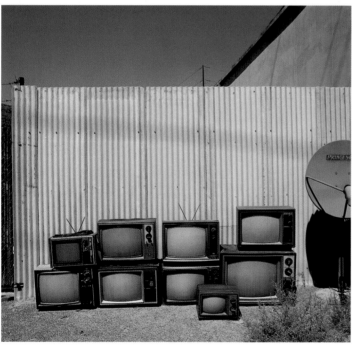

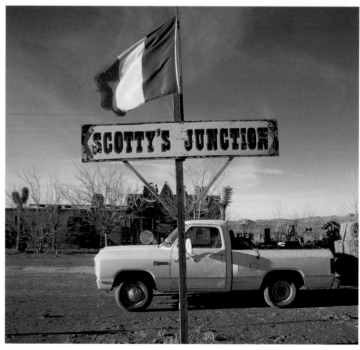

(this spread) Richard Schultz

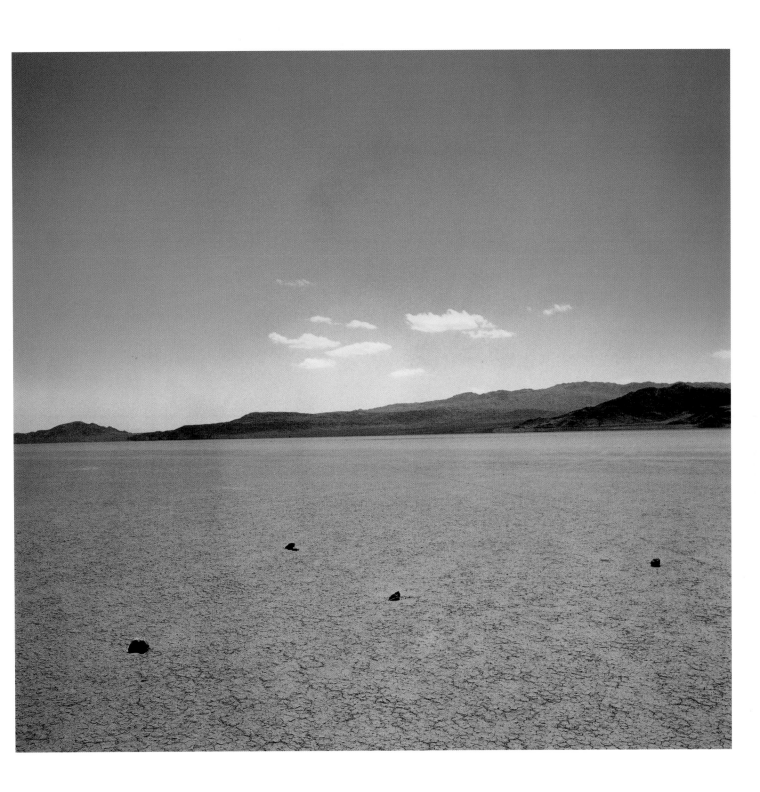

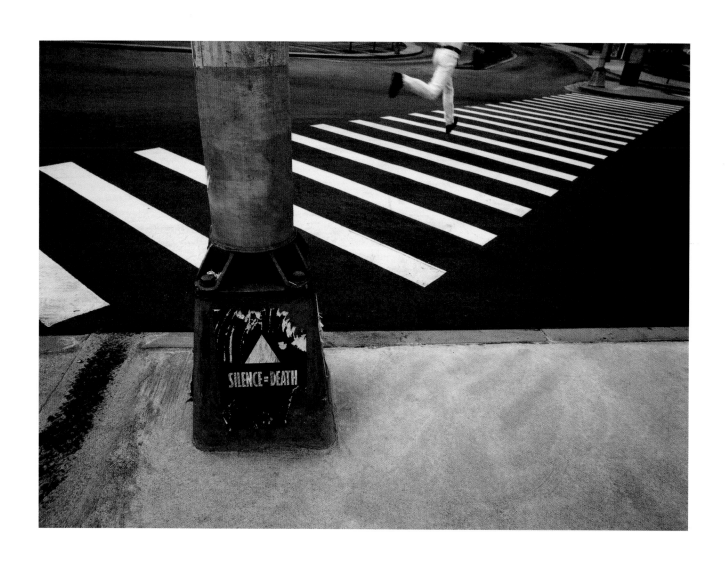

Phil Bekker (this spread)

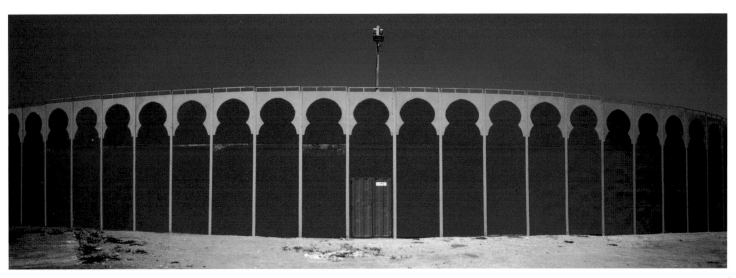

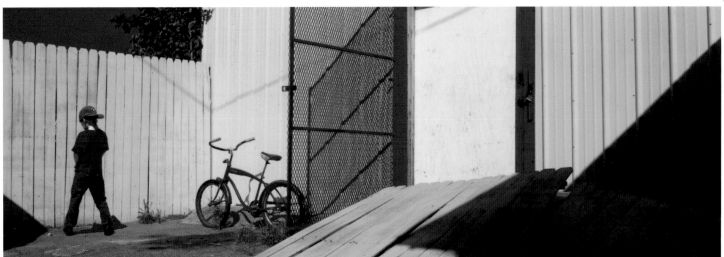

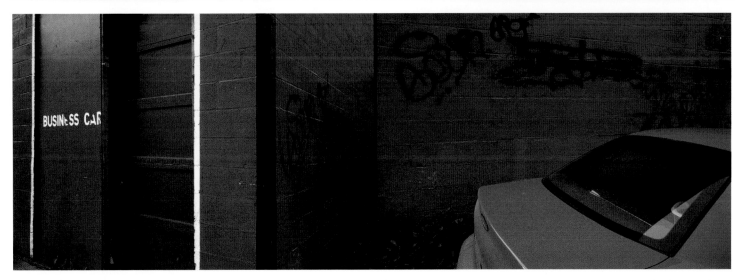

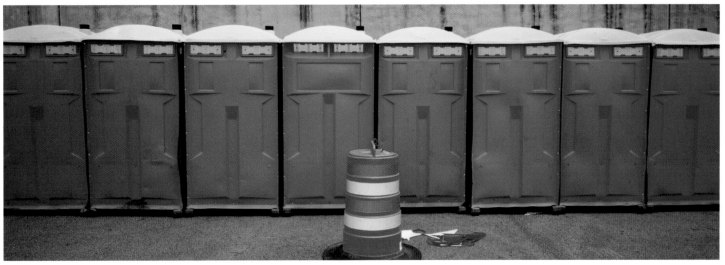

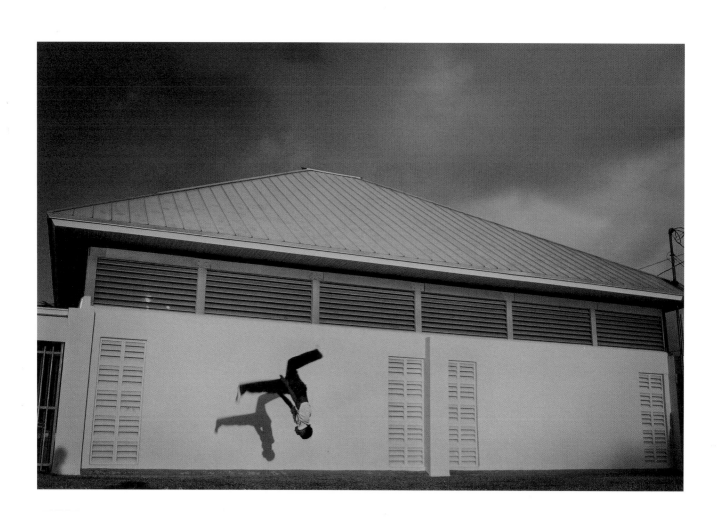

Michael Grecco (this spread)

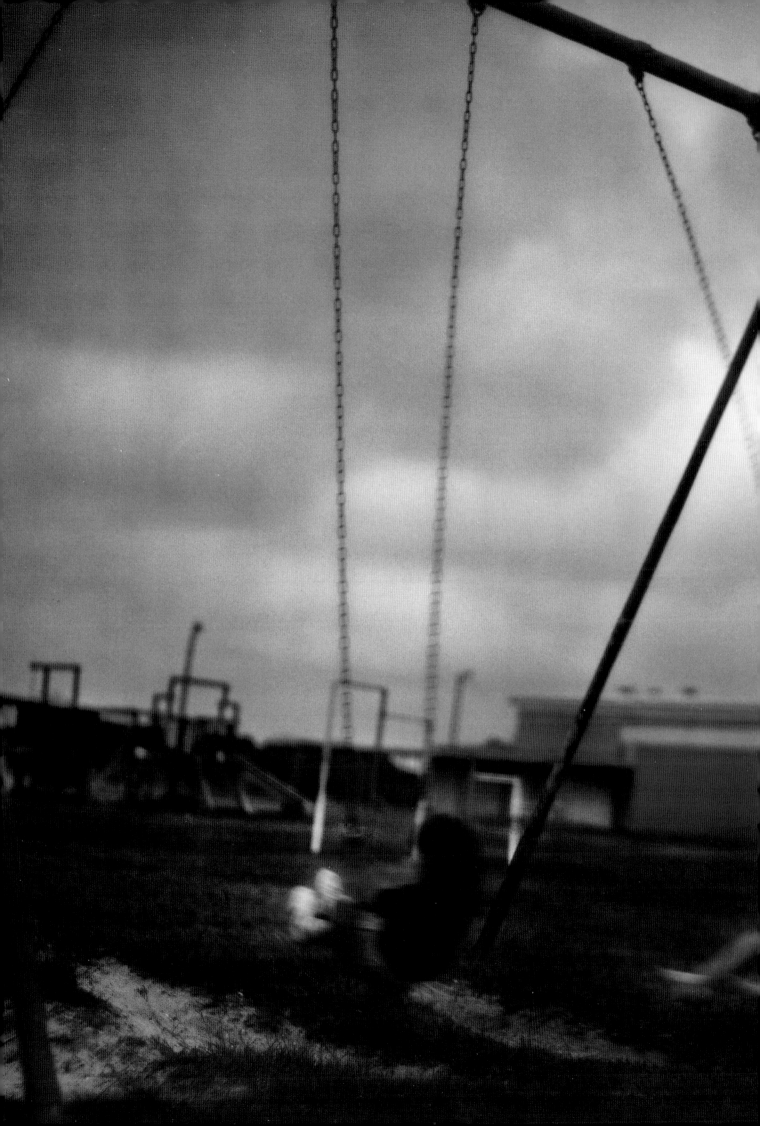

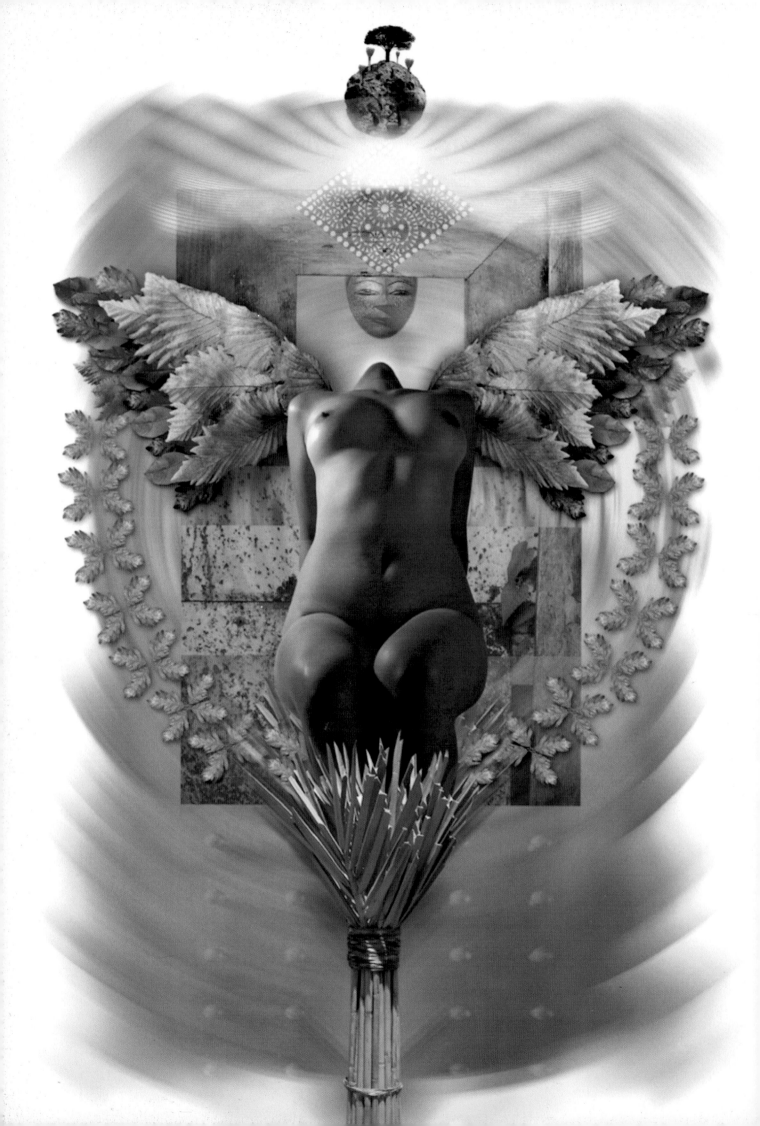

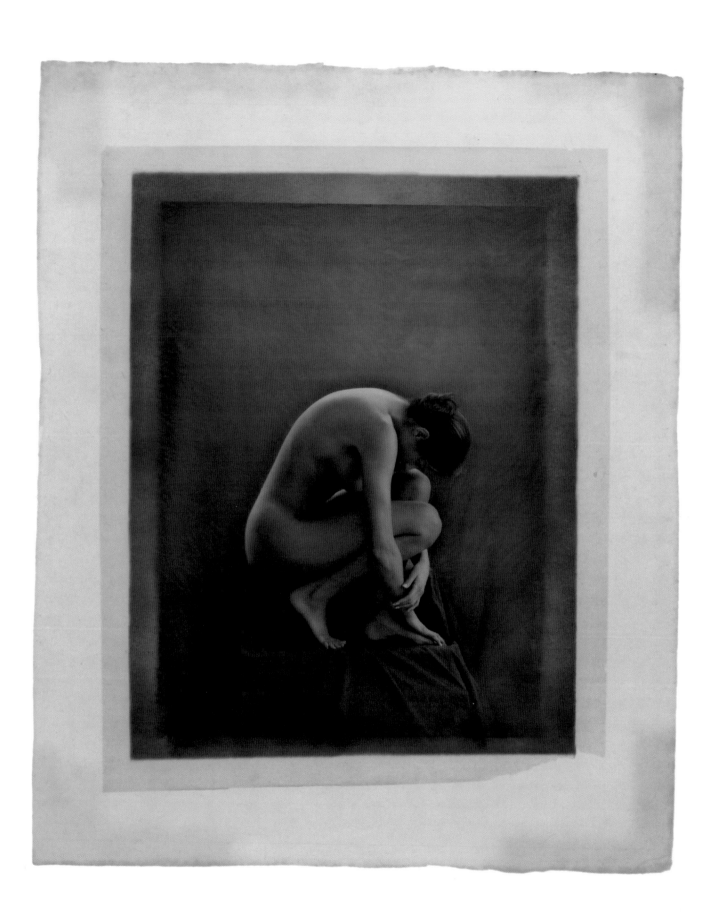

Dopy Doplon (opening page), Parish Kohanim (this spread)

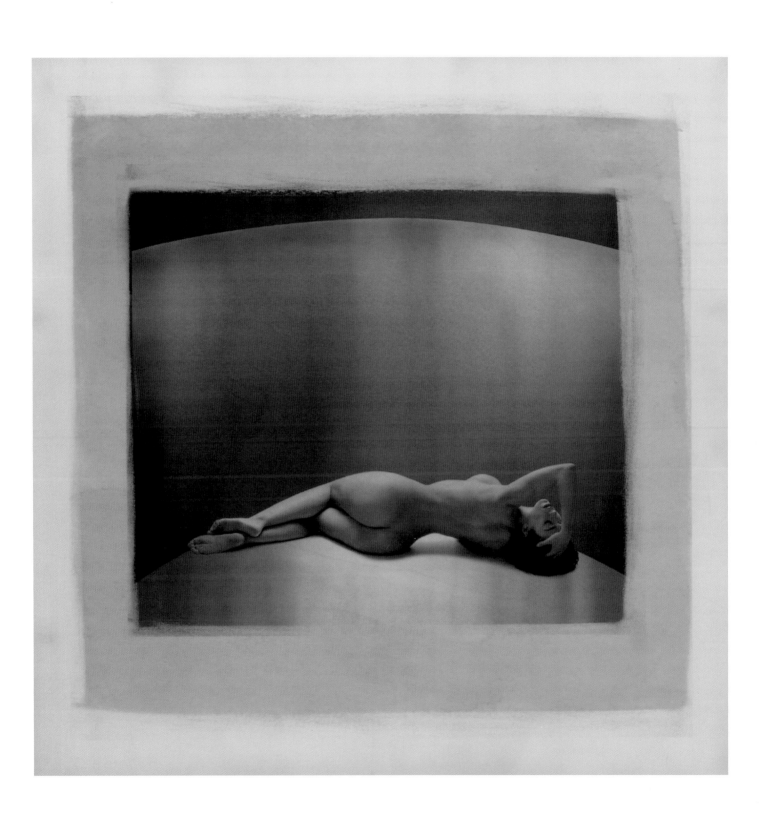

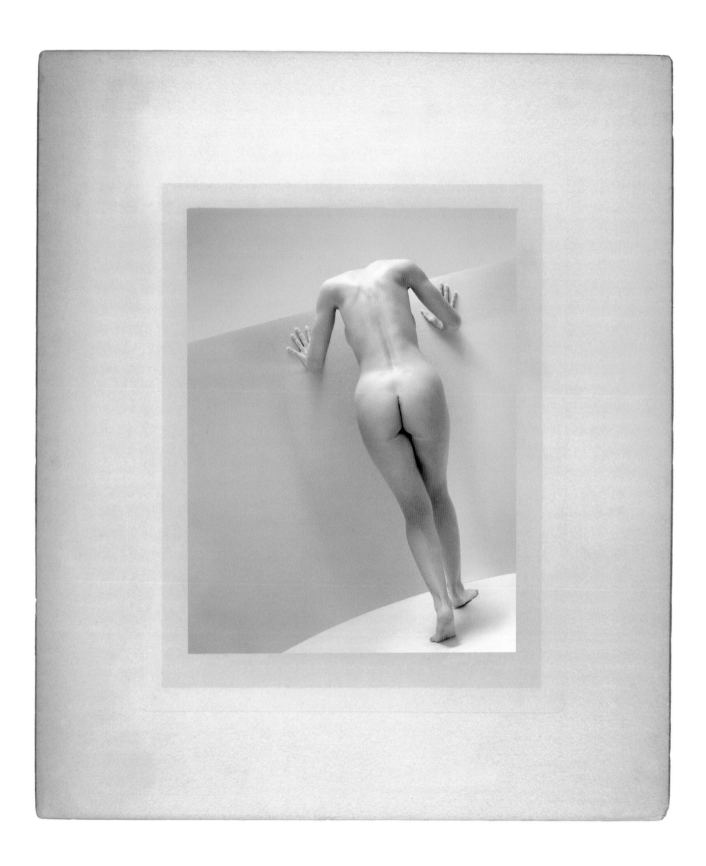

Parish Kohanim (this spread)

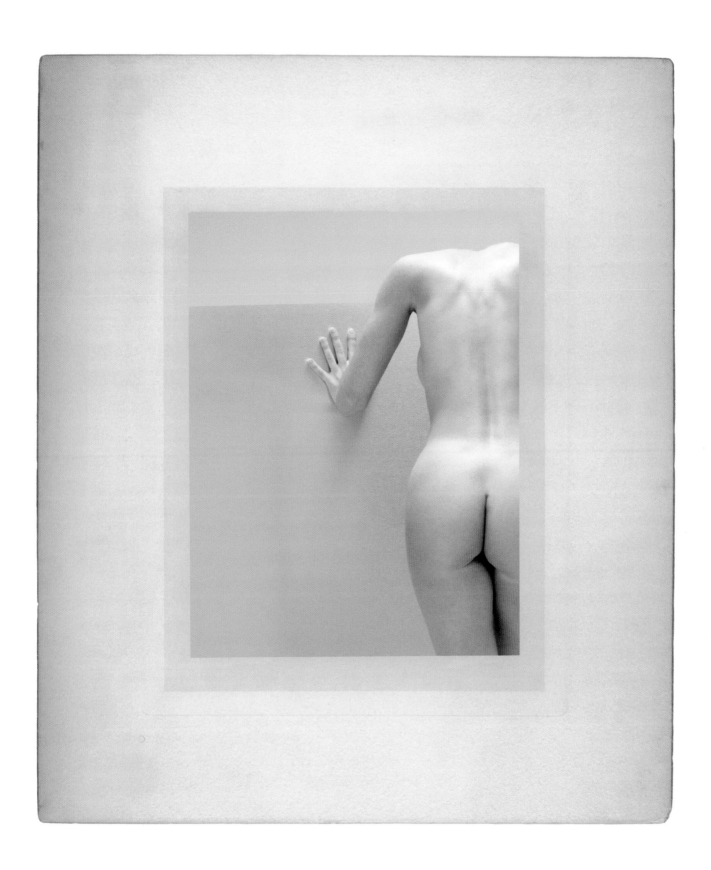

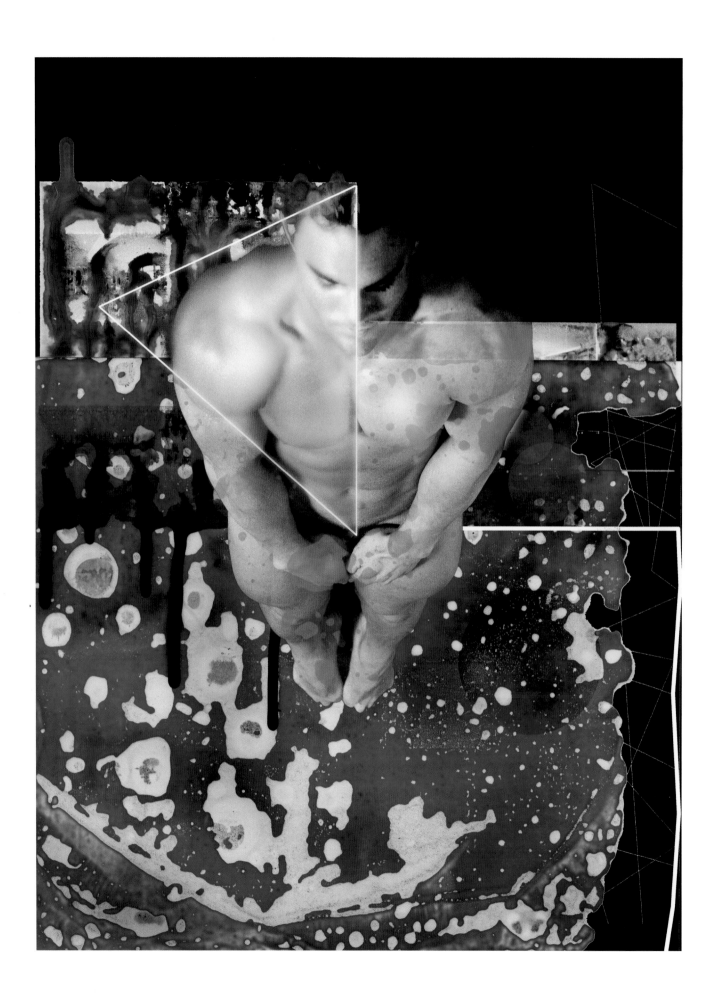

John Bernhard (this page), joSon (right page)

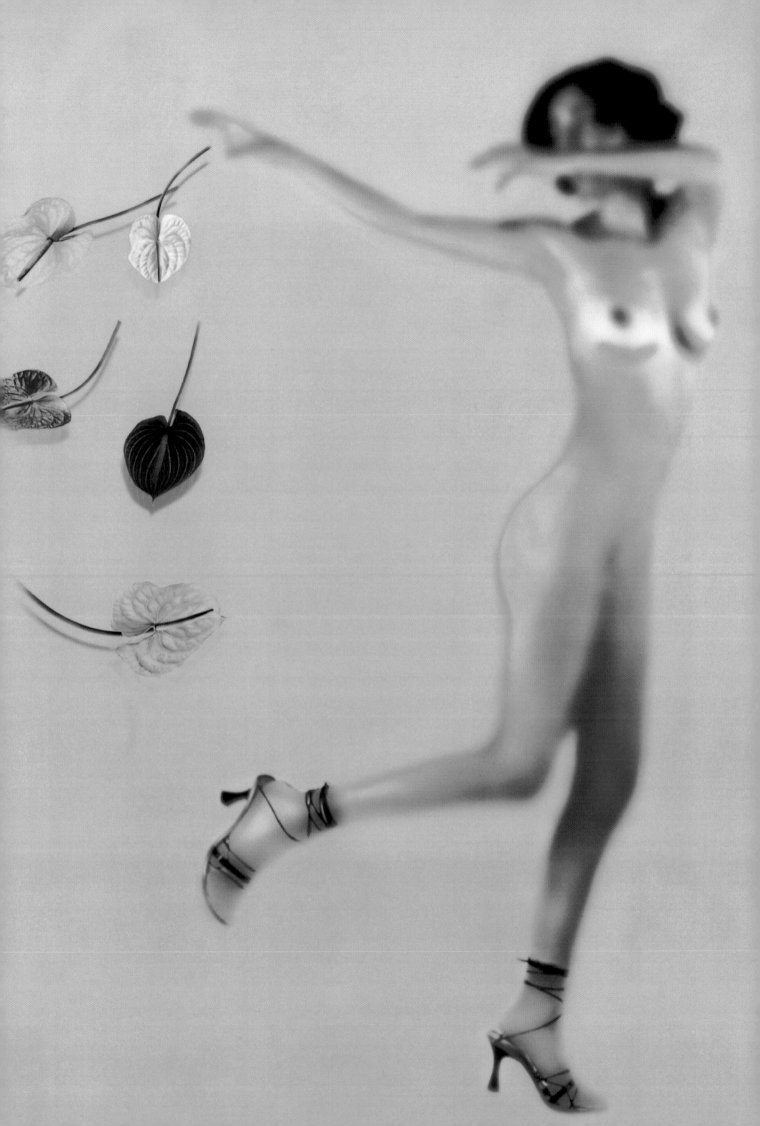

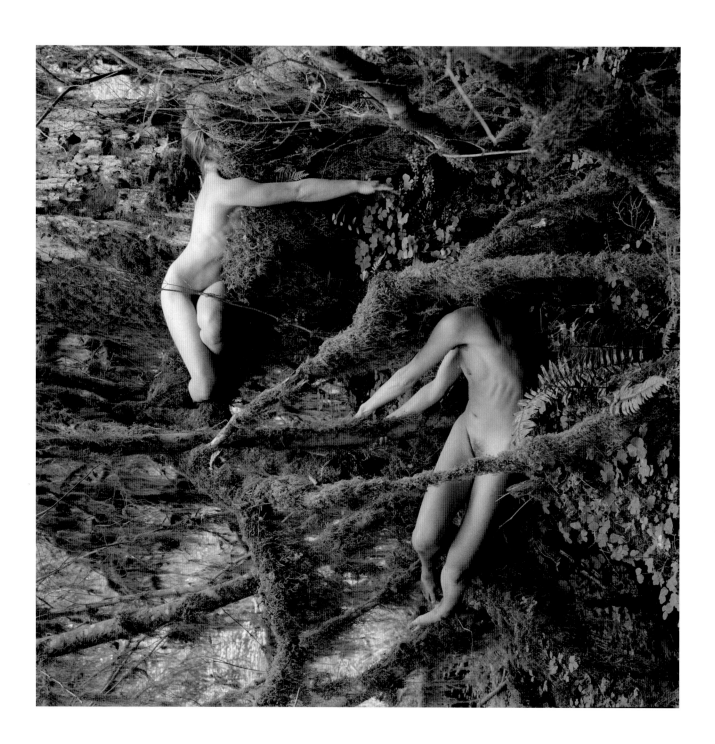

Andy Freeberg

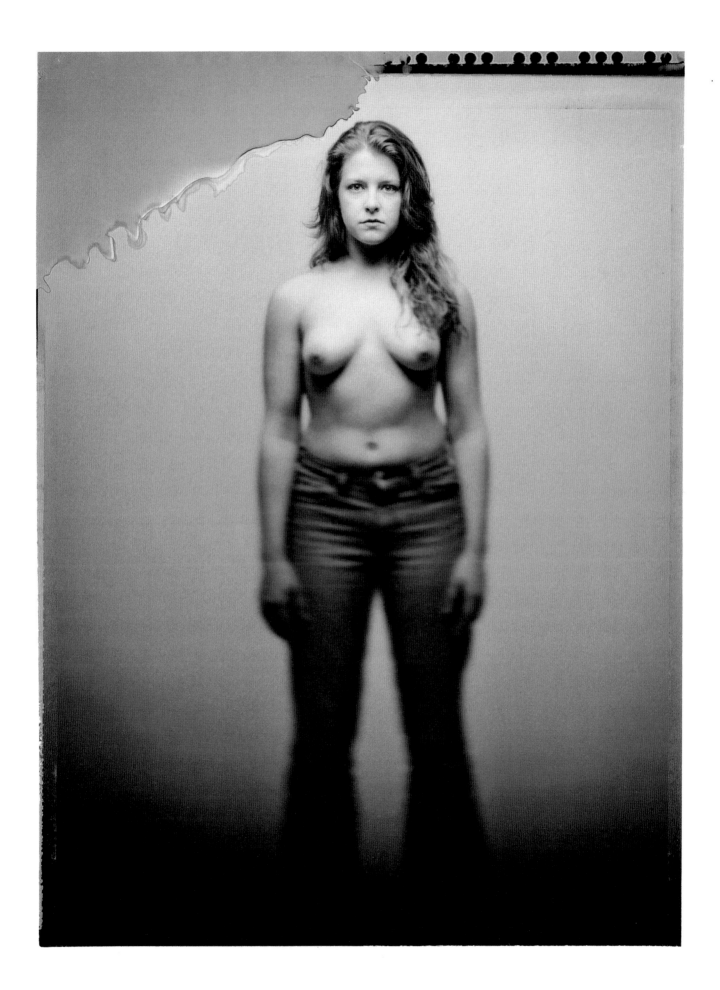

Derek Dudek

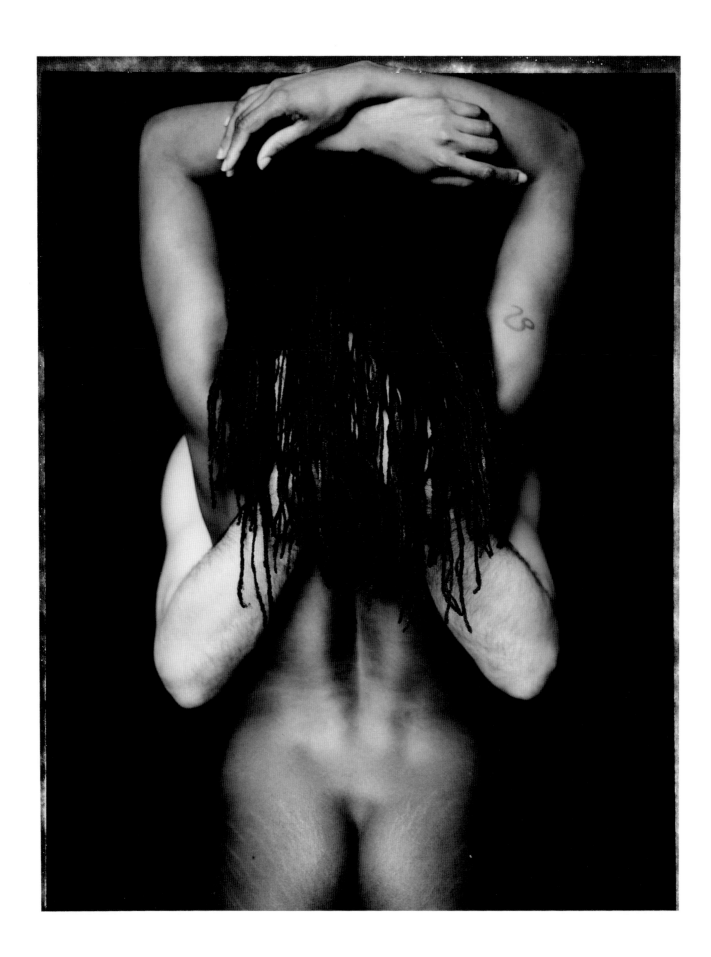

Ron Baxter Smith

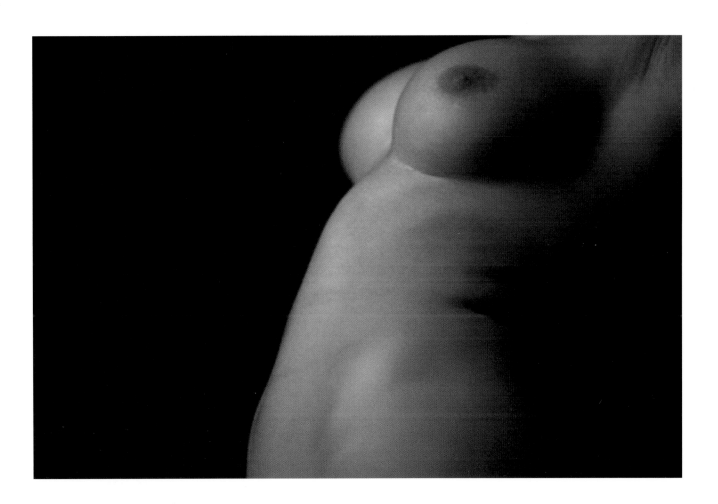

Joseph E. Reid

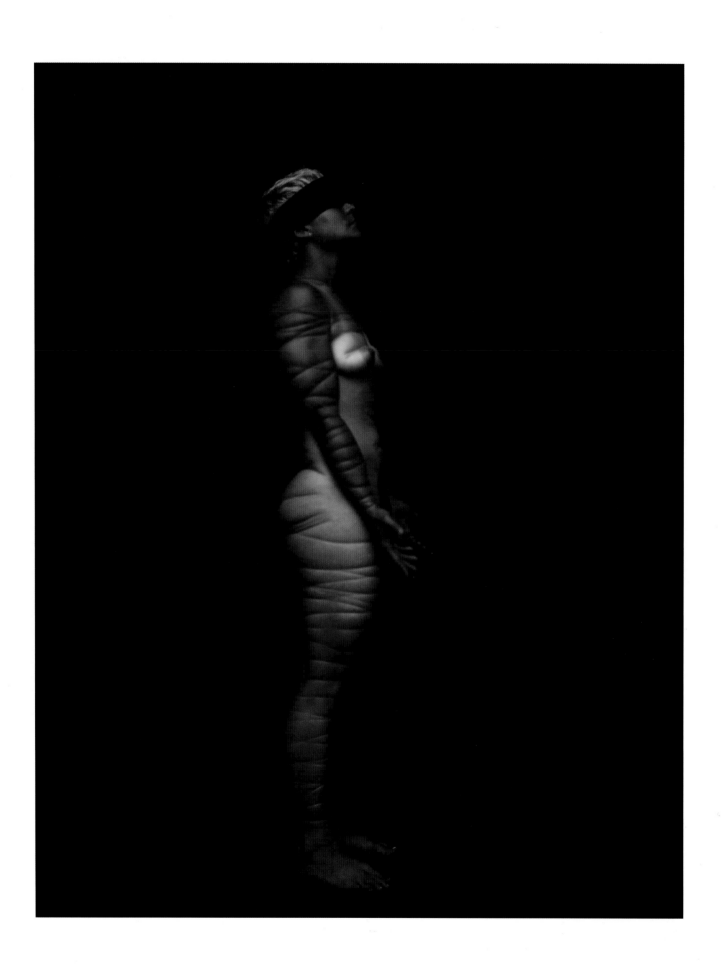

Michael McRae (this spread)

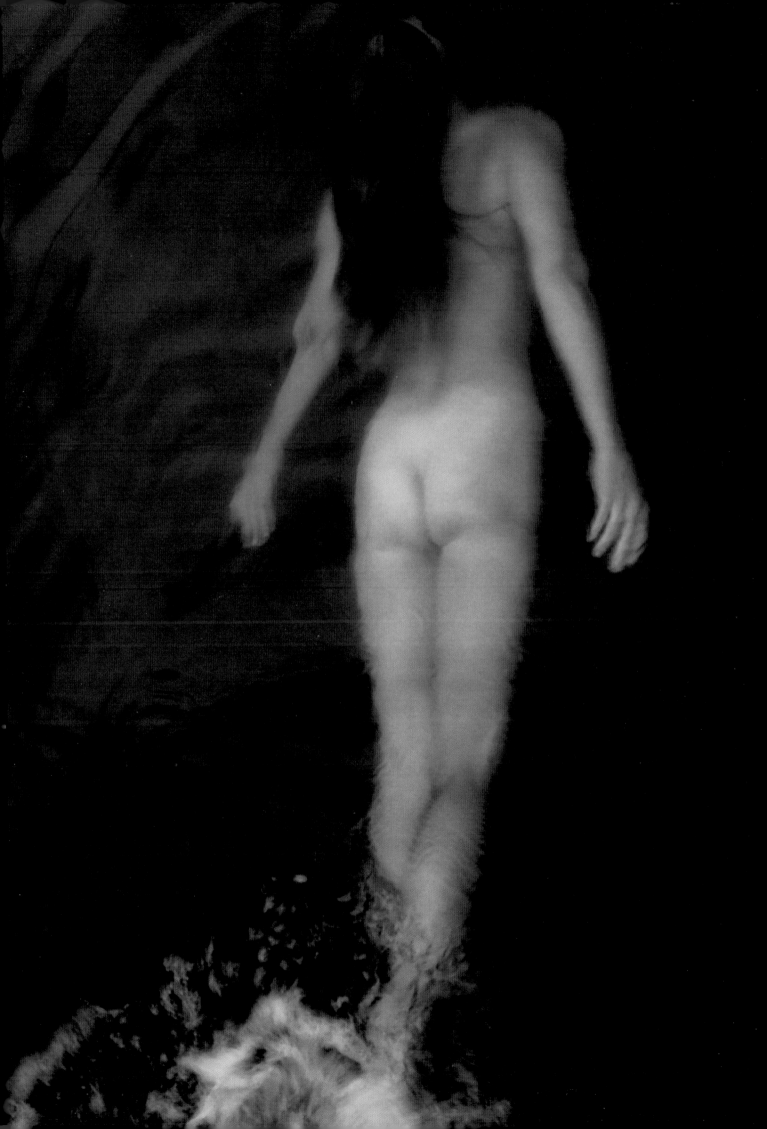

People

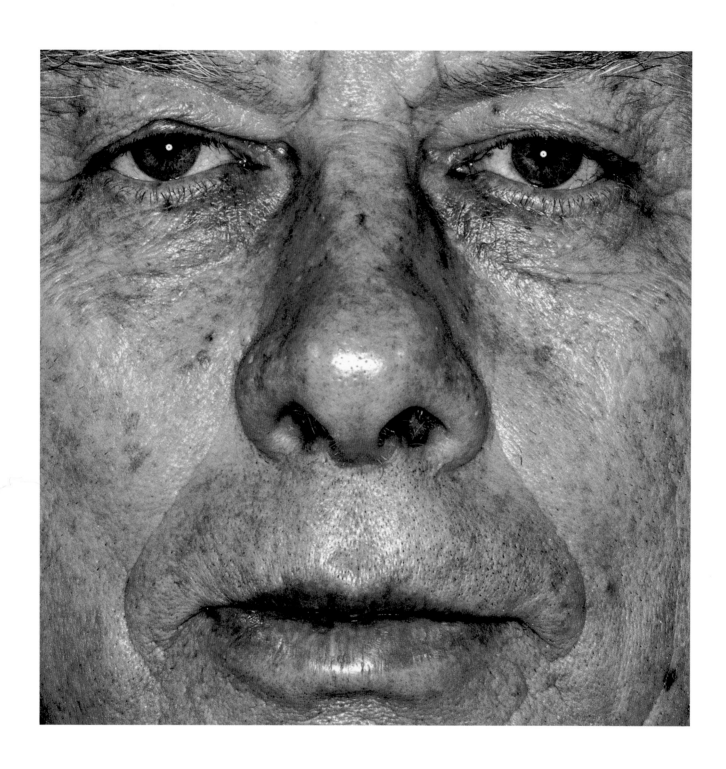

Michael Warren (opening and this page)

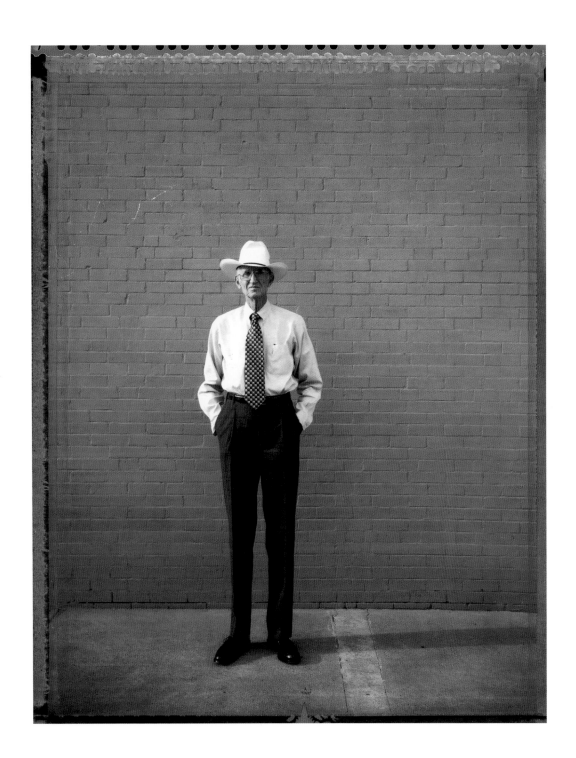

Michael O'Brien

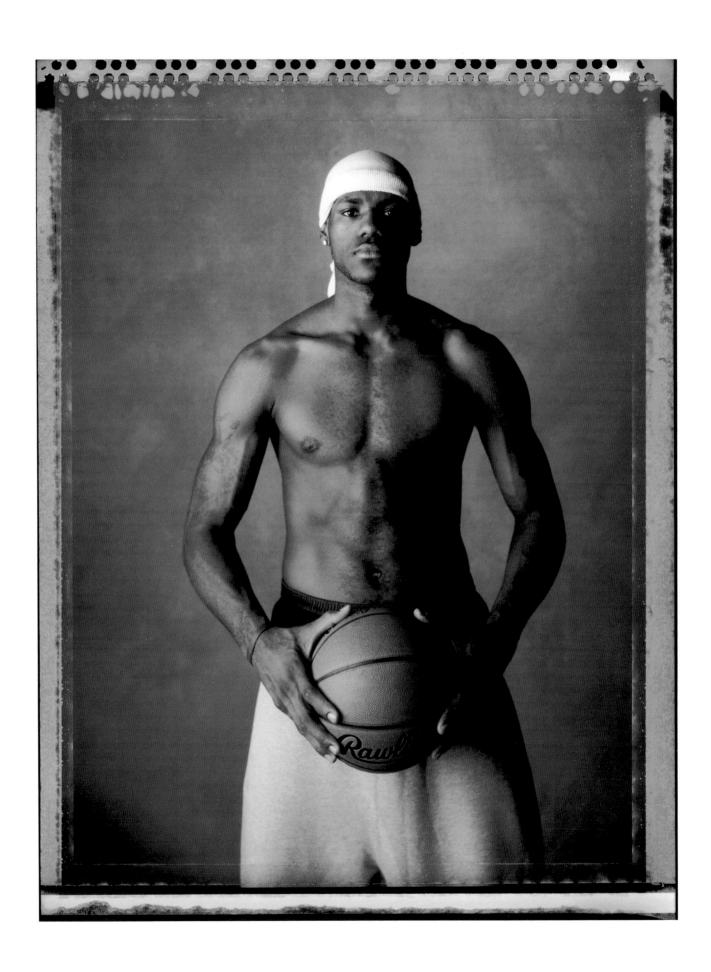

Michael O'Brien (this spread)

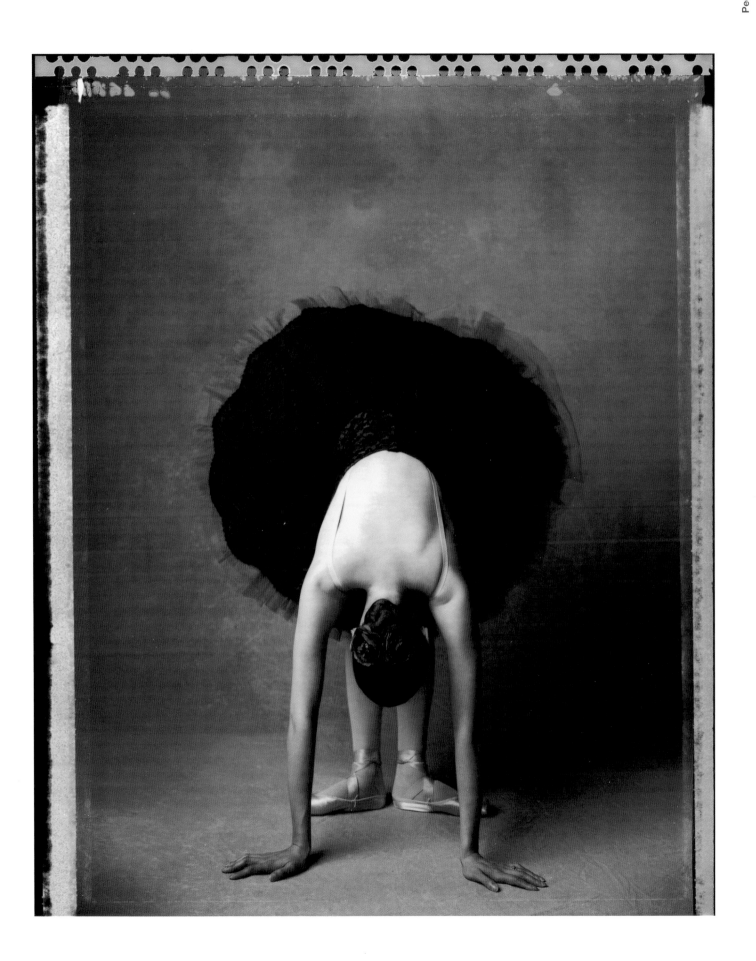

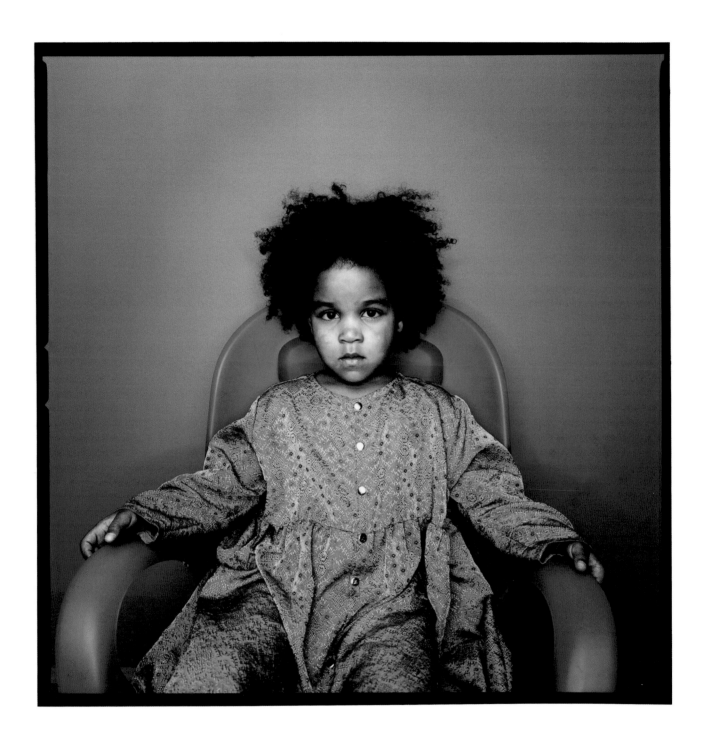

Paul Elledge (this spread)

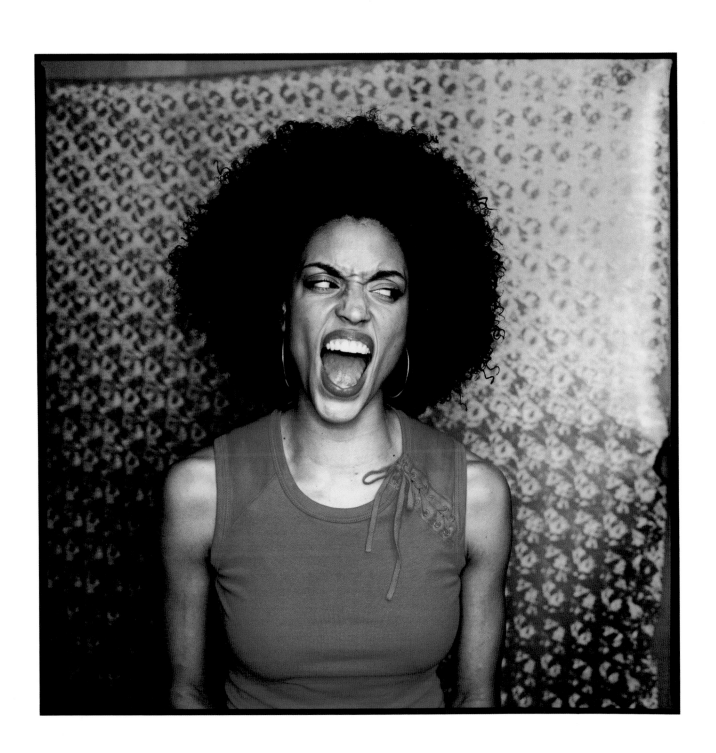

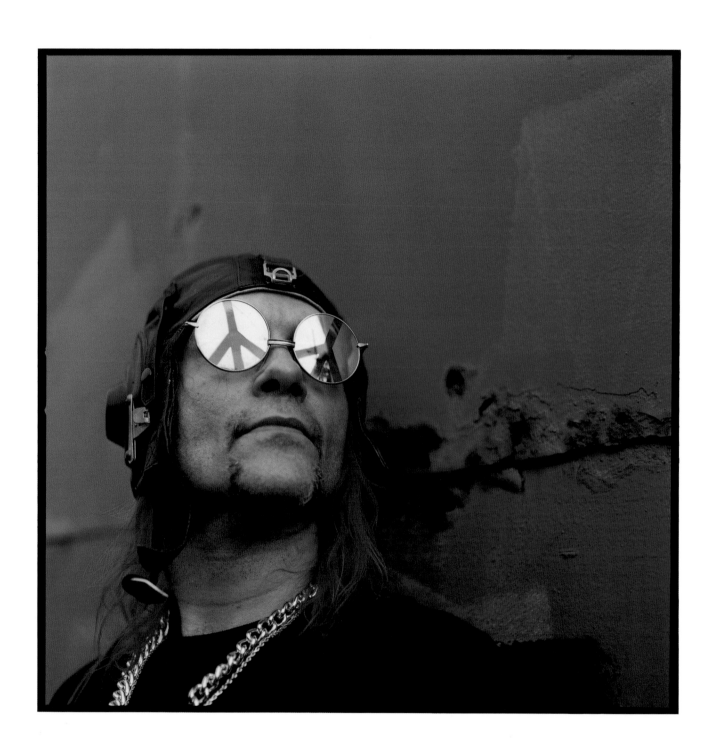

Paul Elledge (this page), Terry Vine (right page)

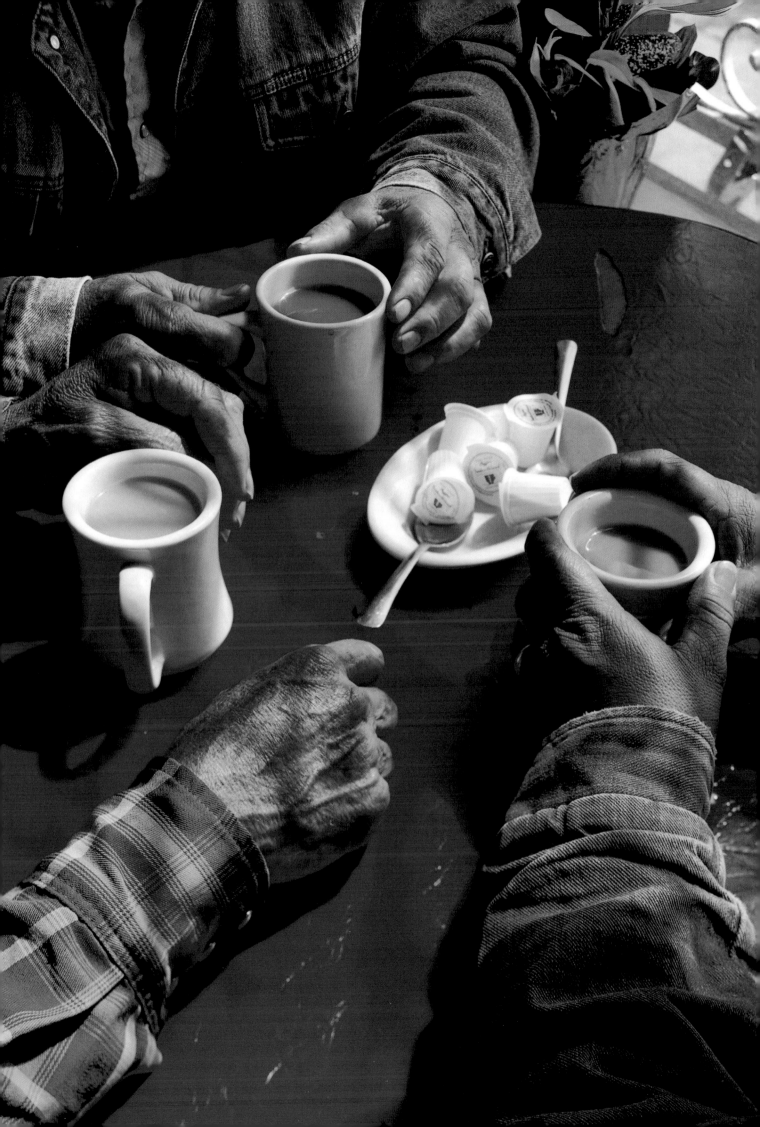

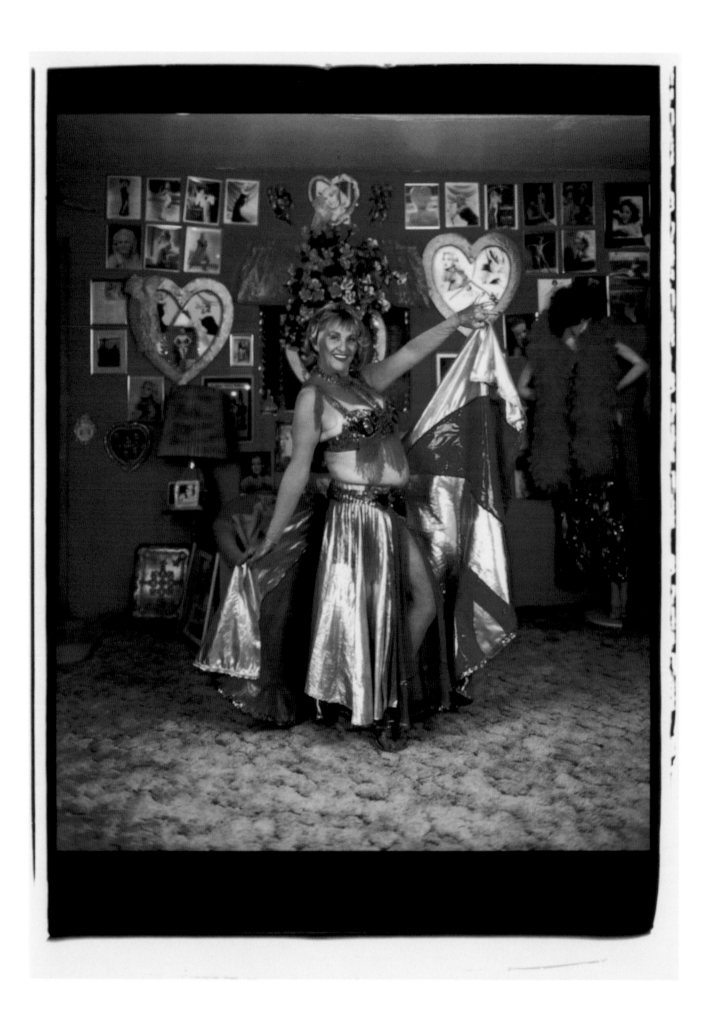

Michael McRae

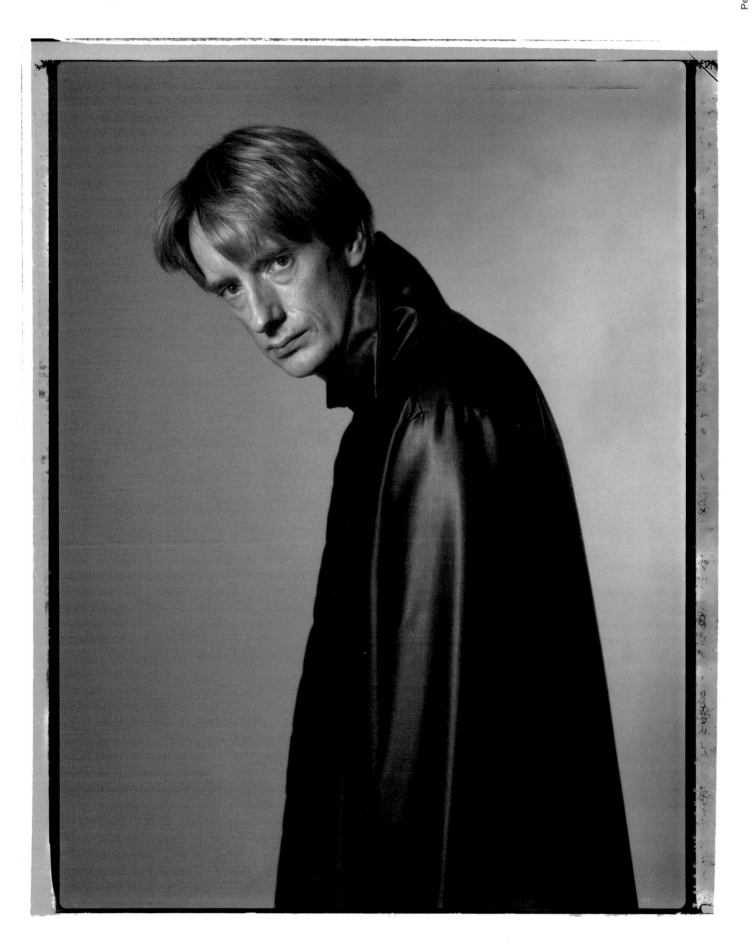

Ringo Tang

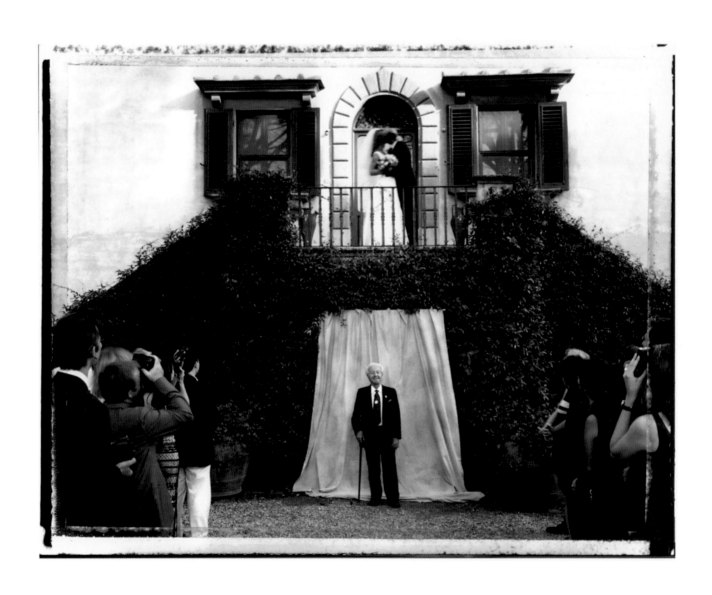

James Salzano (this page), Nick Ruechel (right page)

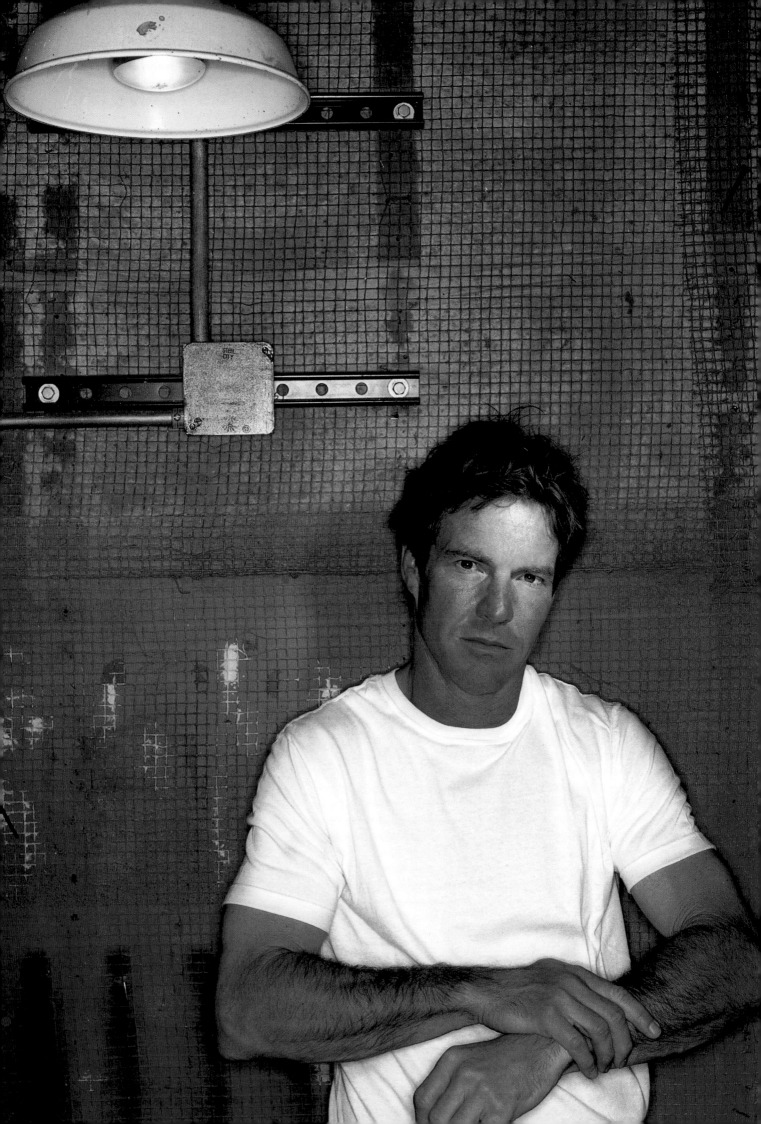

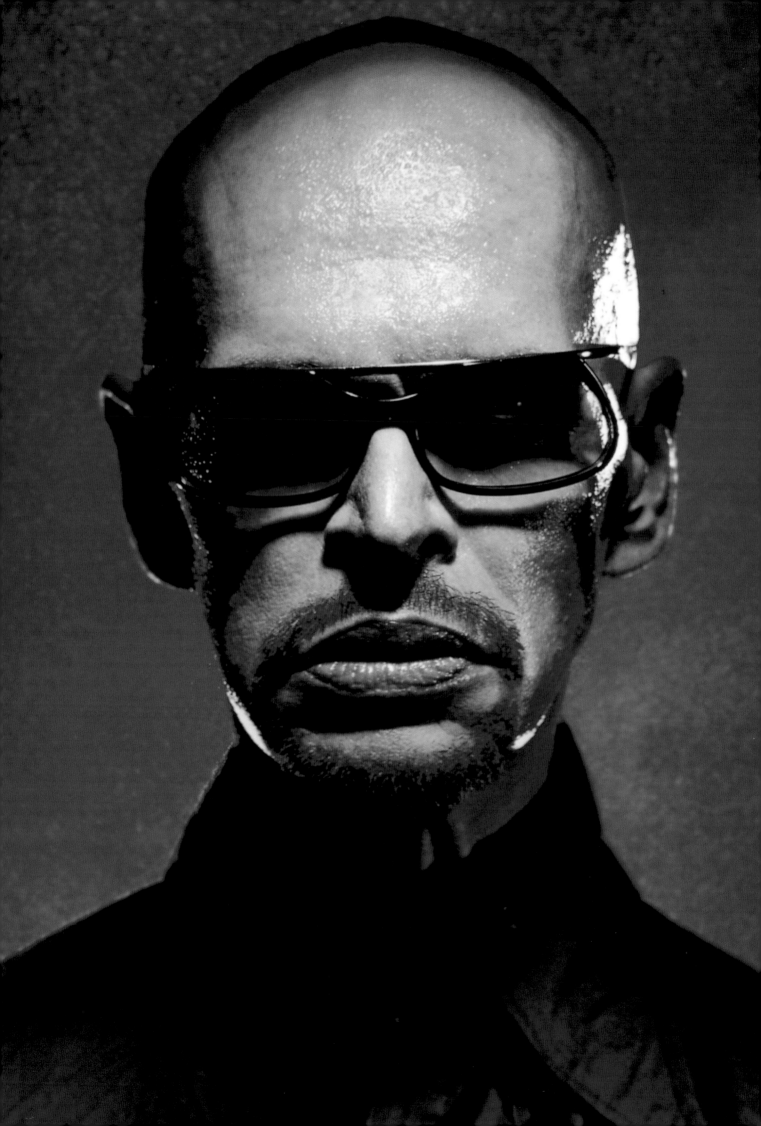

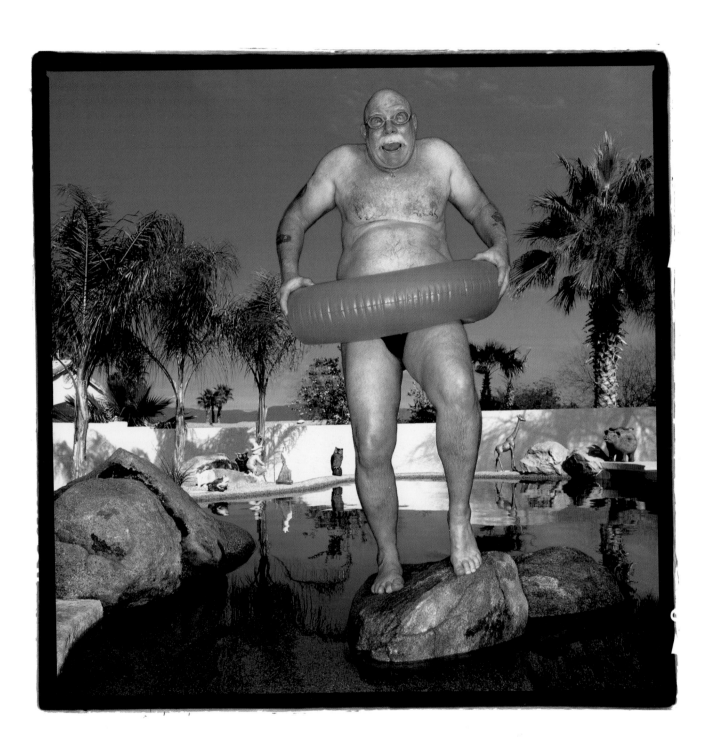

Sue Bennett (this page), Lennart Sjoberg (right page)

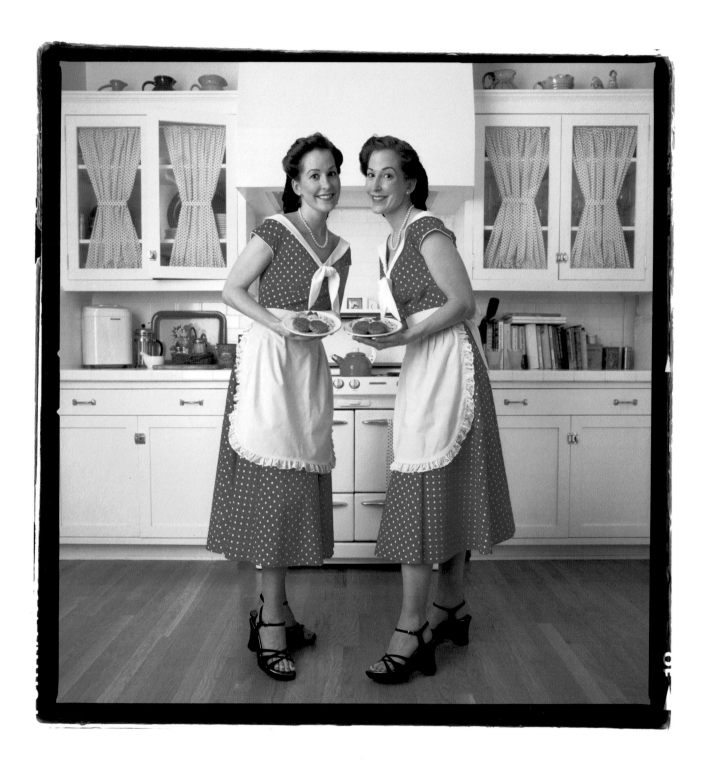

Sue Bennett (this spread)

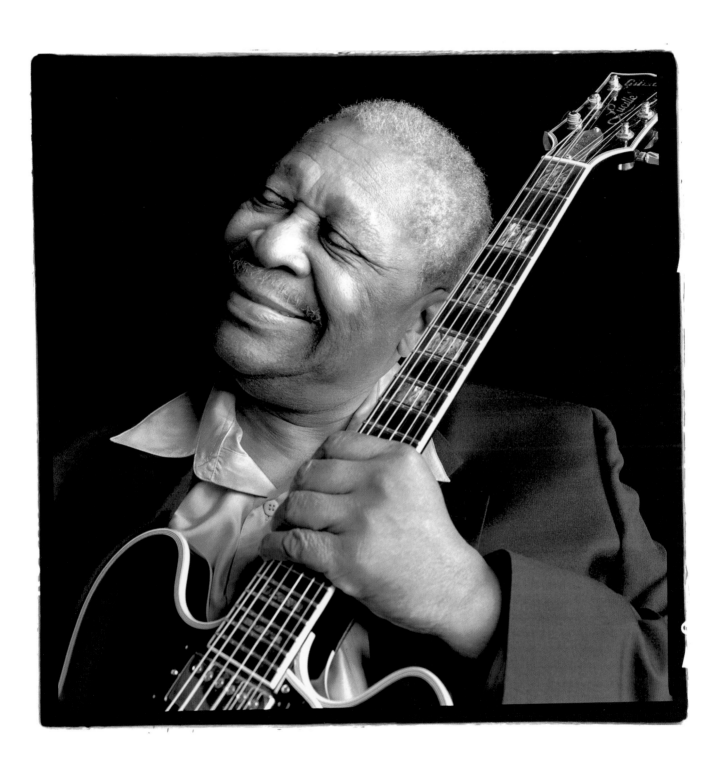

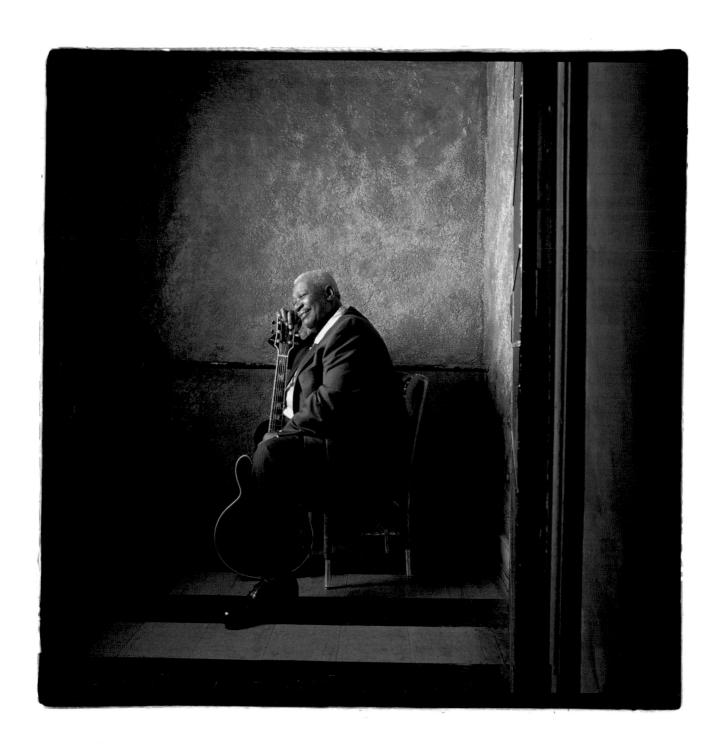

Sue Bennett

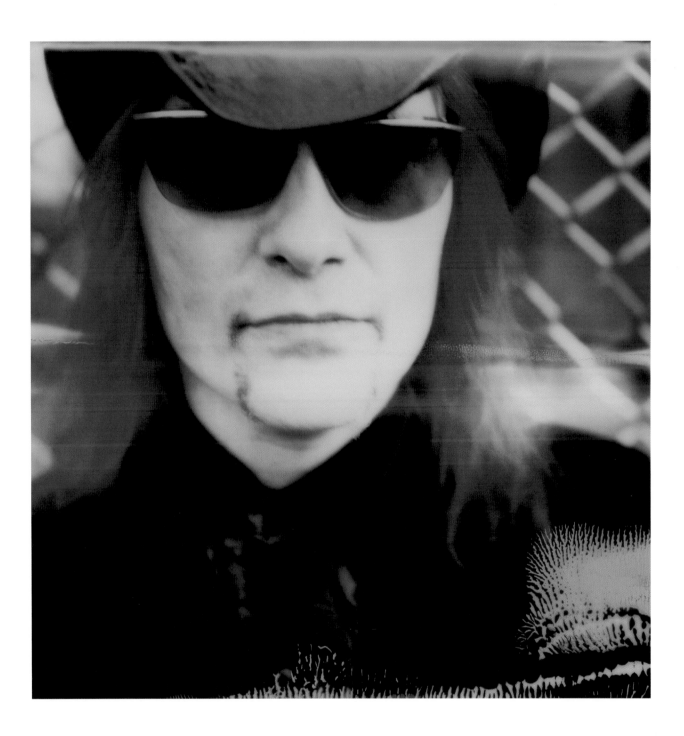

Paul Elledge

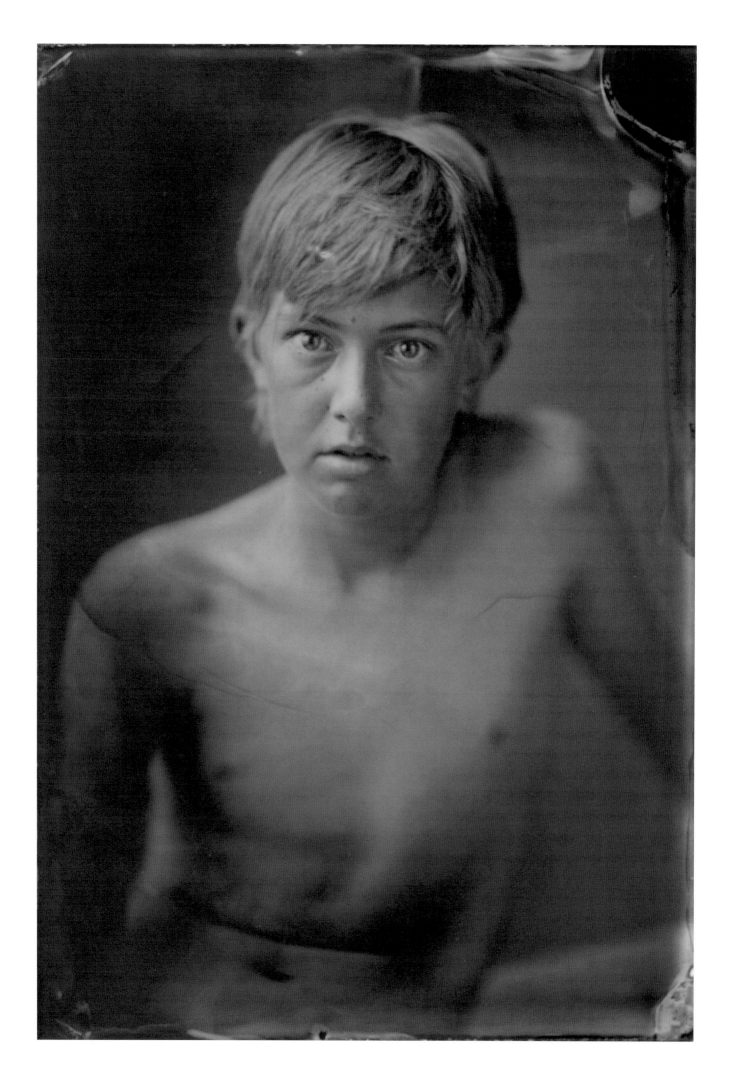

Michael McRae (this spread)

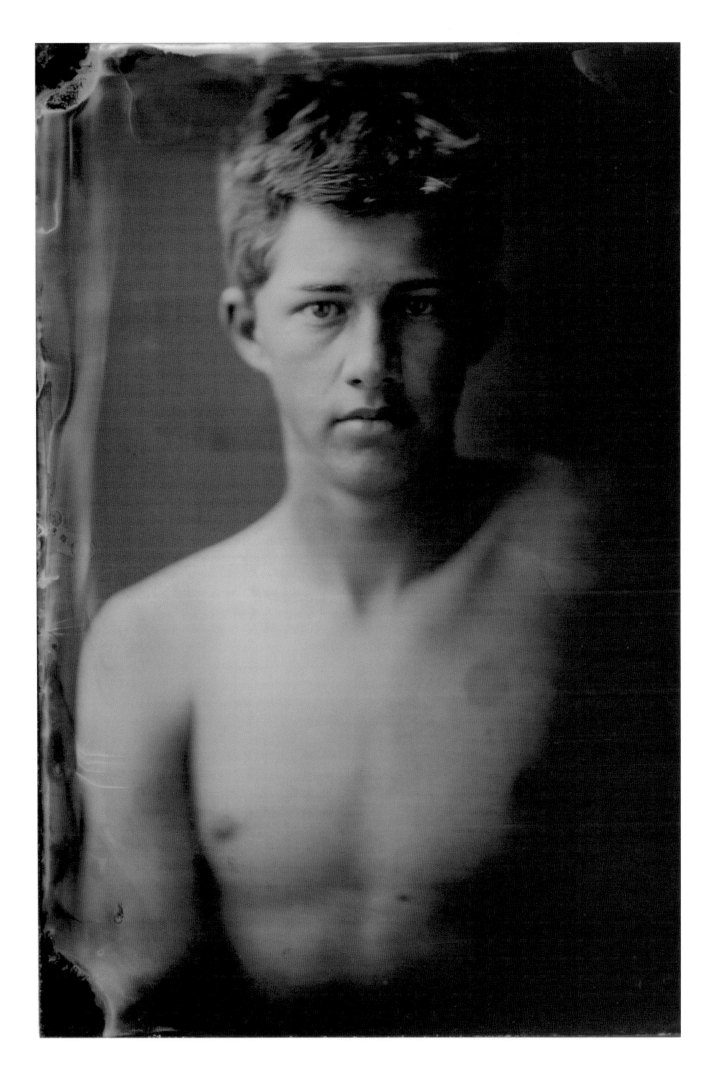

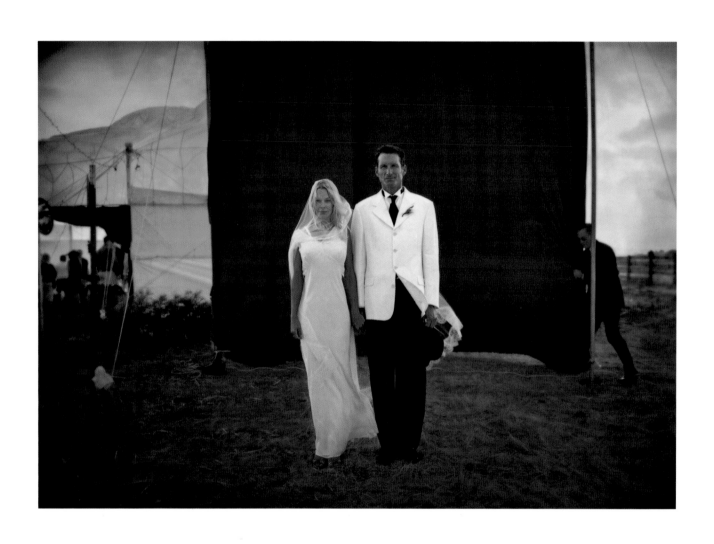

Terry Husebye (this page), Peter Dazeley (right page)

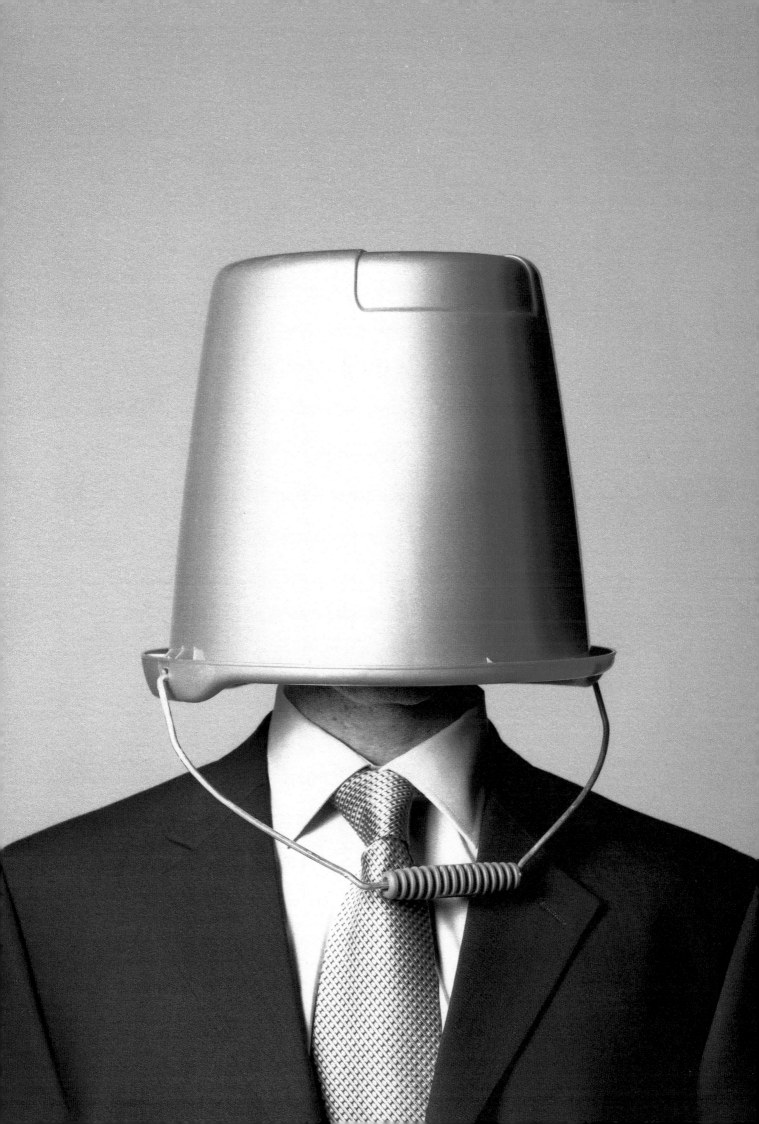

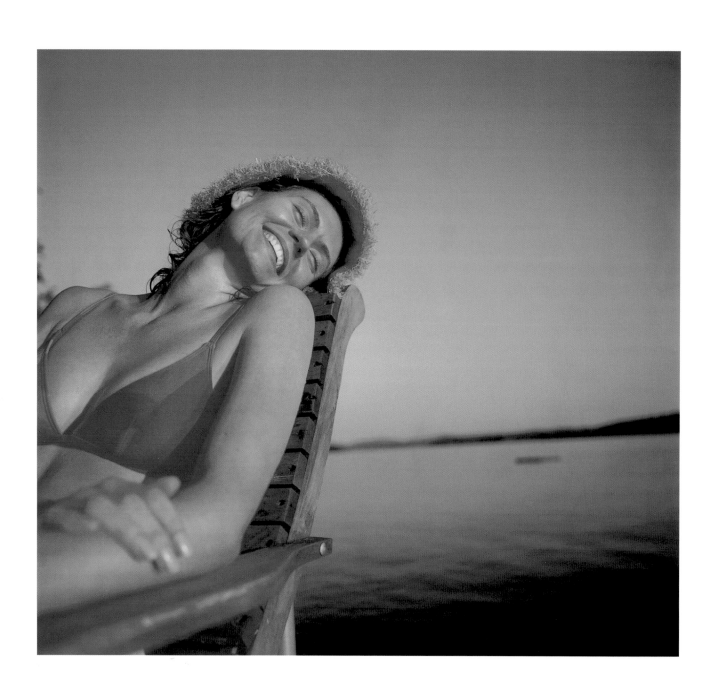

Richard Schultz (this page), Michael Grecco (right page)

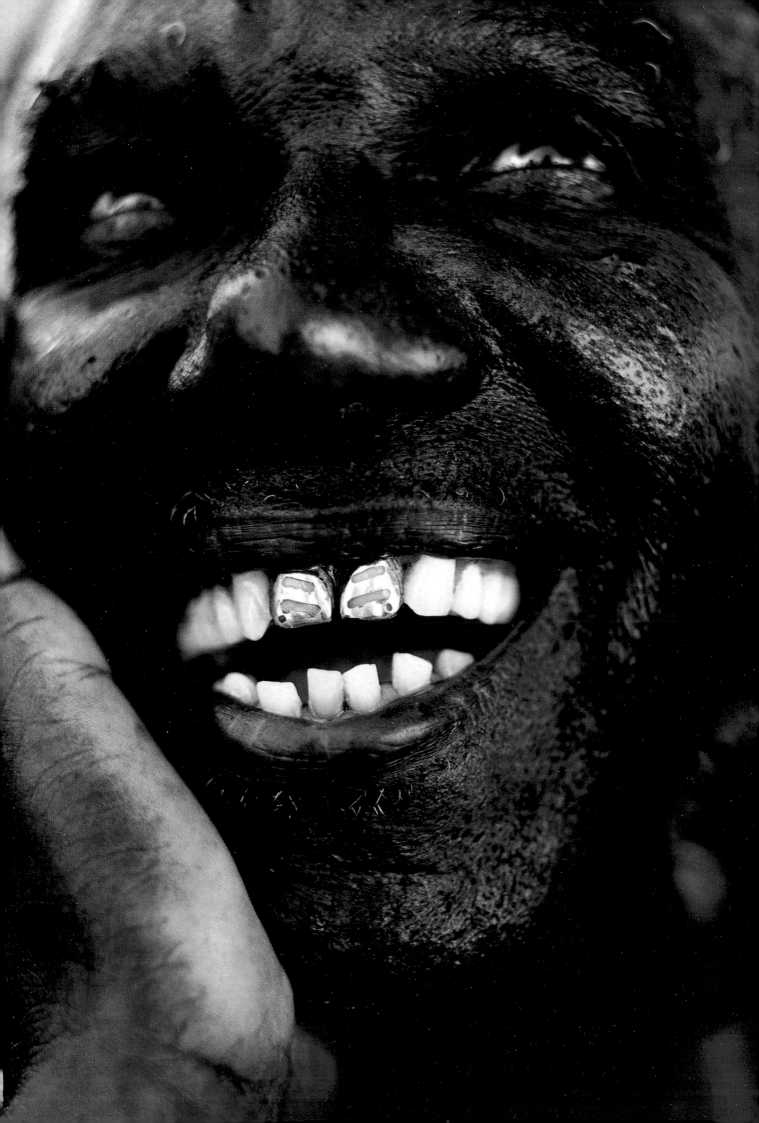

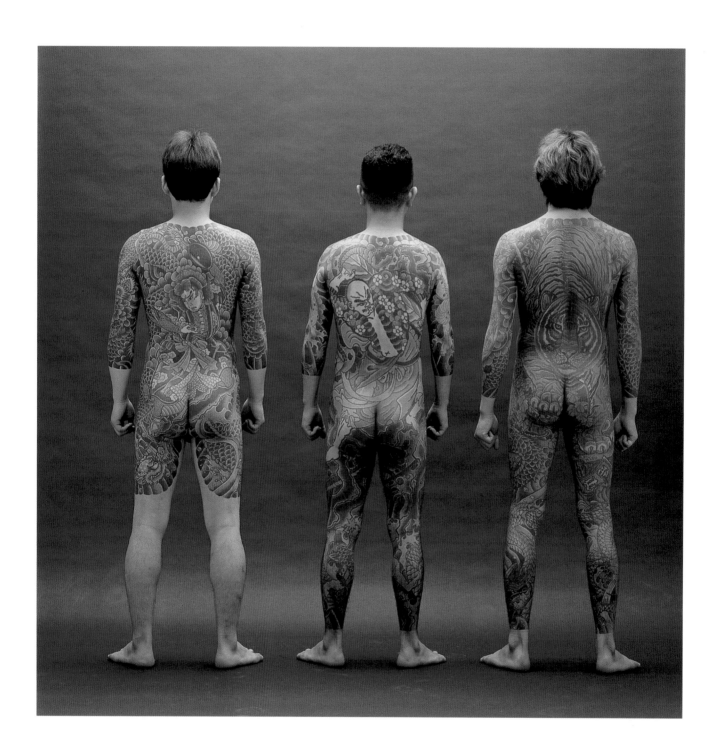

Ryu Mizuno

Rodney Smith

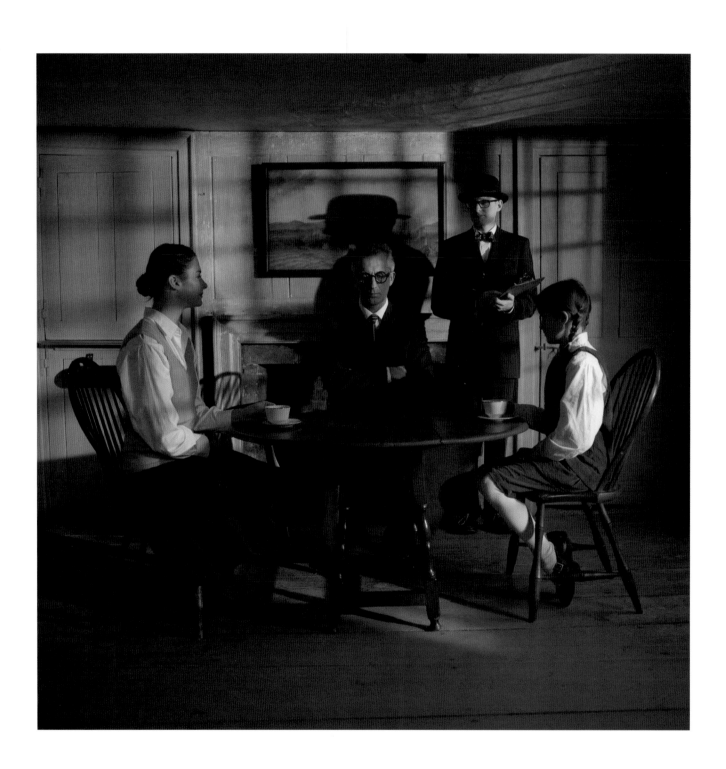

Rodney Smith (this spread)

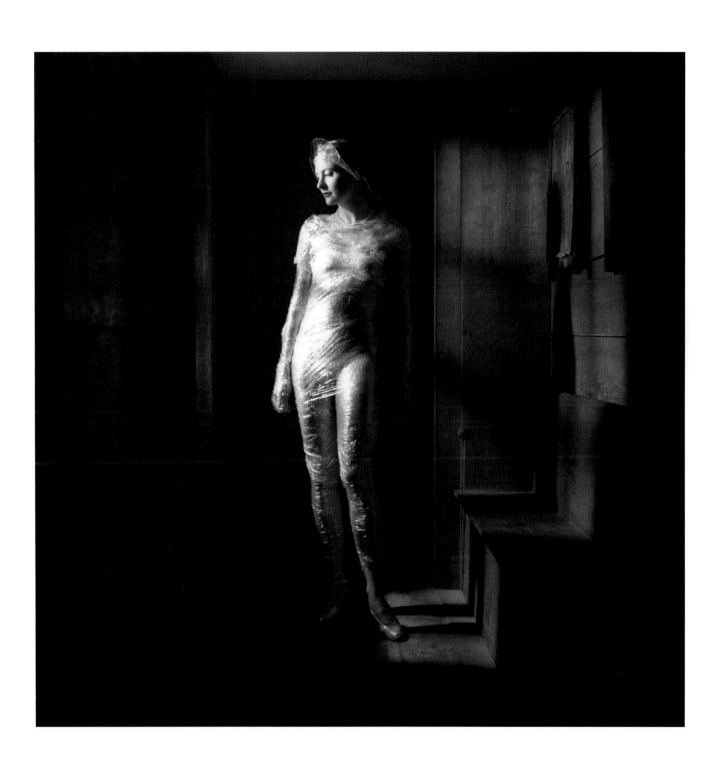

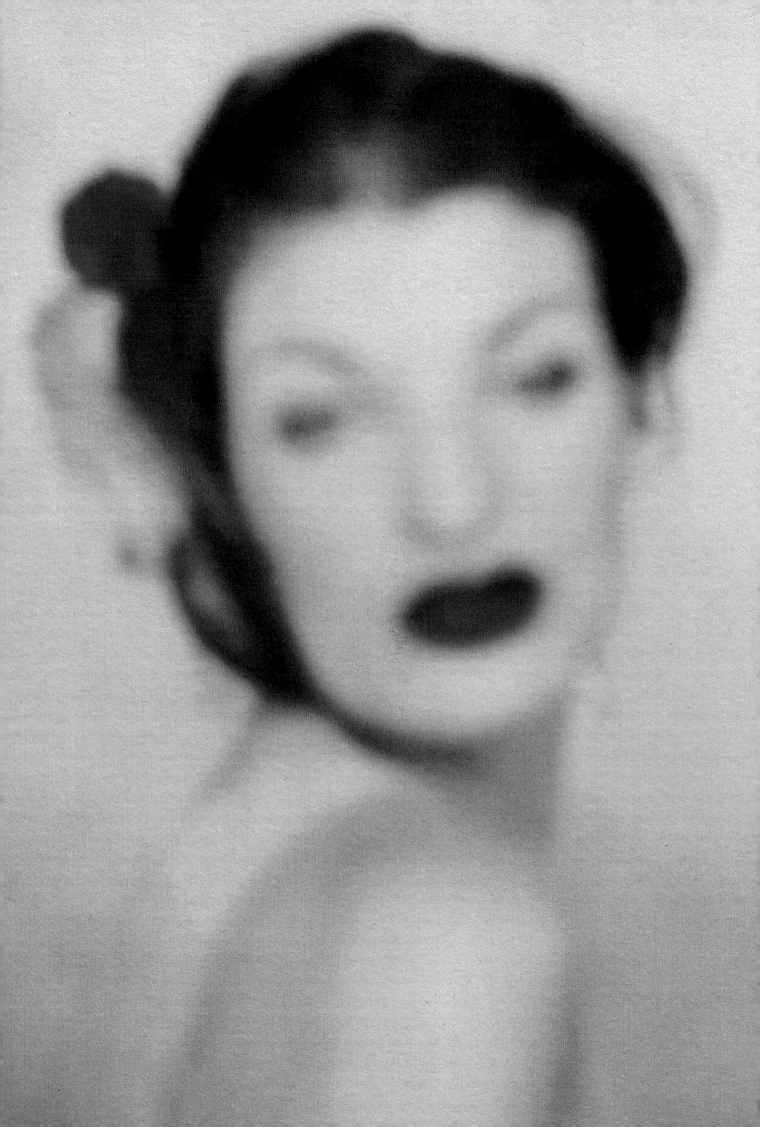

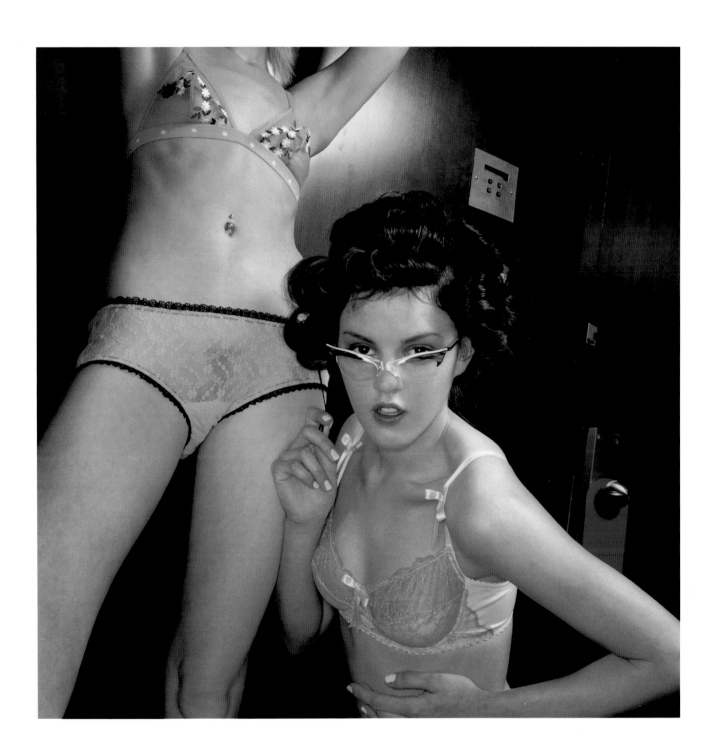

Frank Herholdt (this page), Debra McClinton (left page)

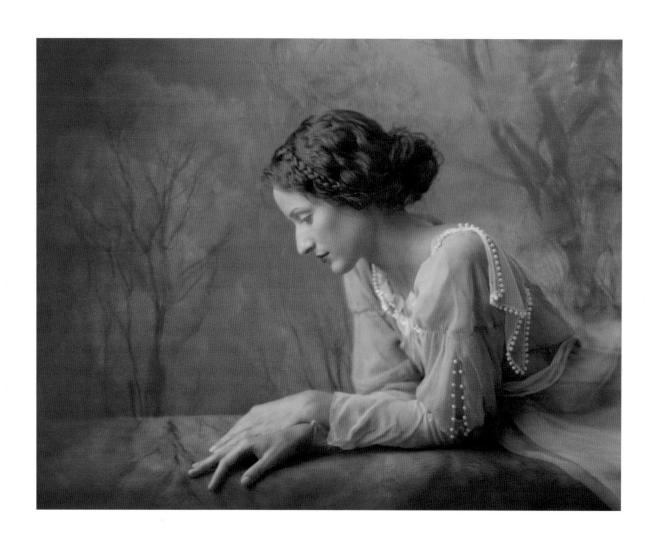

Parish Kohanim (this spread)

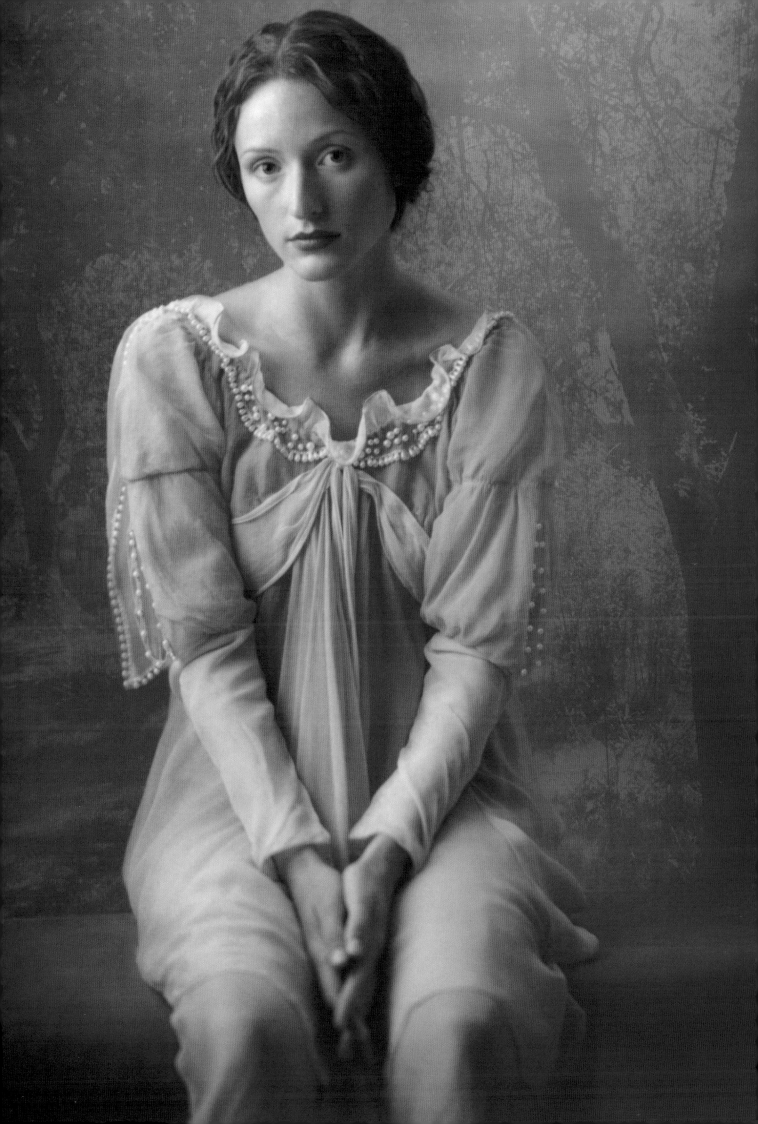

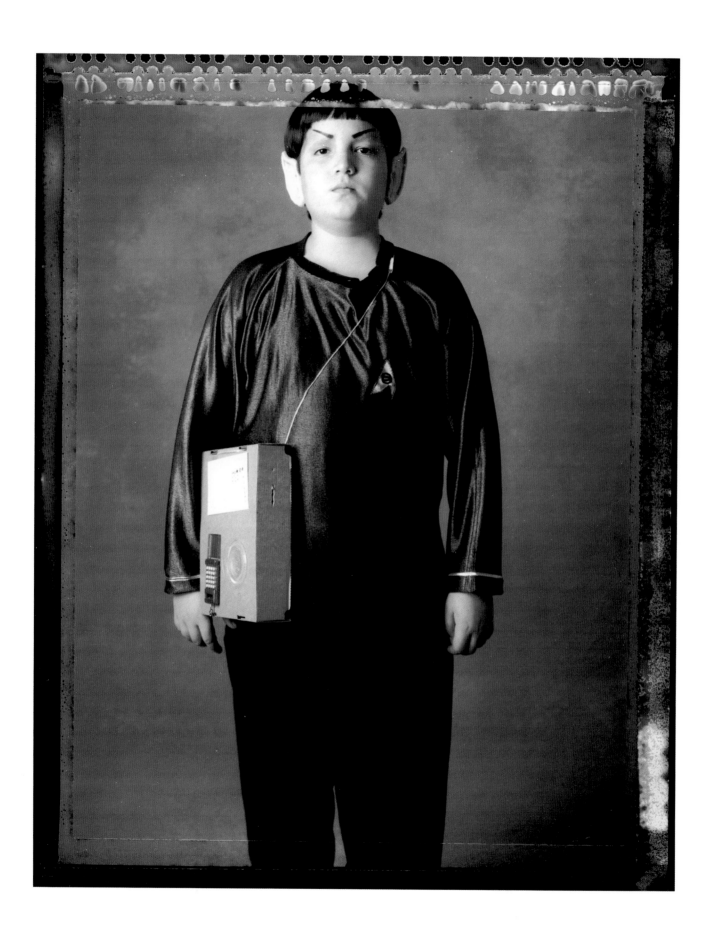

Michael O'Brien

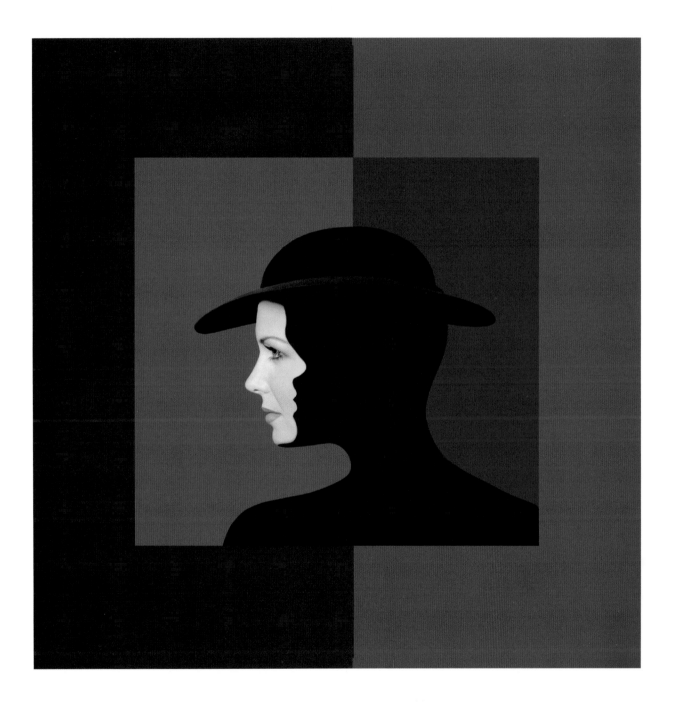

Parish Kohanim

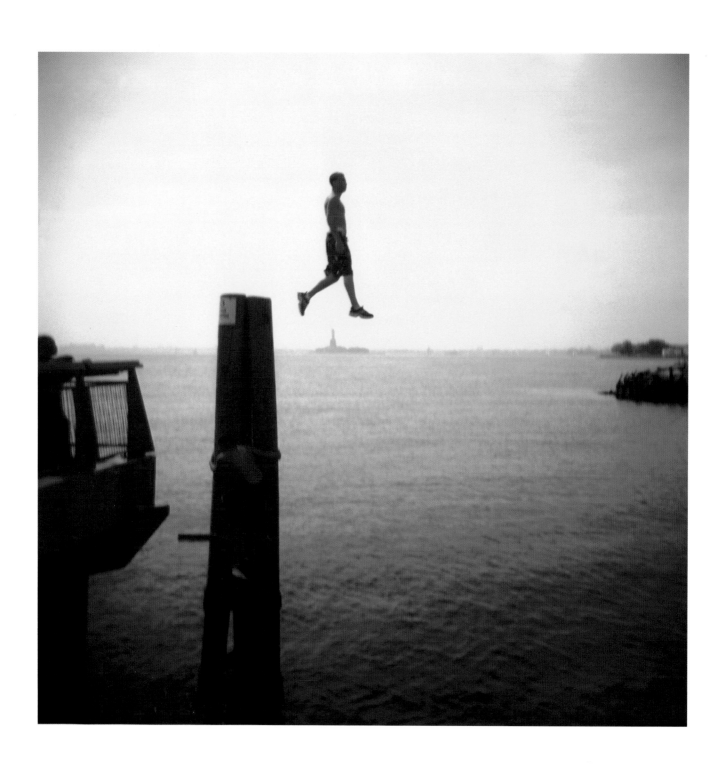

Paul Ambrose (this page), Tom Atwood (right page)

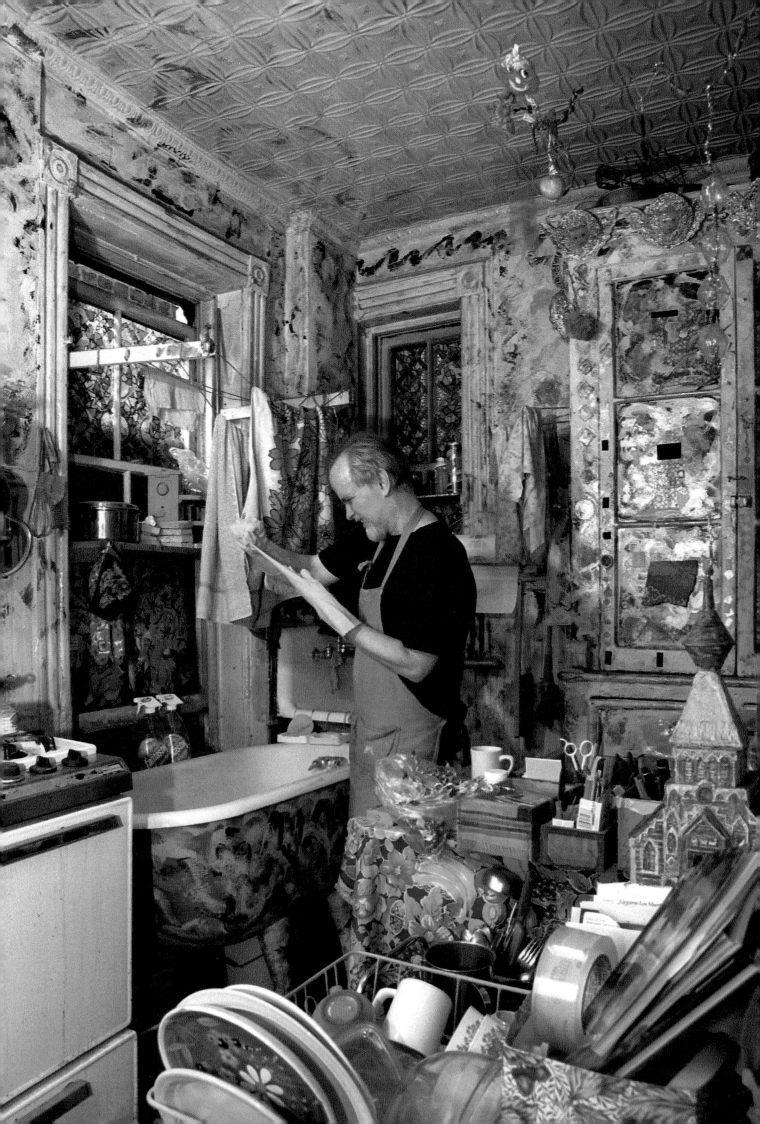

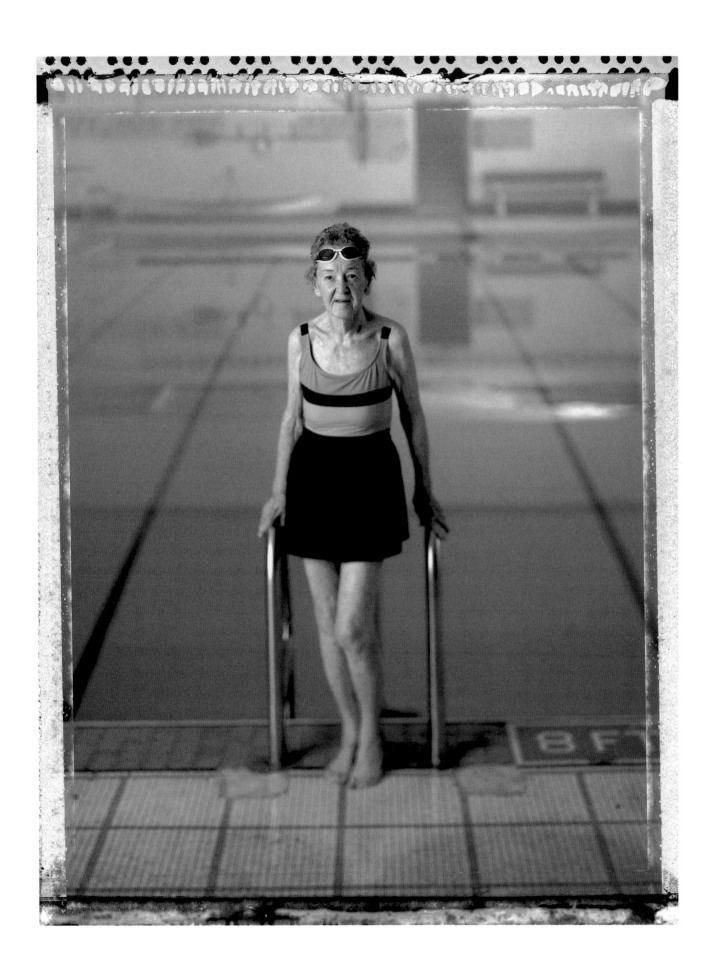

James Salzano

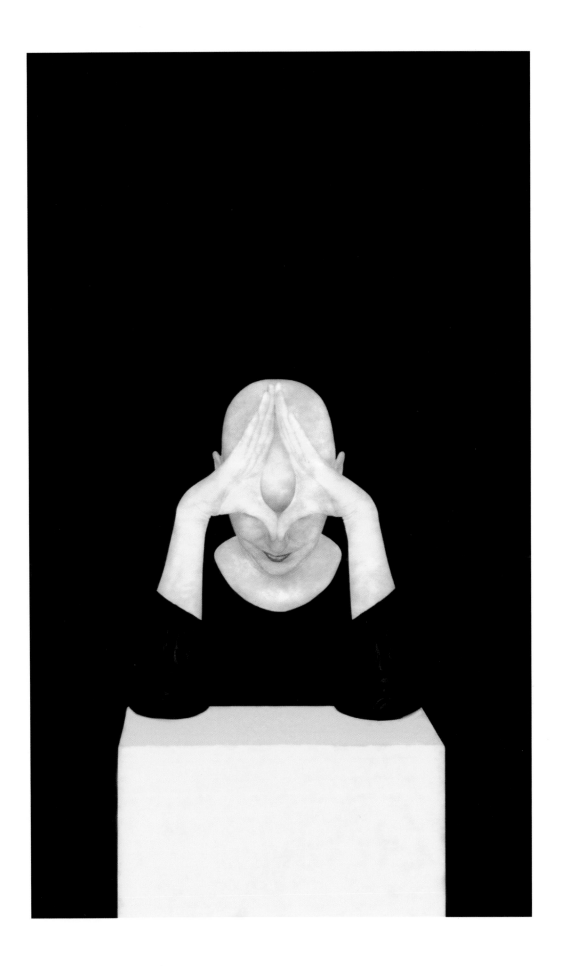

Giorgio Karayiannis

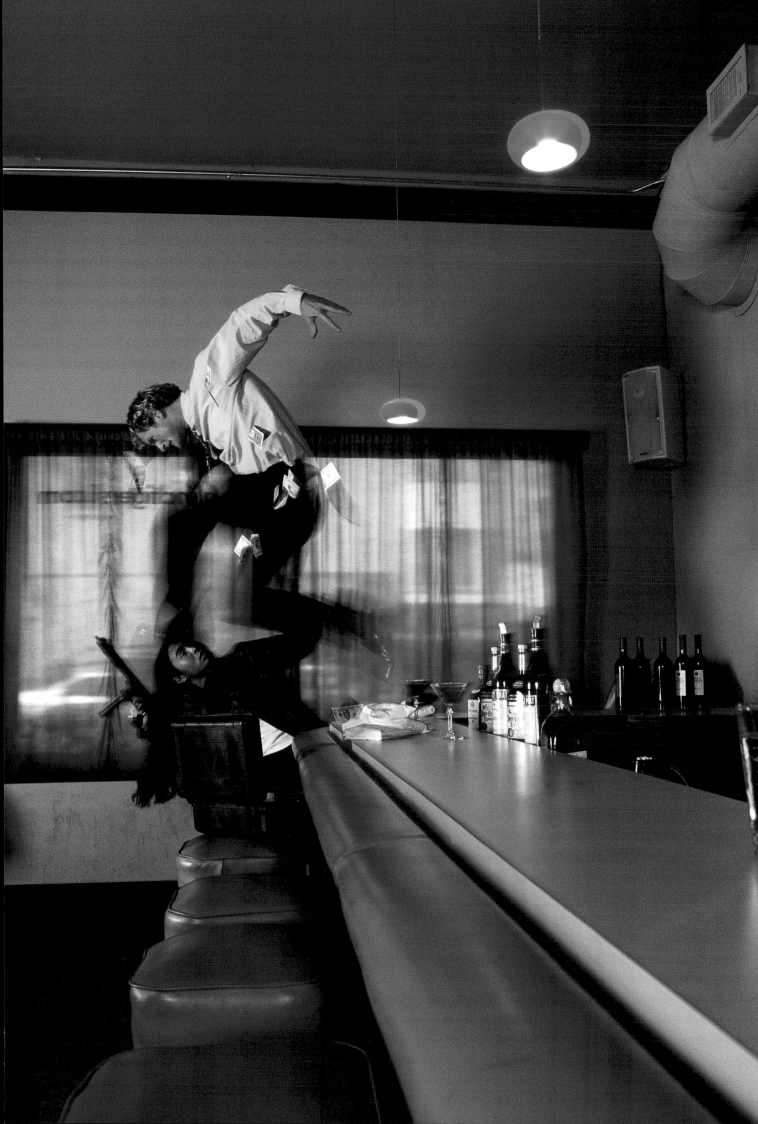

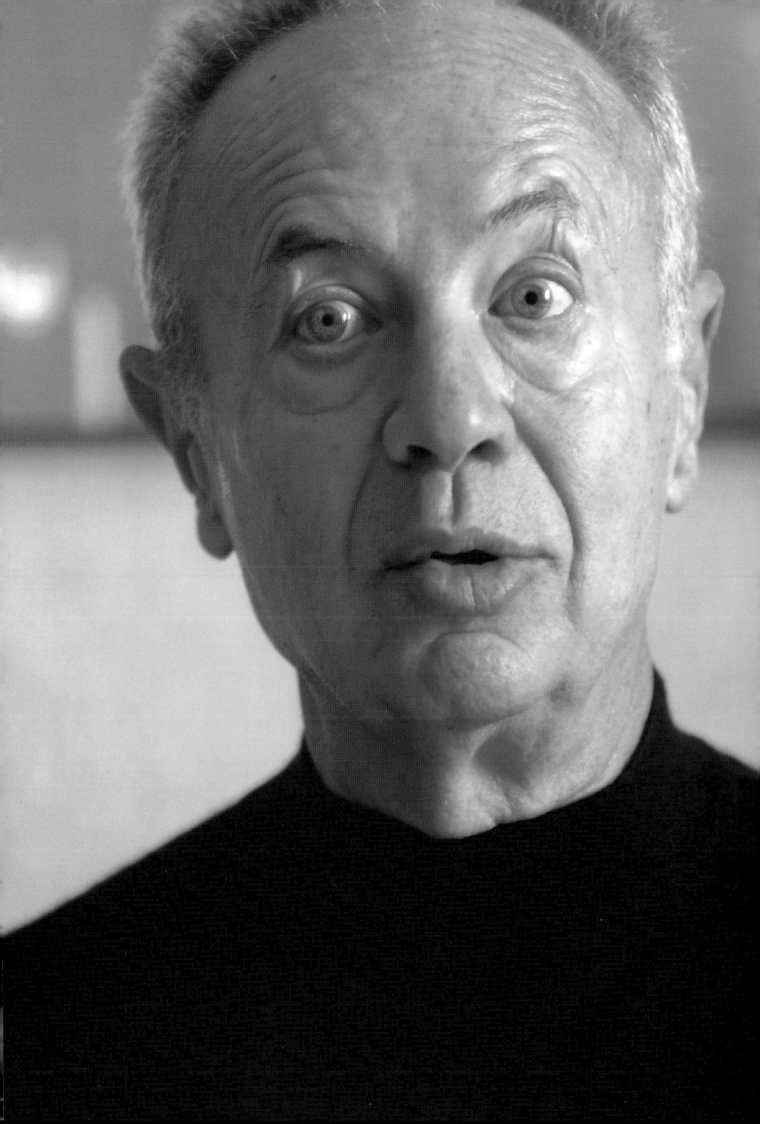

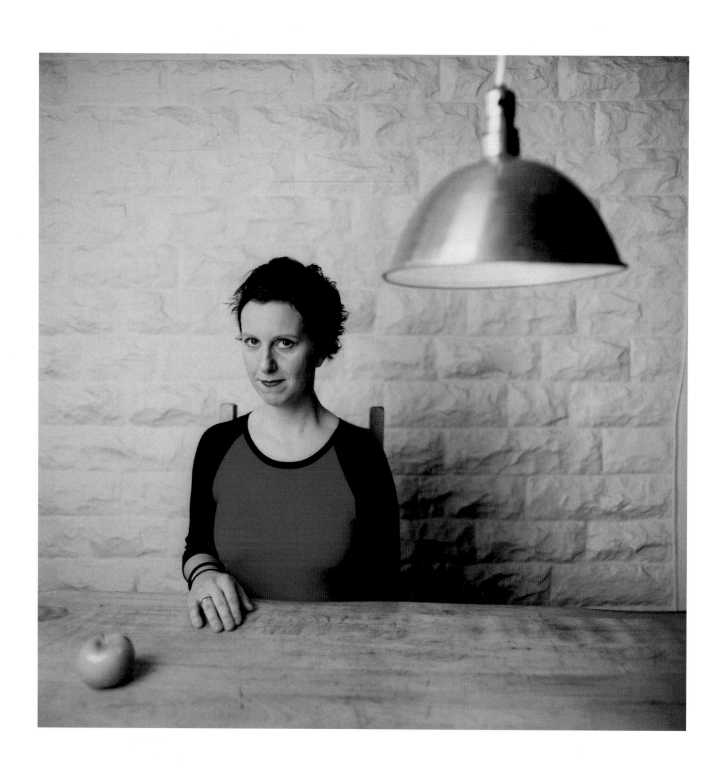

Claudia Goetzelmann (previous spread), Julie Durocher (this page), Rick English (right page)

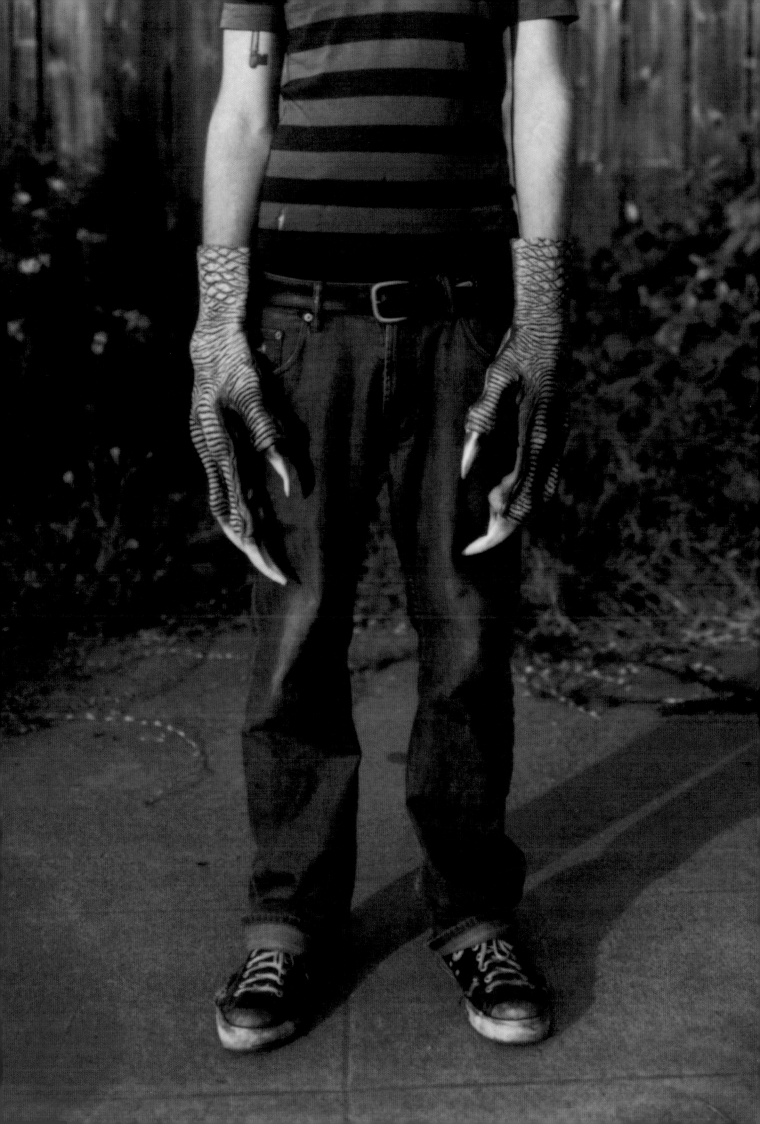

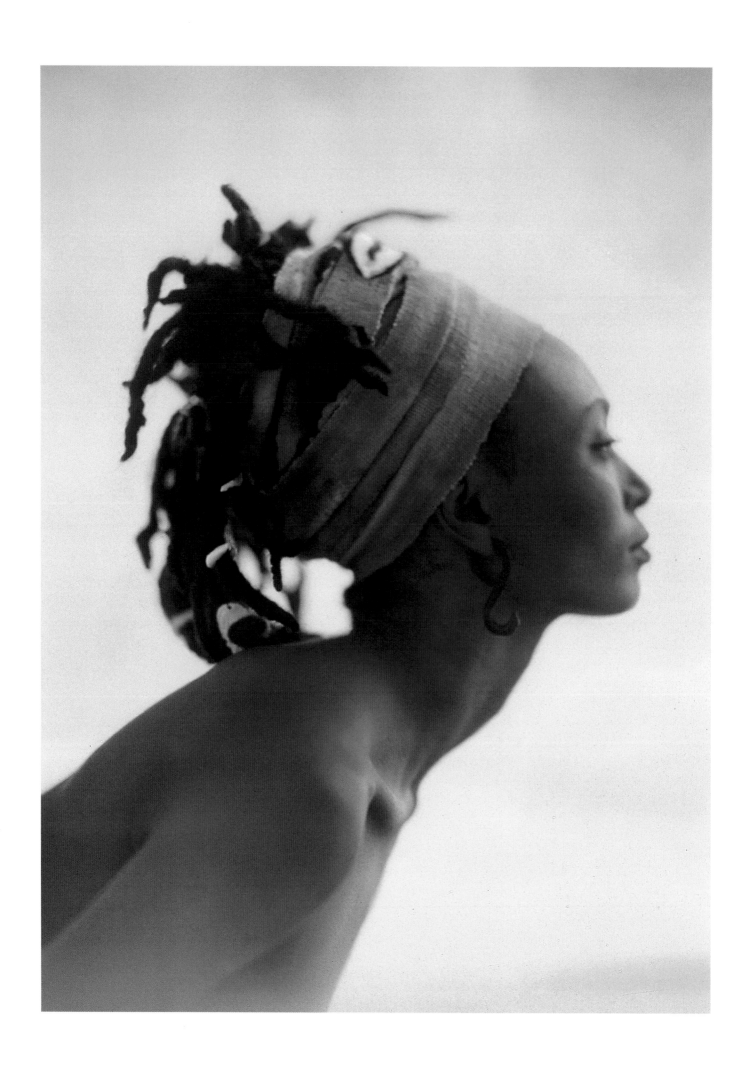

Jim Erickson

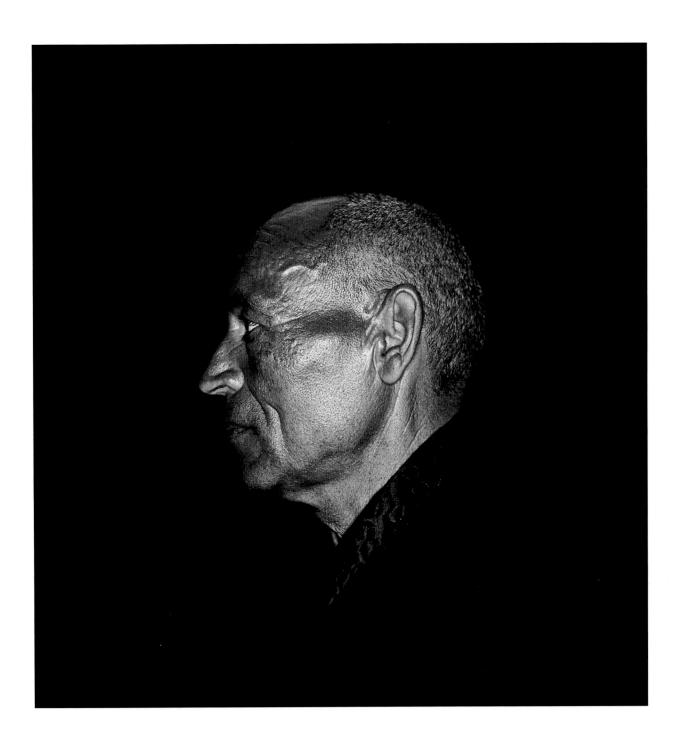

Debra McClinton

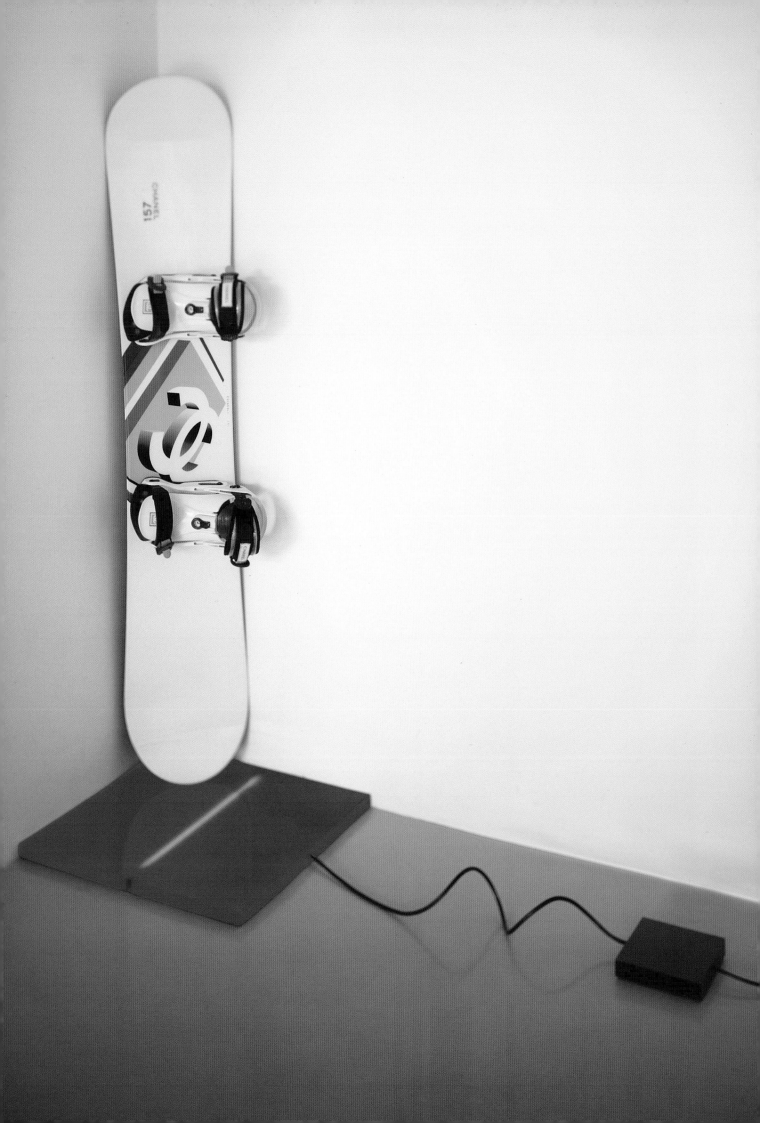

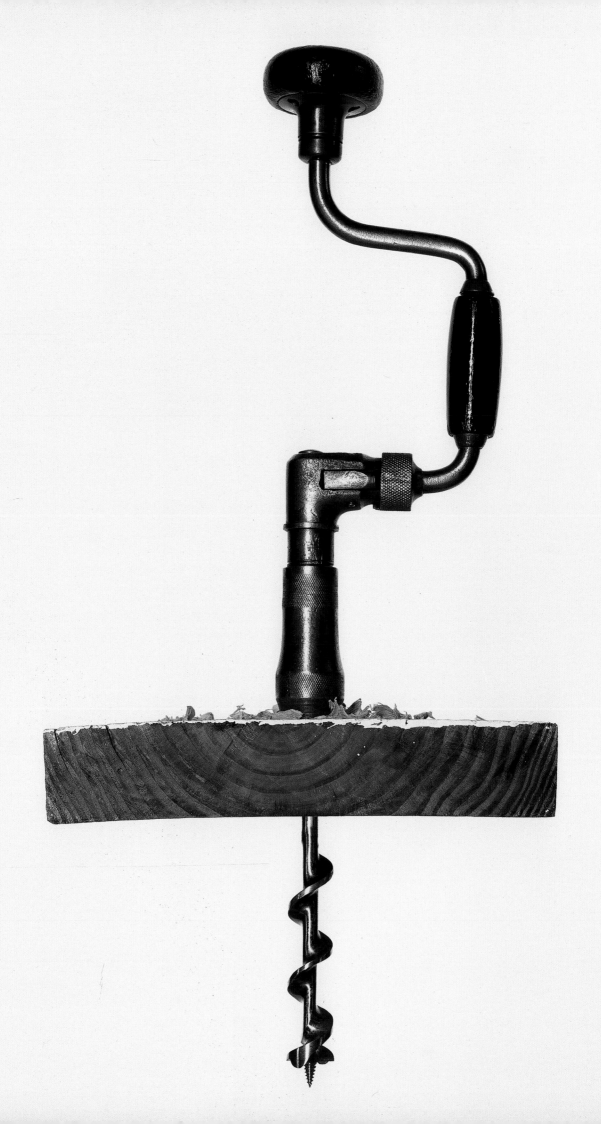

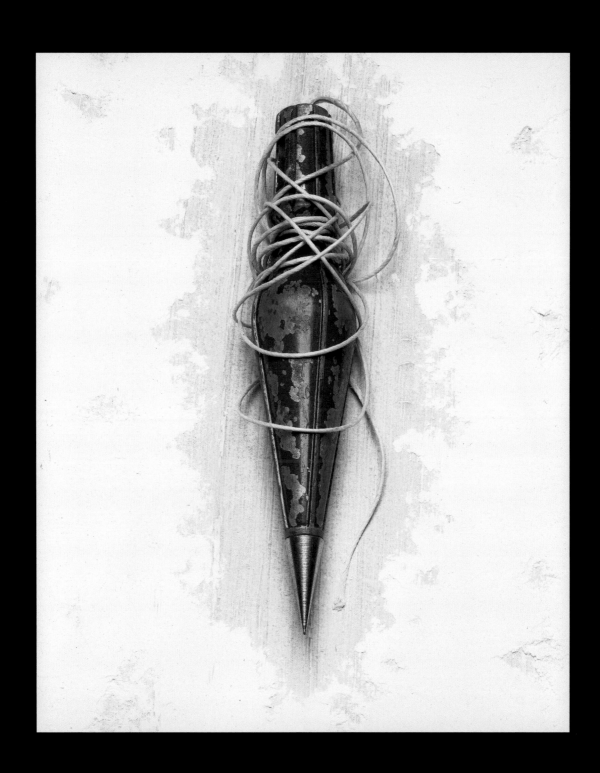

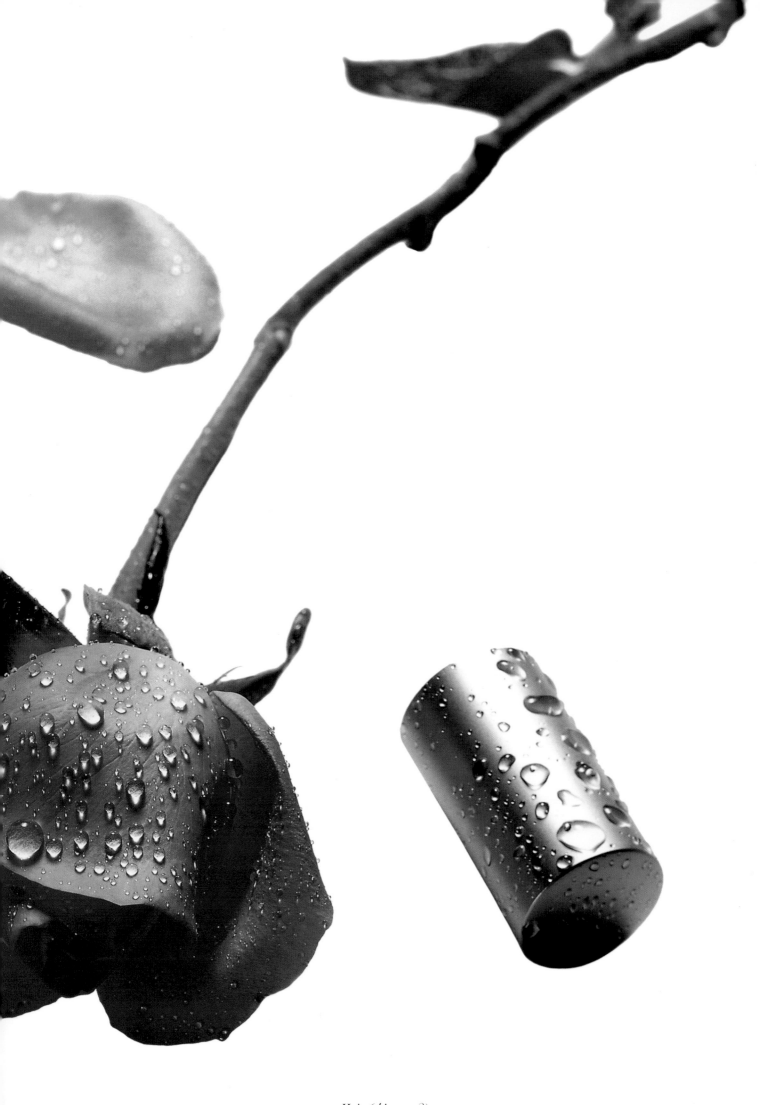

Haig (this spread)

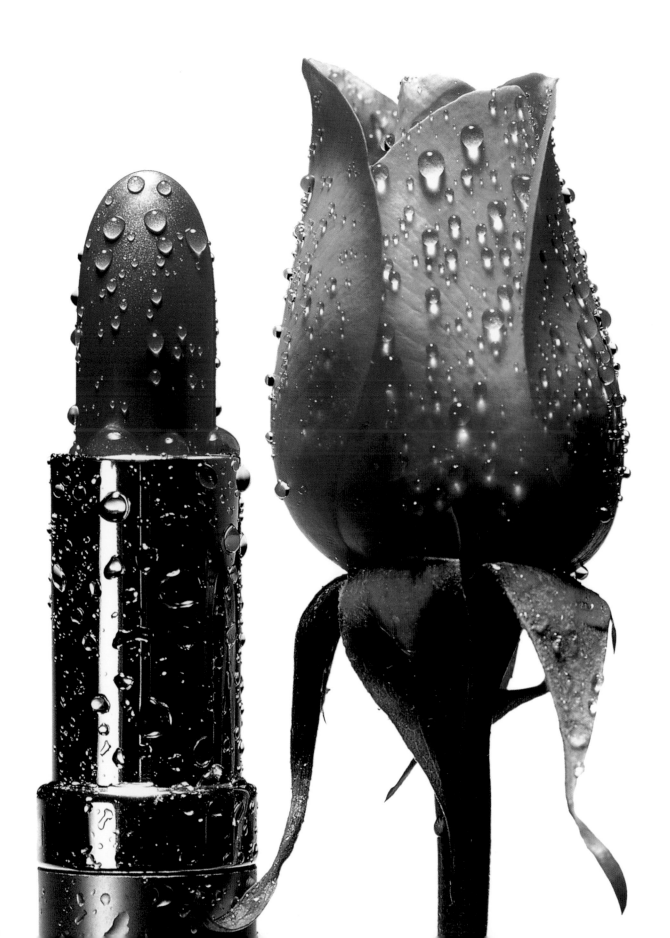

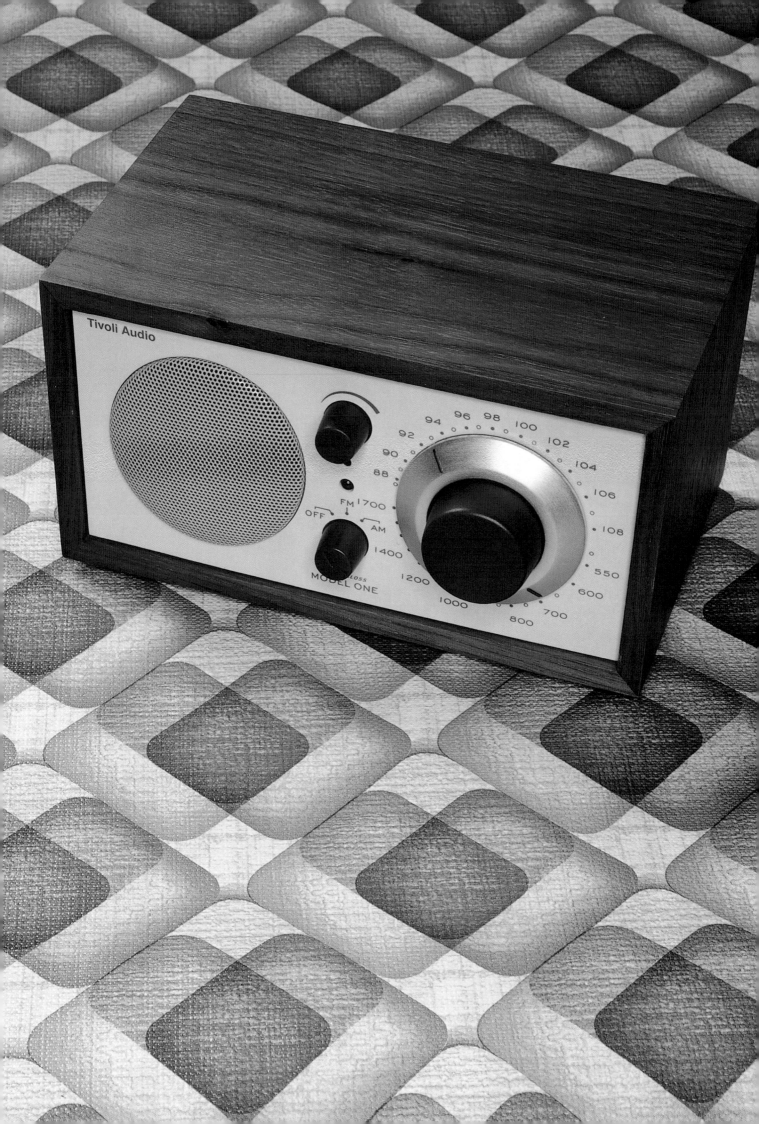

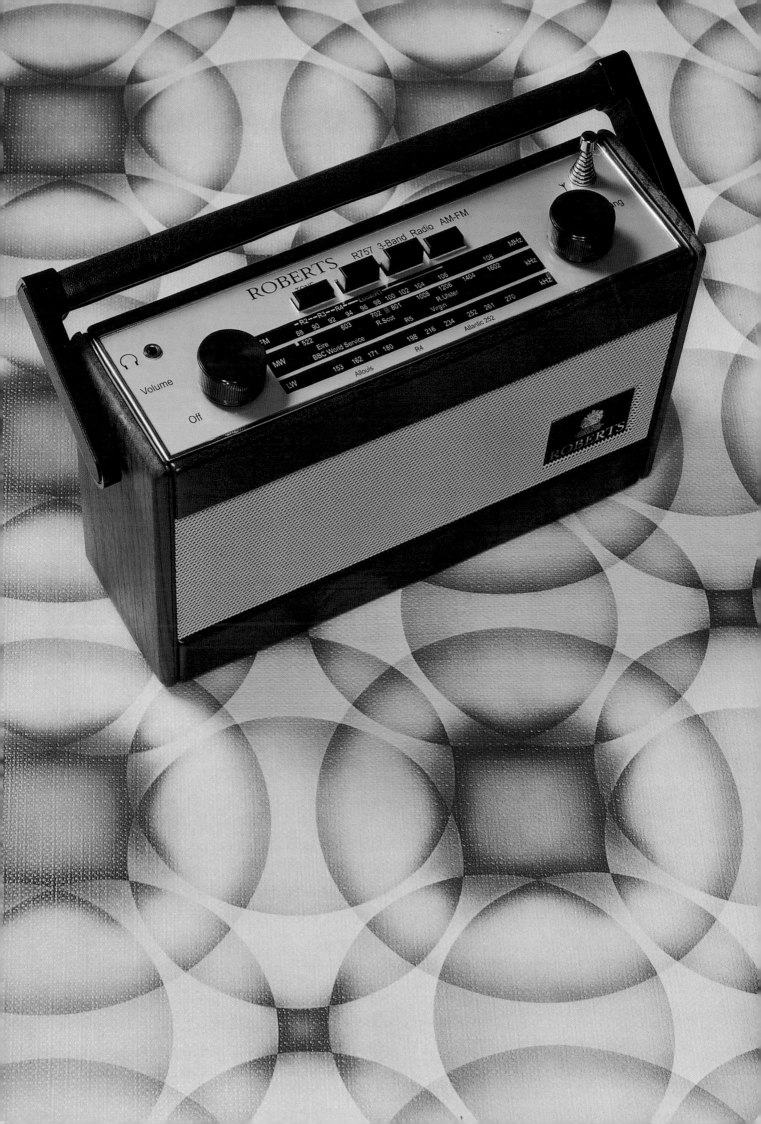

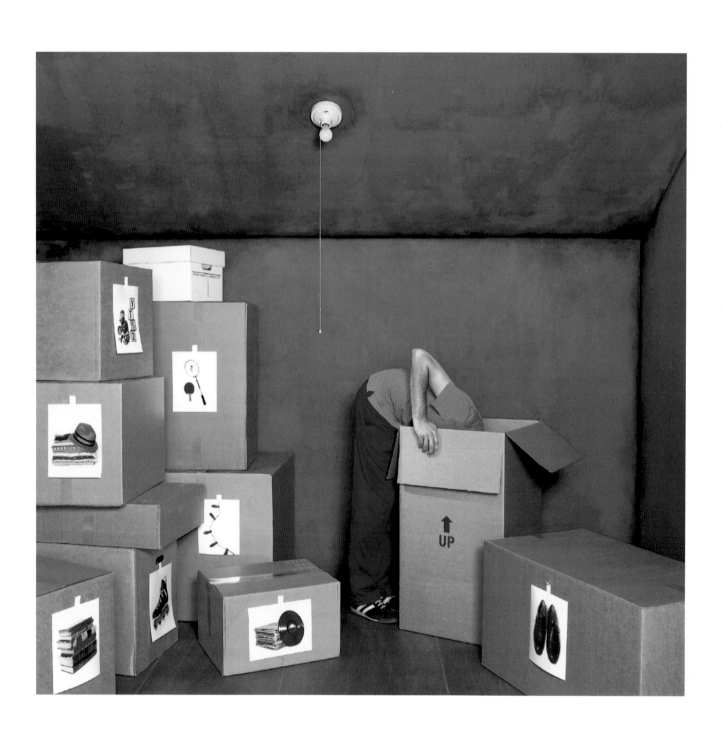

(previous spread) Jonathan Knowles, (this spread) Zachary Scott

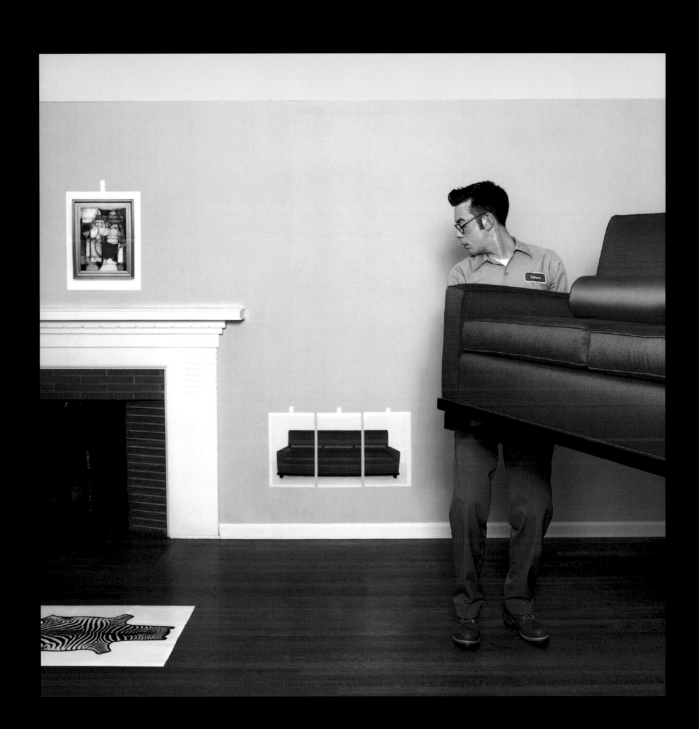

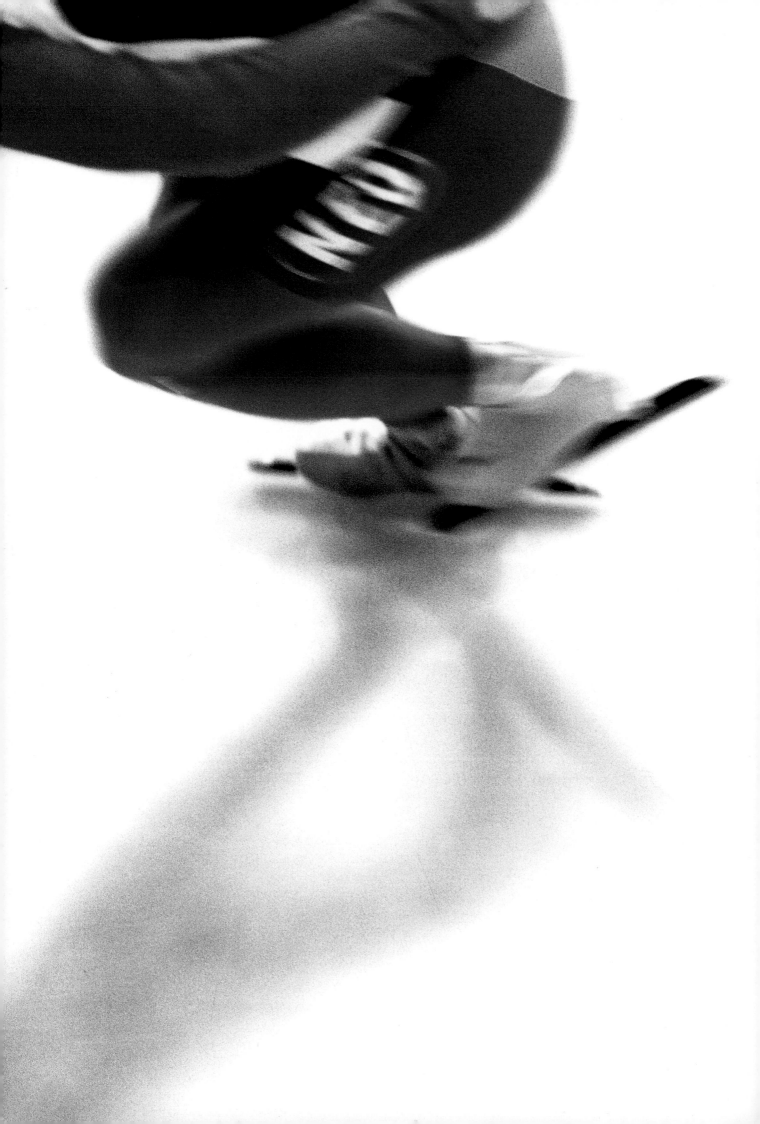

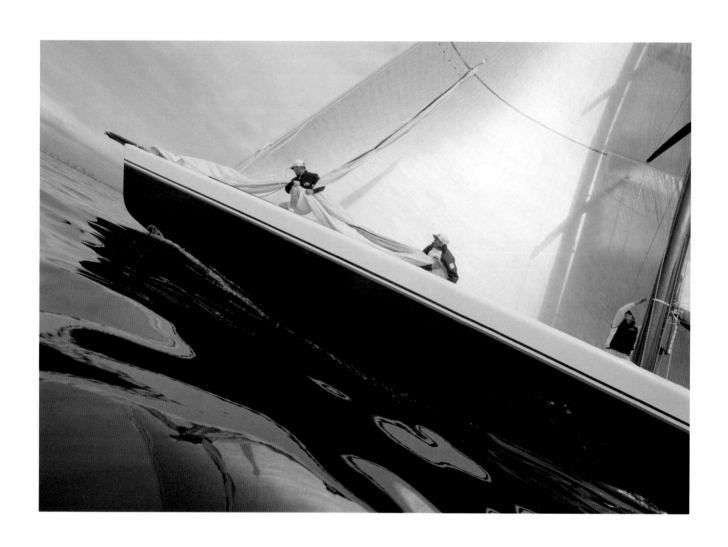

John Huet (opening page), Clint Clemens (this spread)

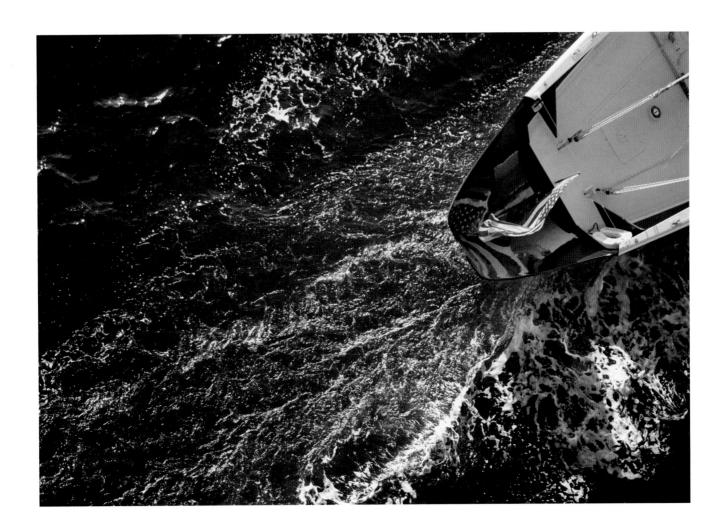

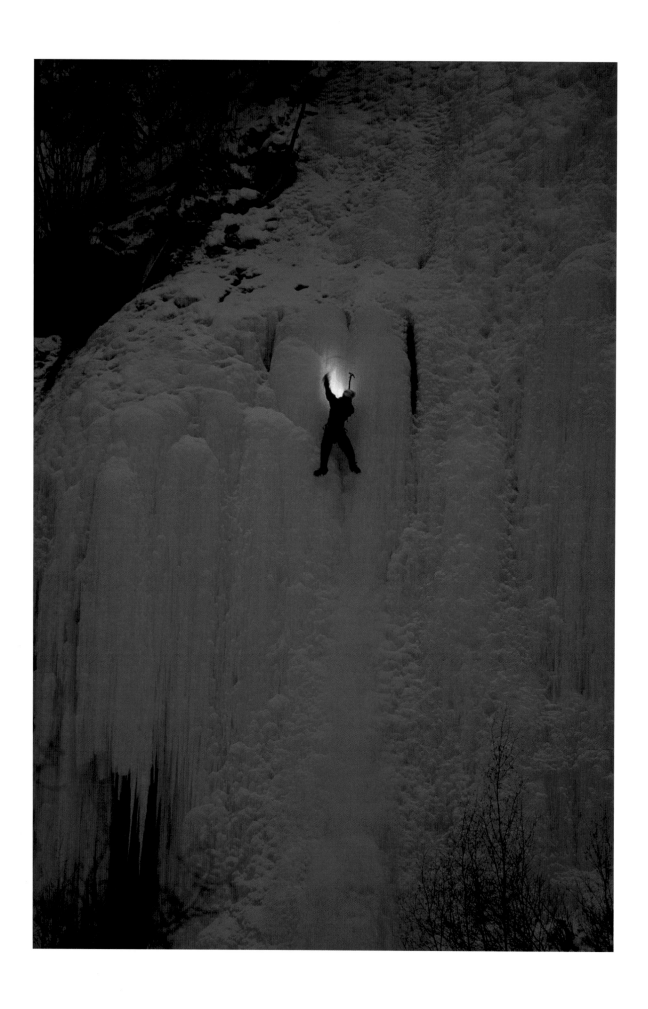

Paolo Marchesi (this page), David Foster (right page)

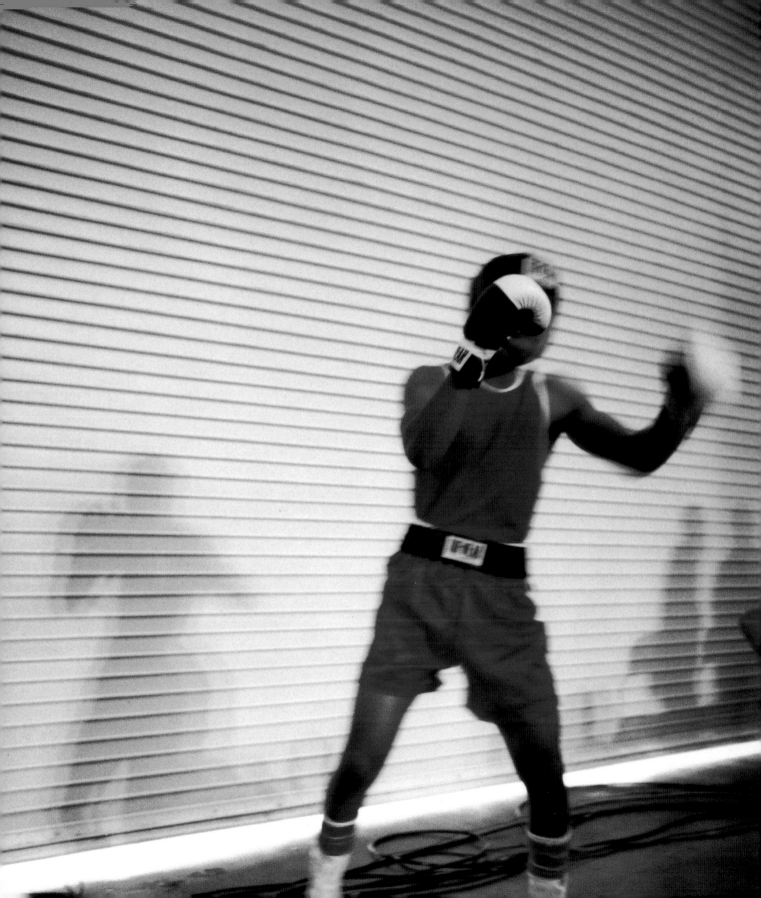

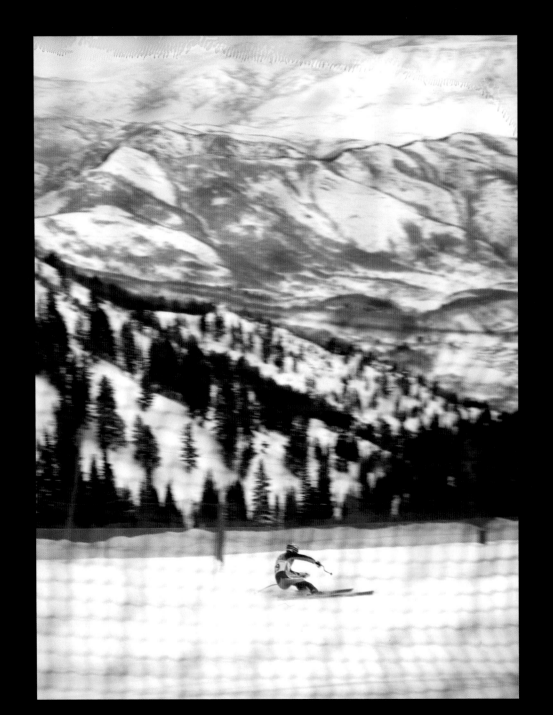

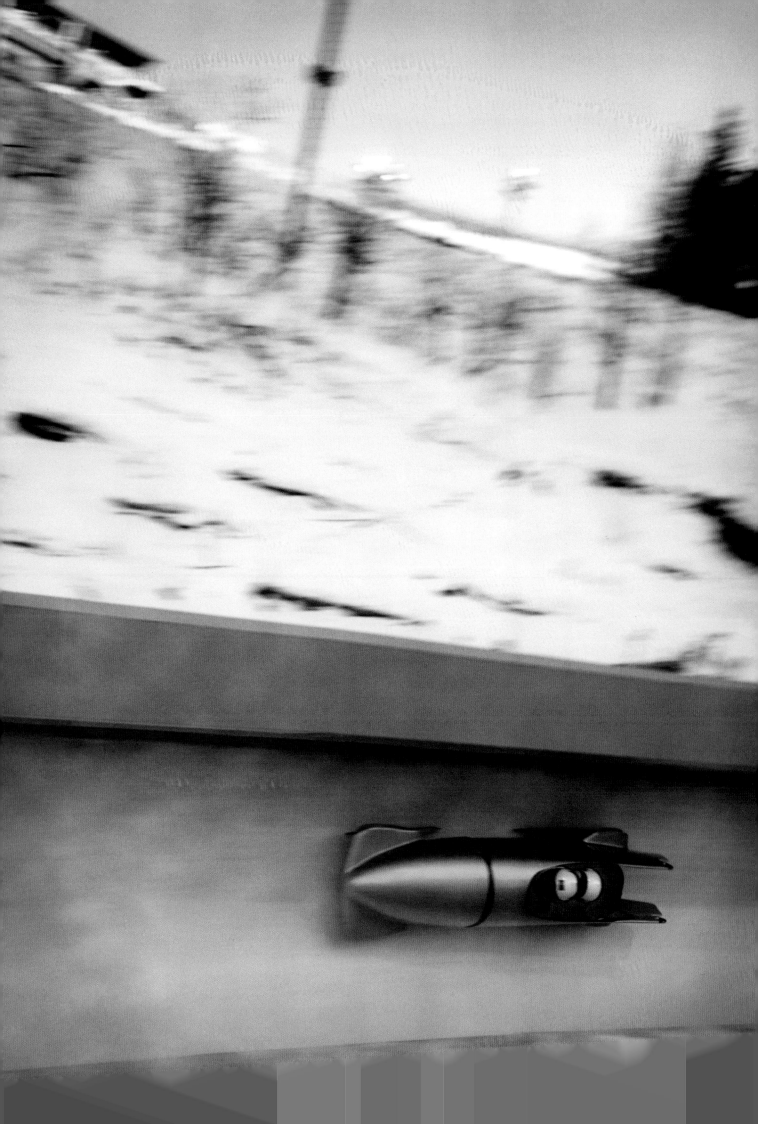

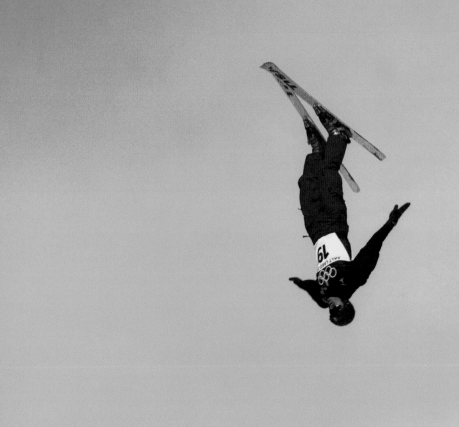

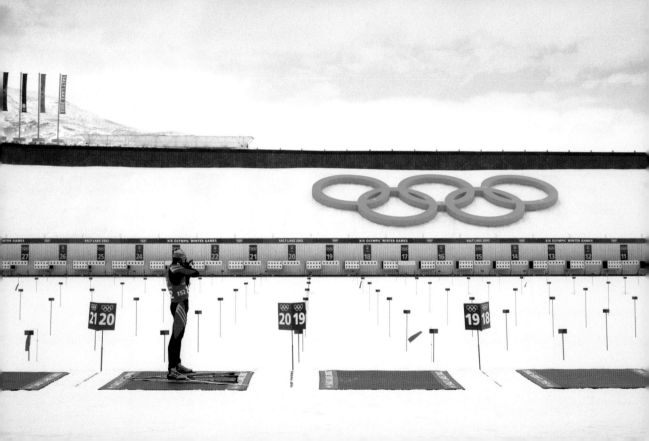

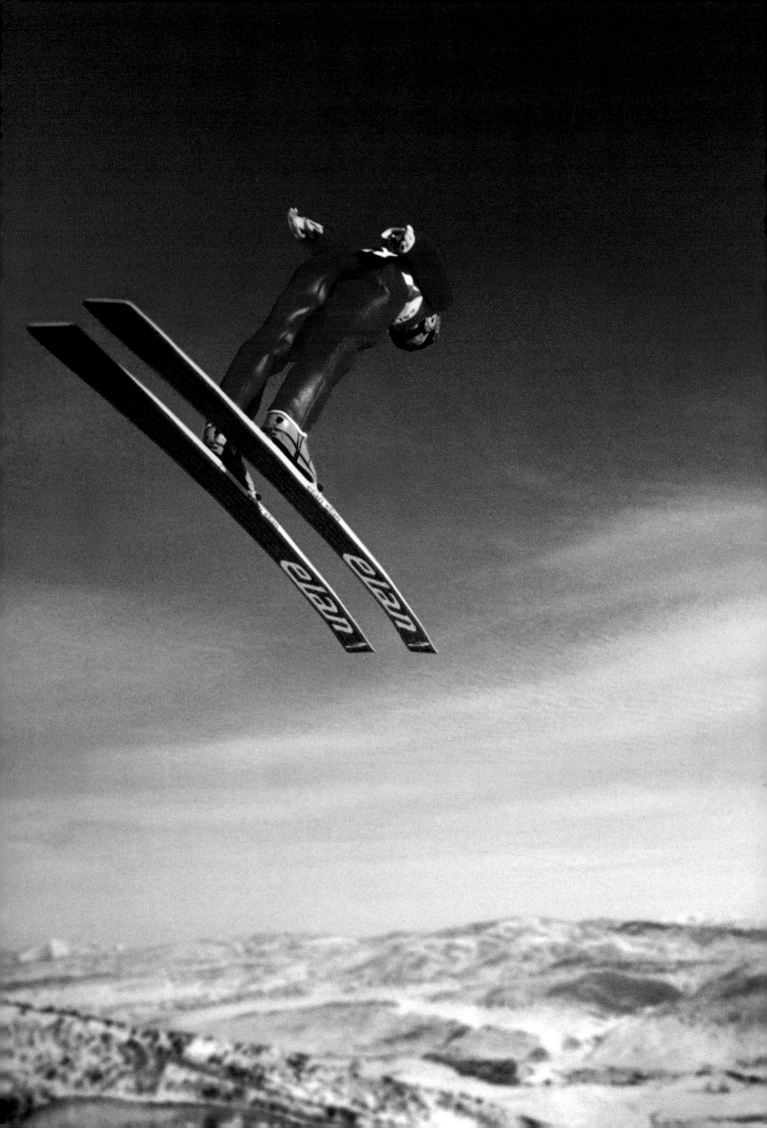

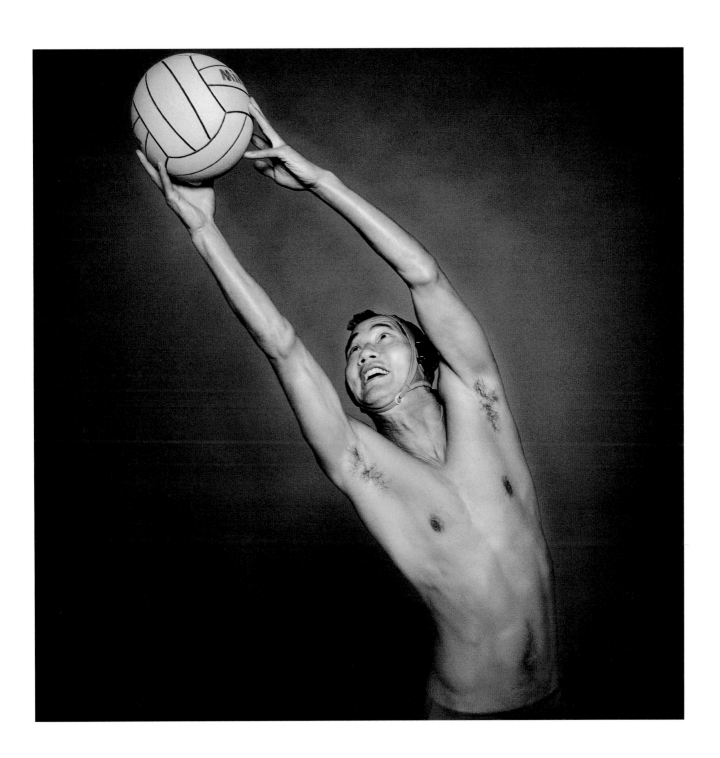

Clint Clemens (left page), joSon (this page)

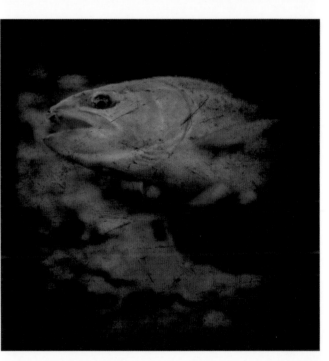

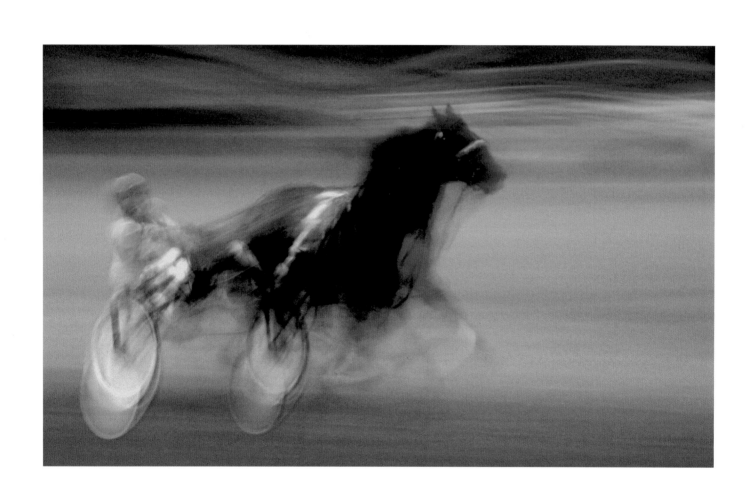

Marilyn Miller (this page), Terry Vine (right page)

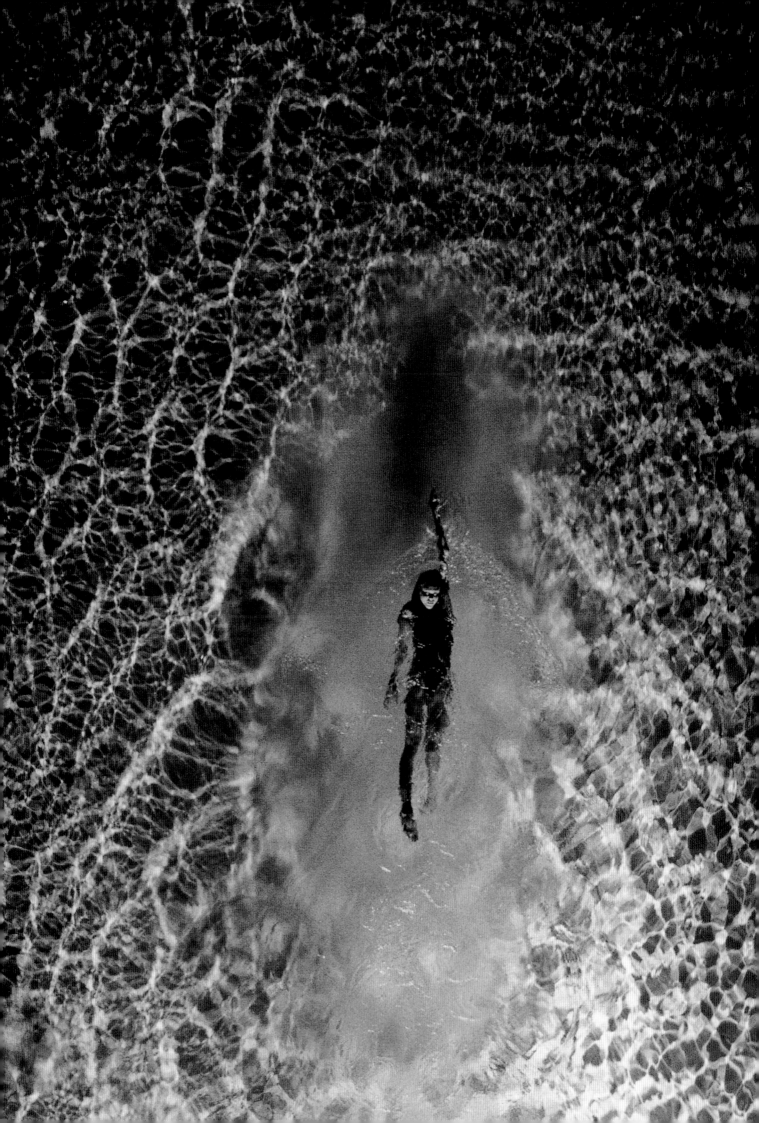

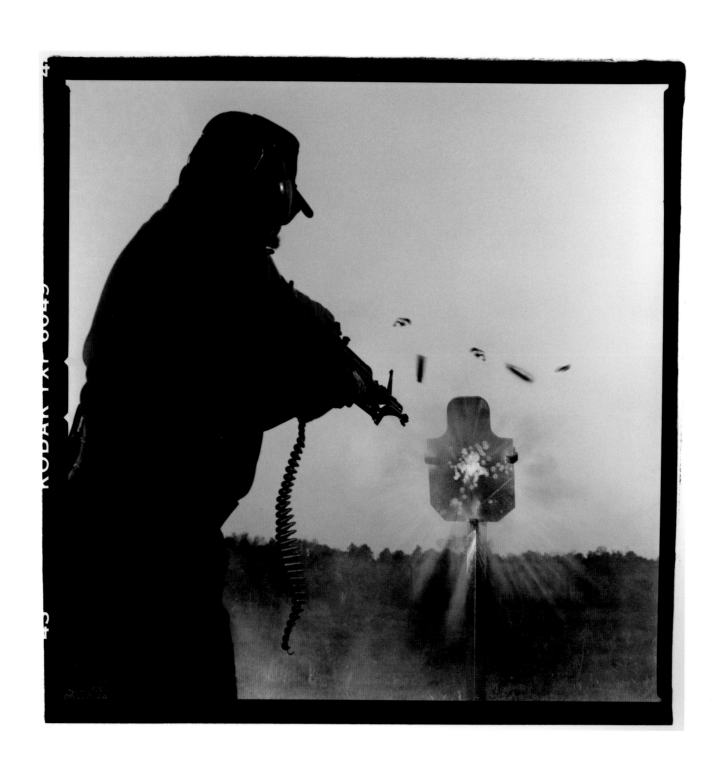

James Salzano (this page), Doug Lanoreth (right page)

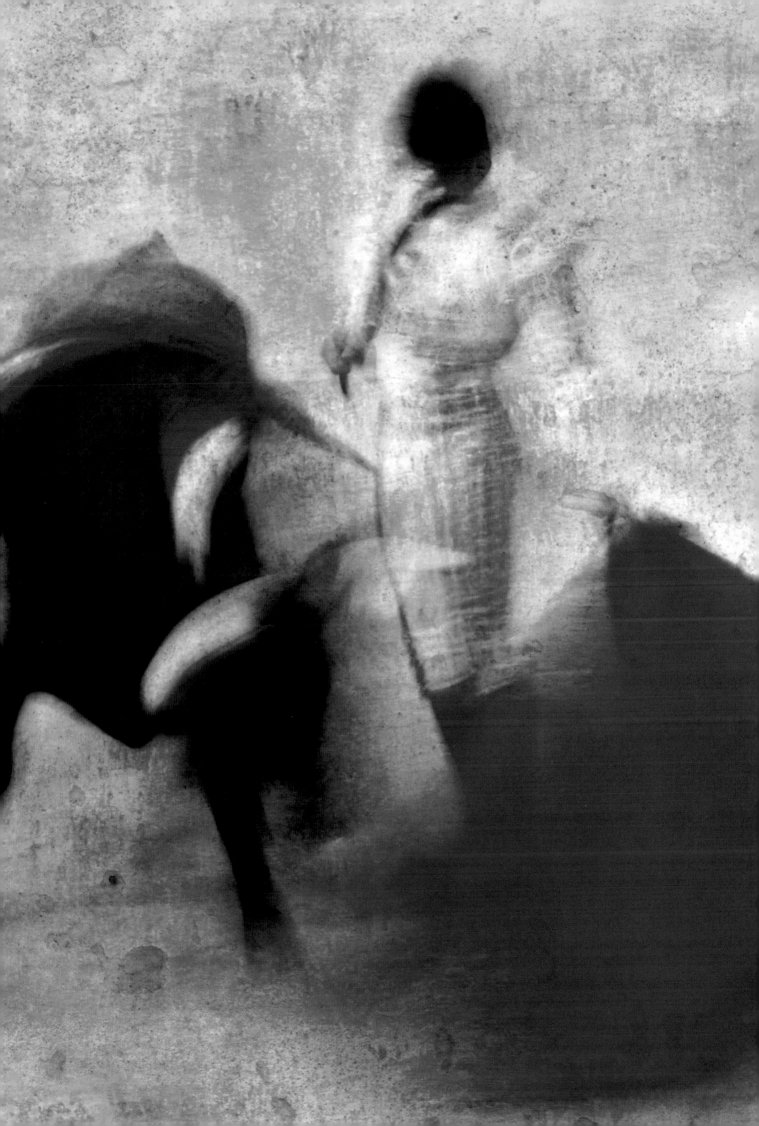

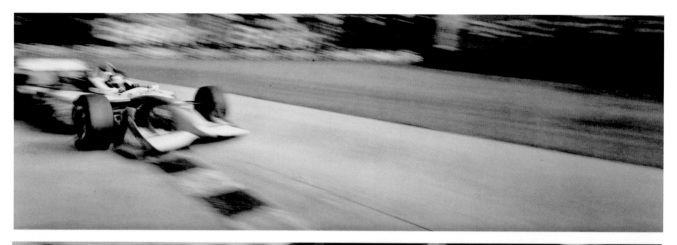

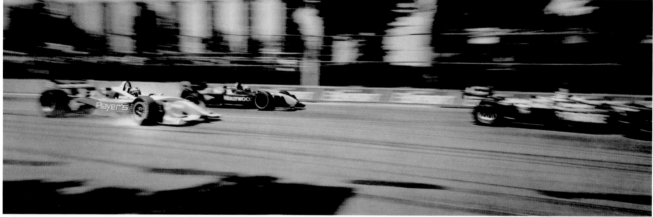

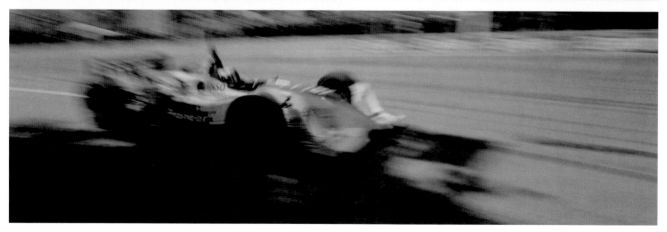

Peter A. Sellar

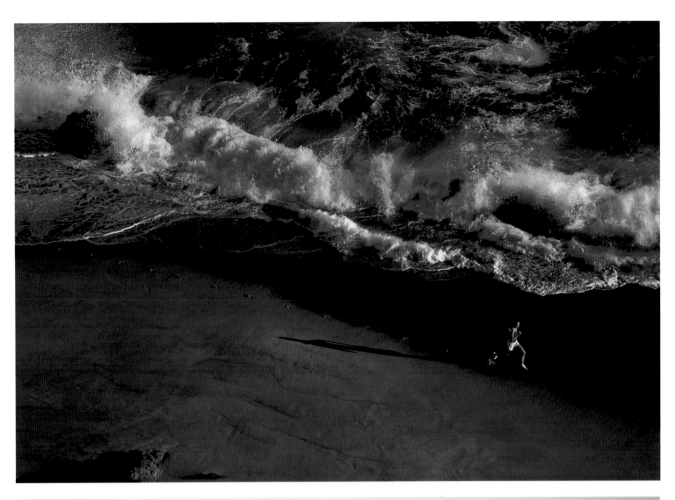

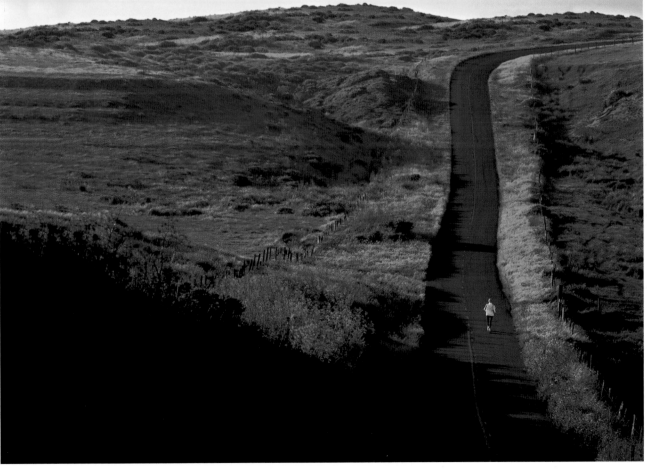

Robert Mizono

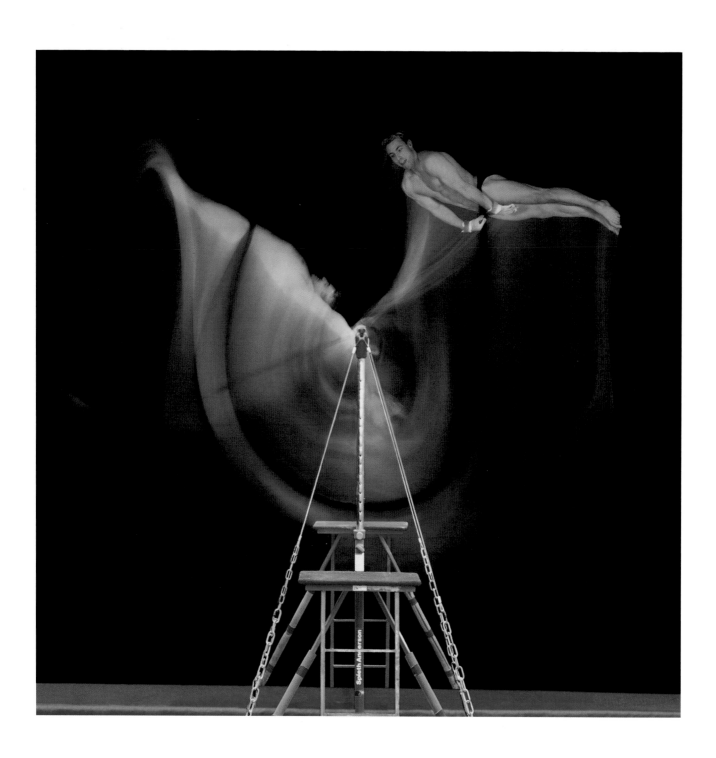

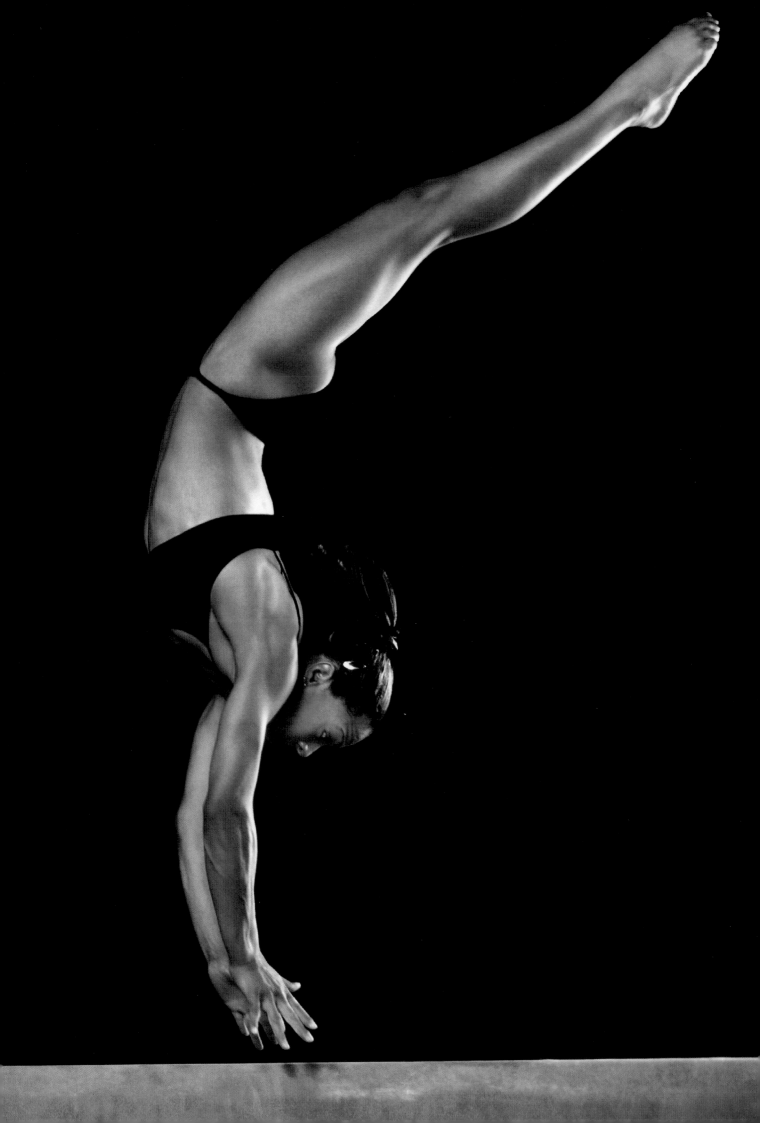

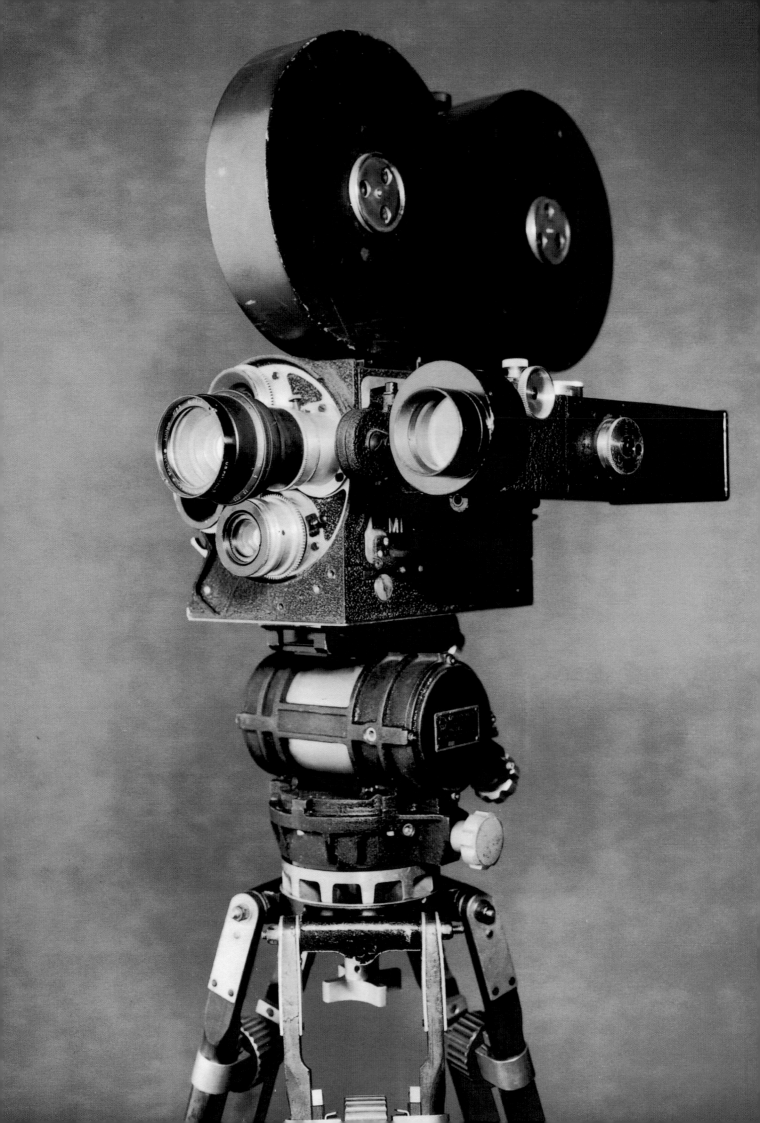

Craig Cutler (opening page and this spread)

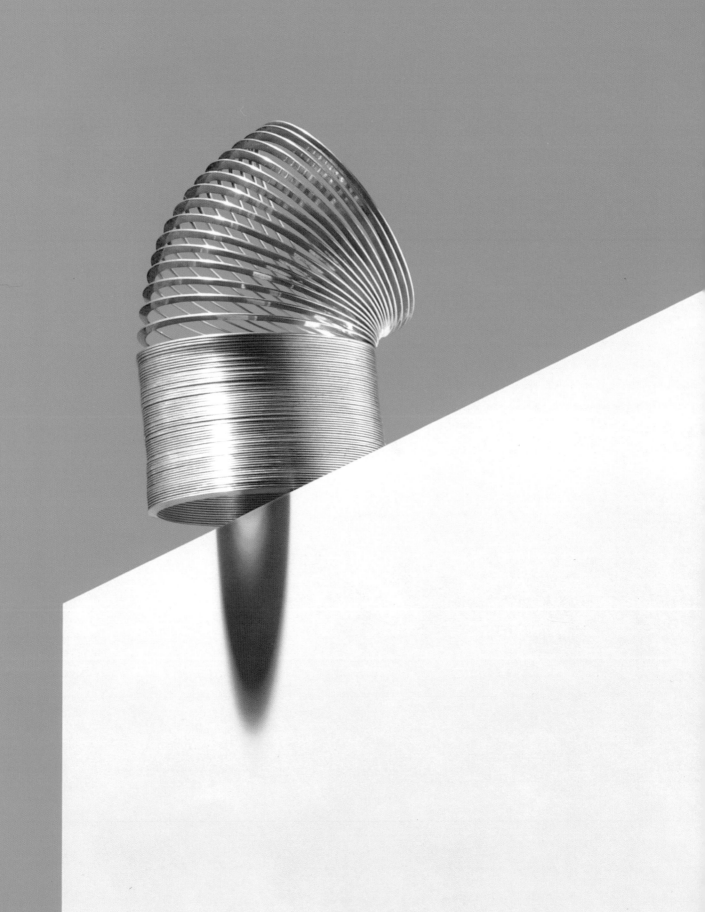

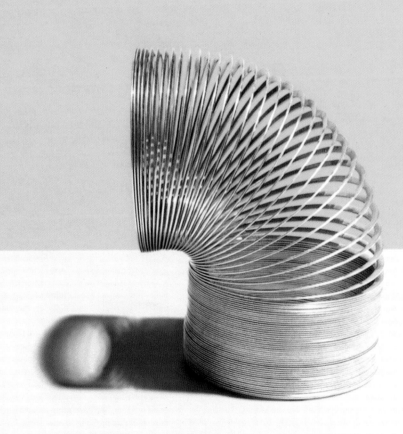

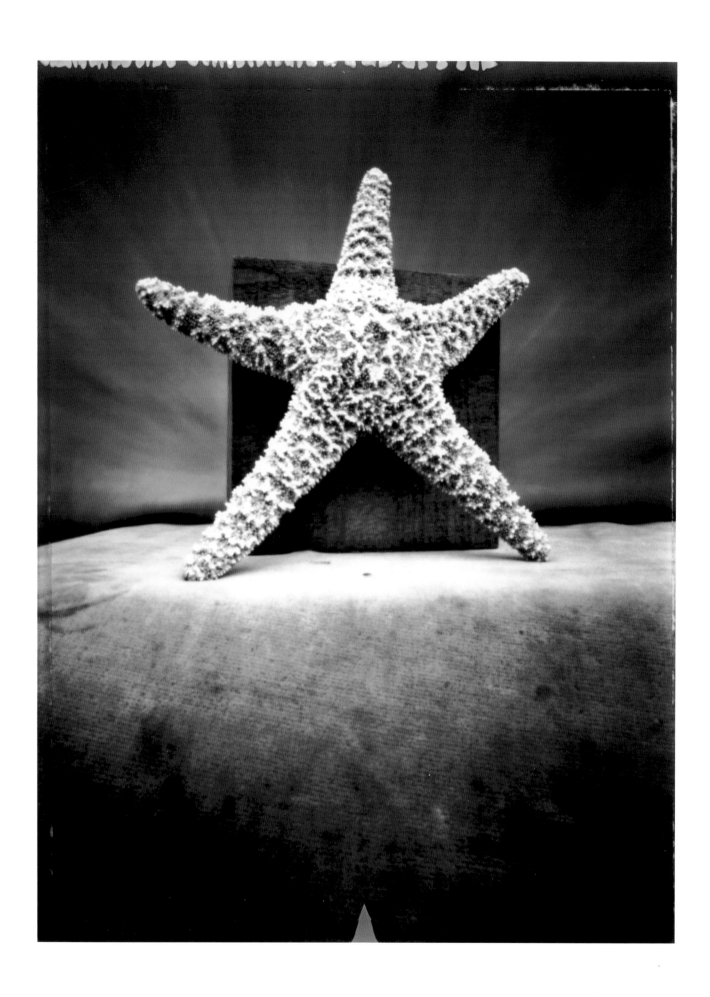

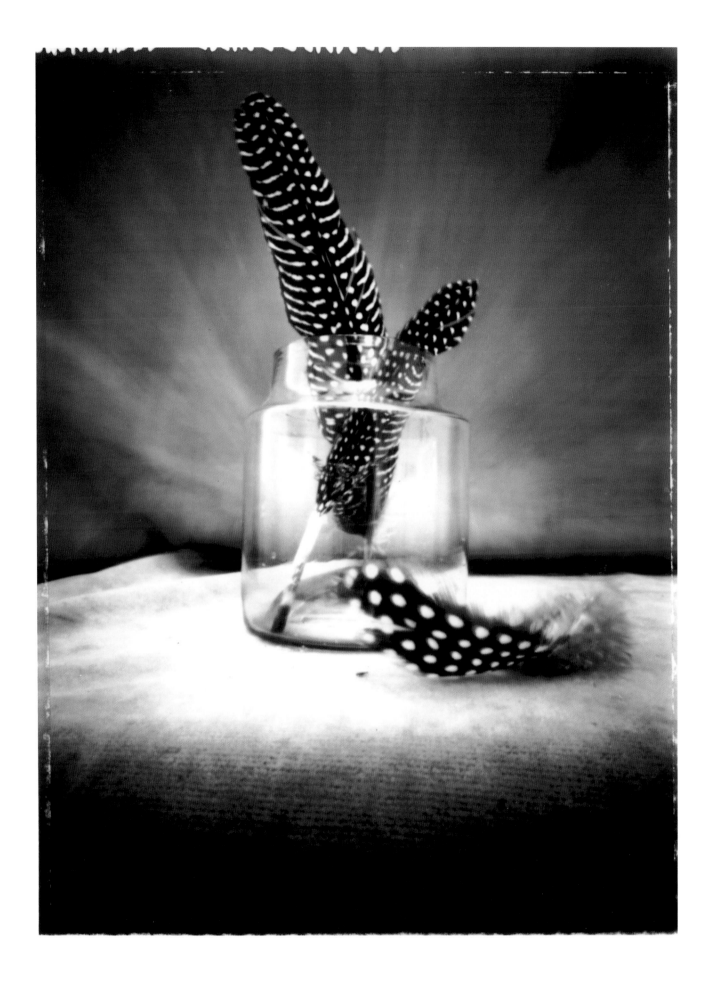

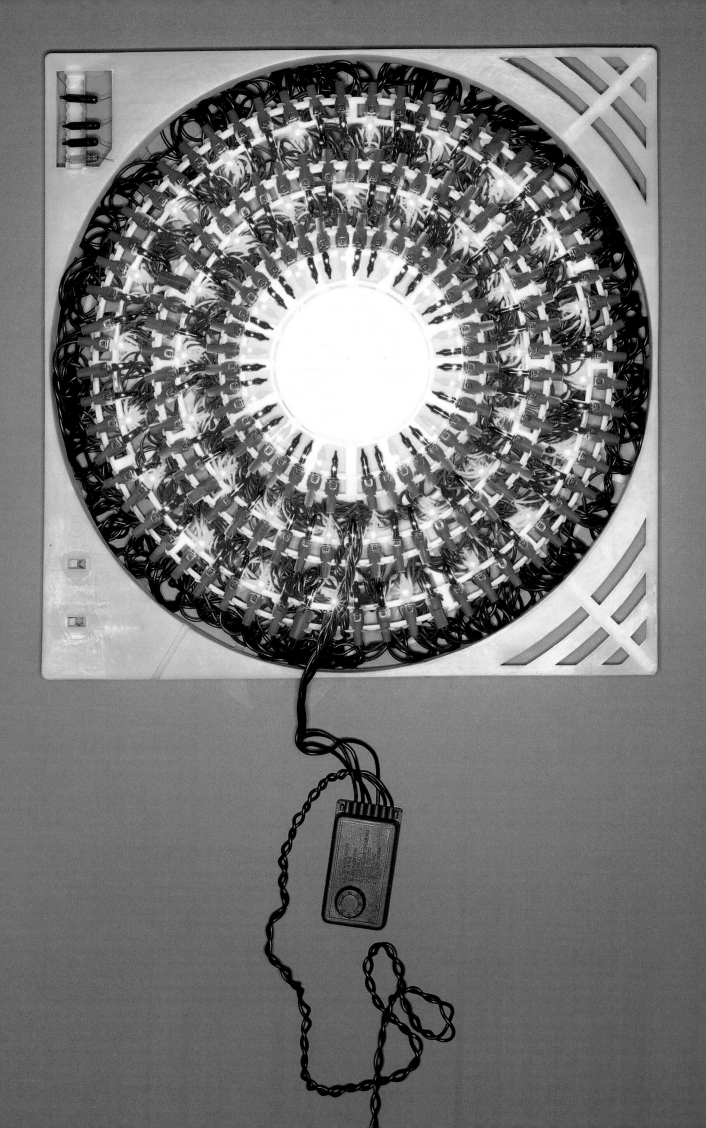

Craig Cutler (this spread)

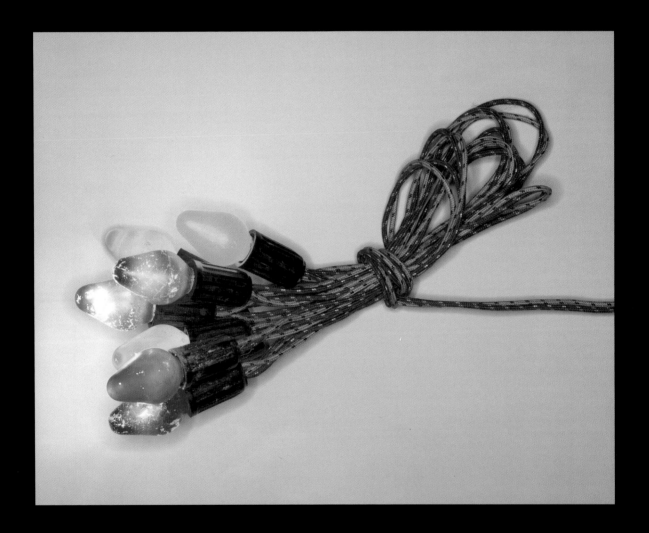

Craig Cutler (this spread)

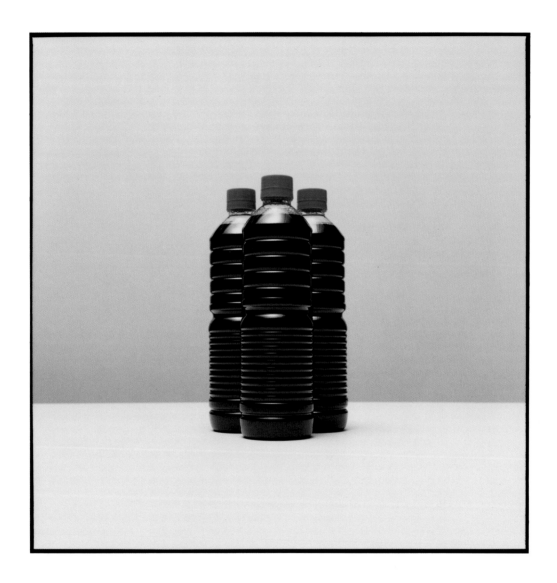

Craig Cutler

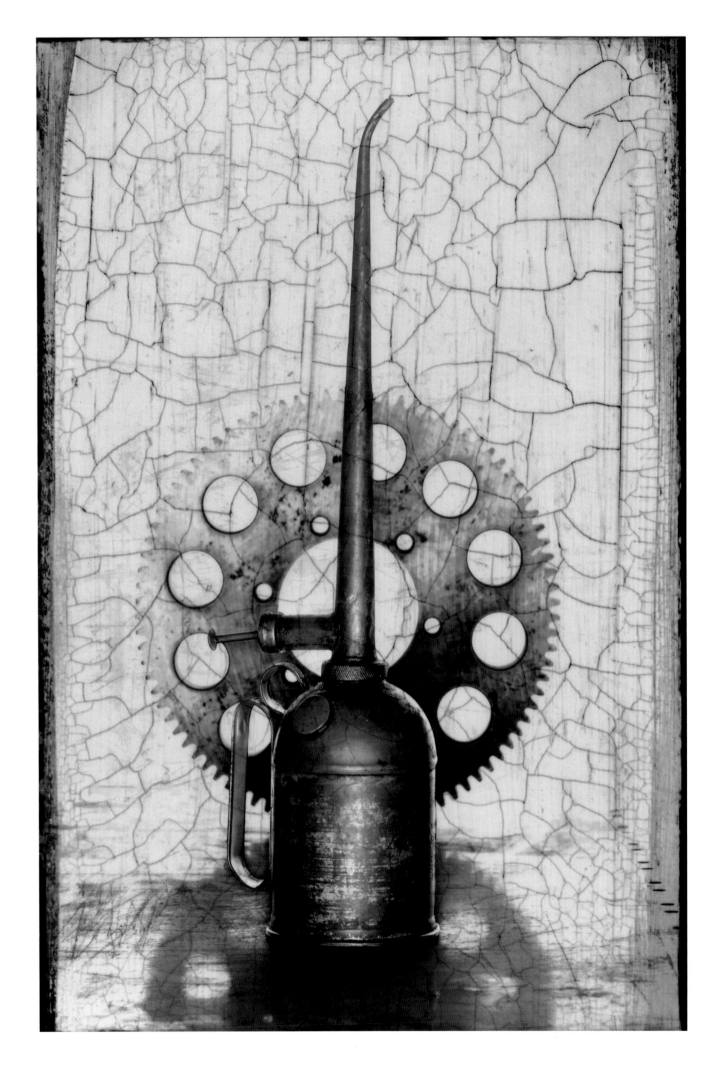

Doug Landreth

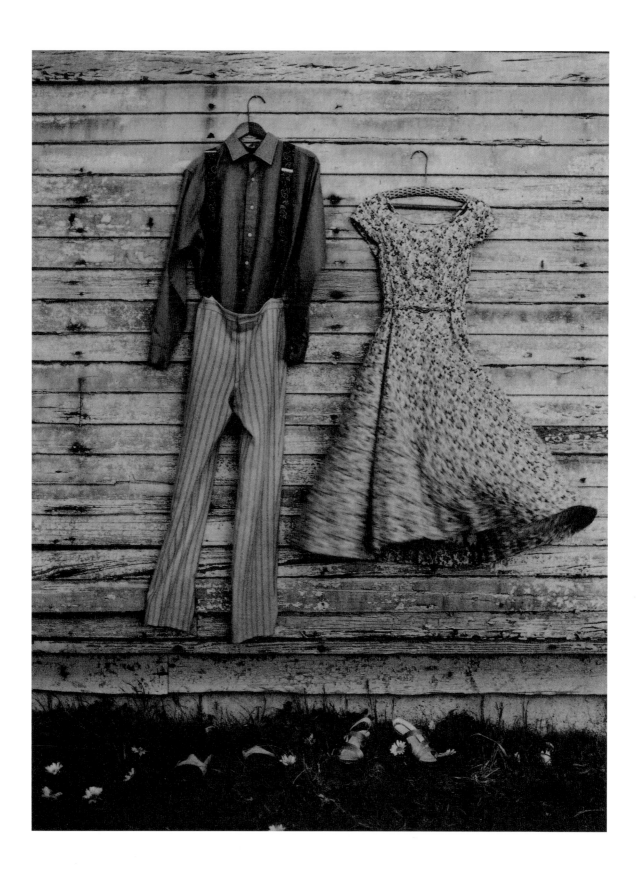

Debra McClinton (this spread), Terry Vine (following spread)

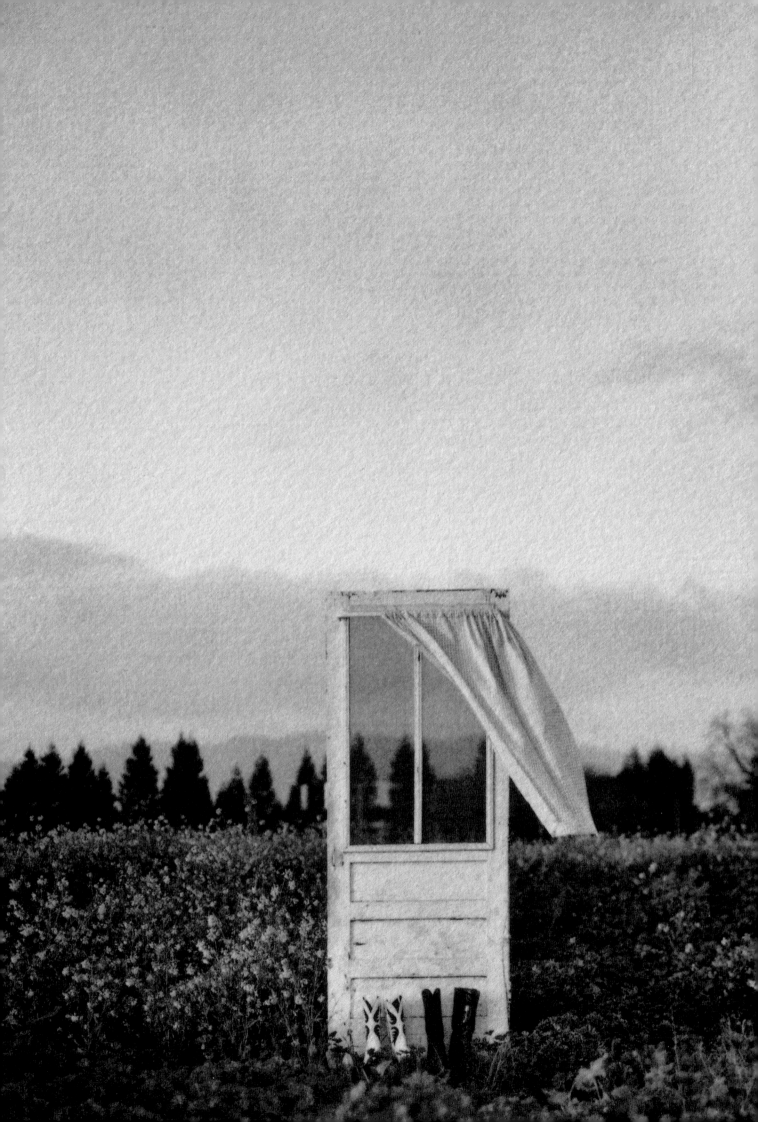

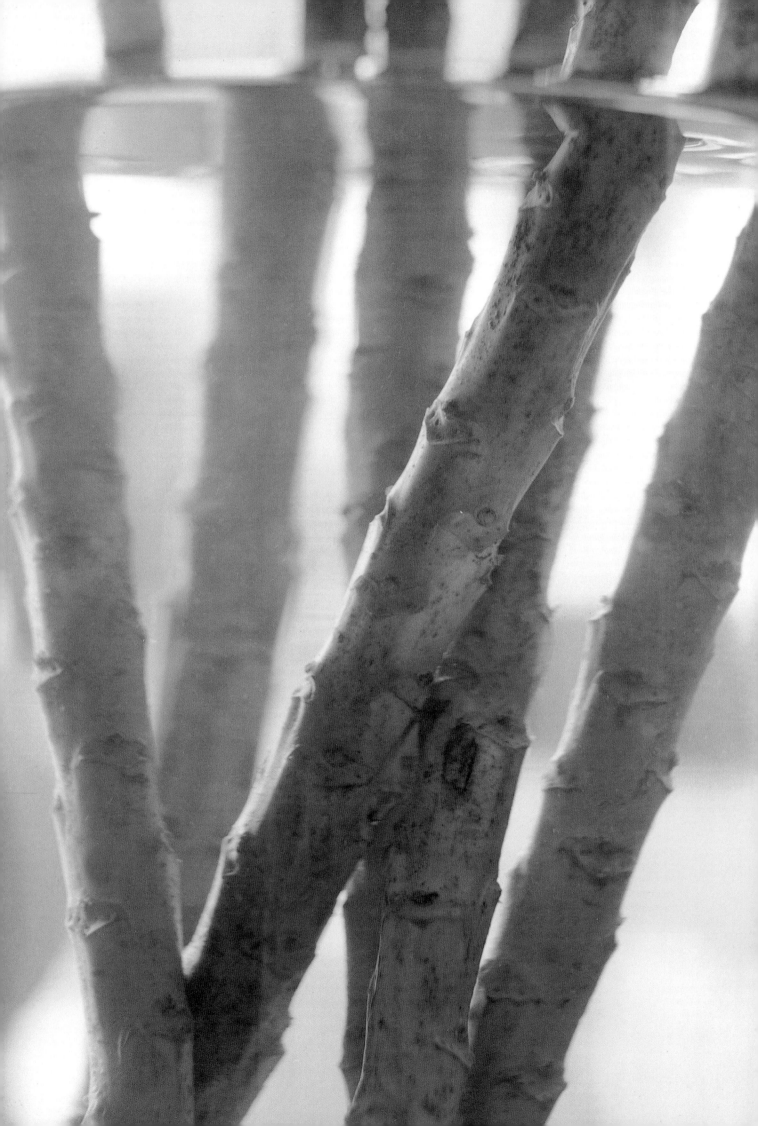

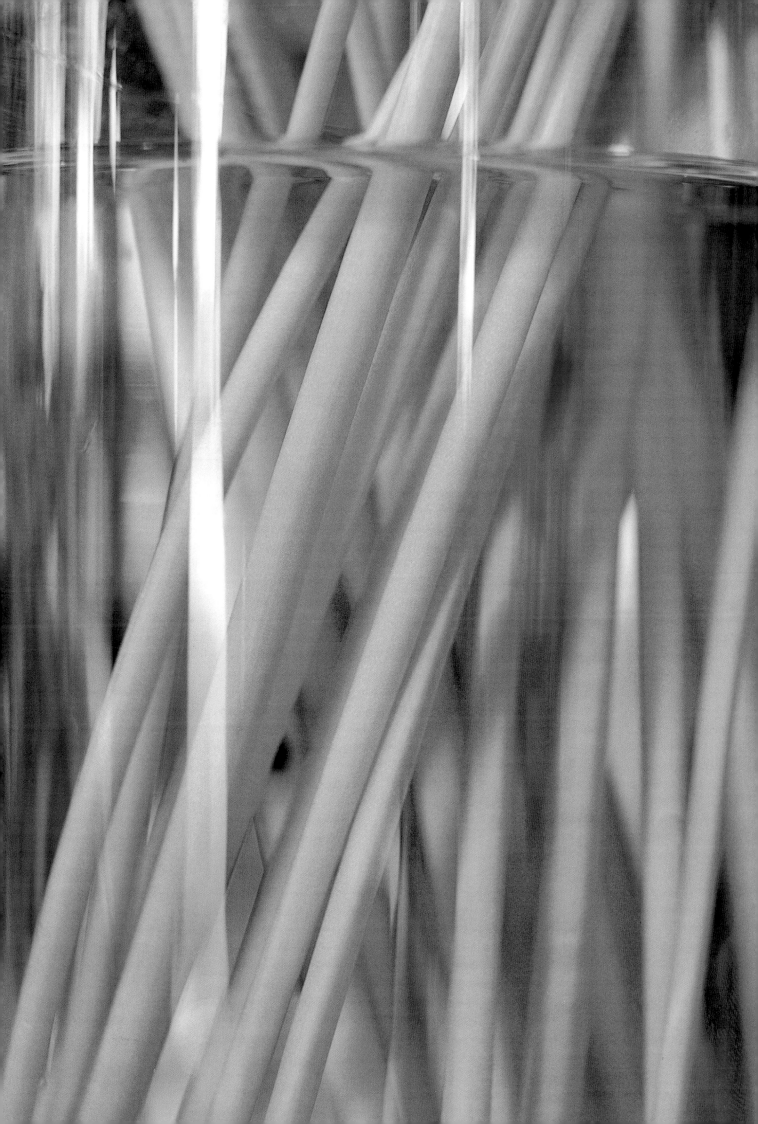

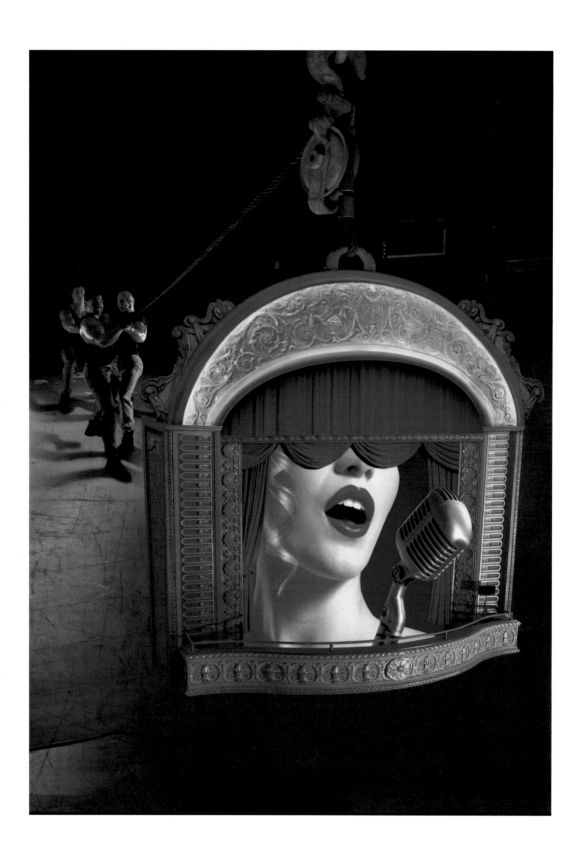

Doug Landreth (this page), Don Carstens (right page)

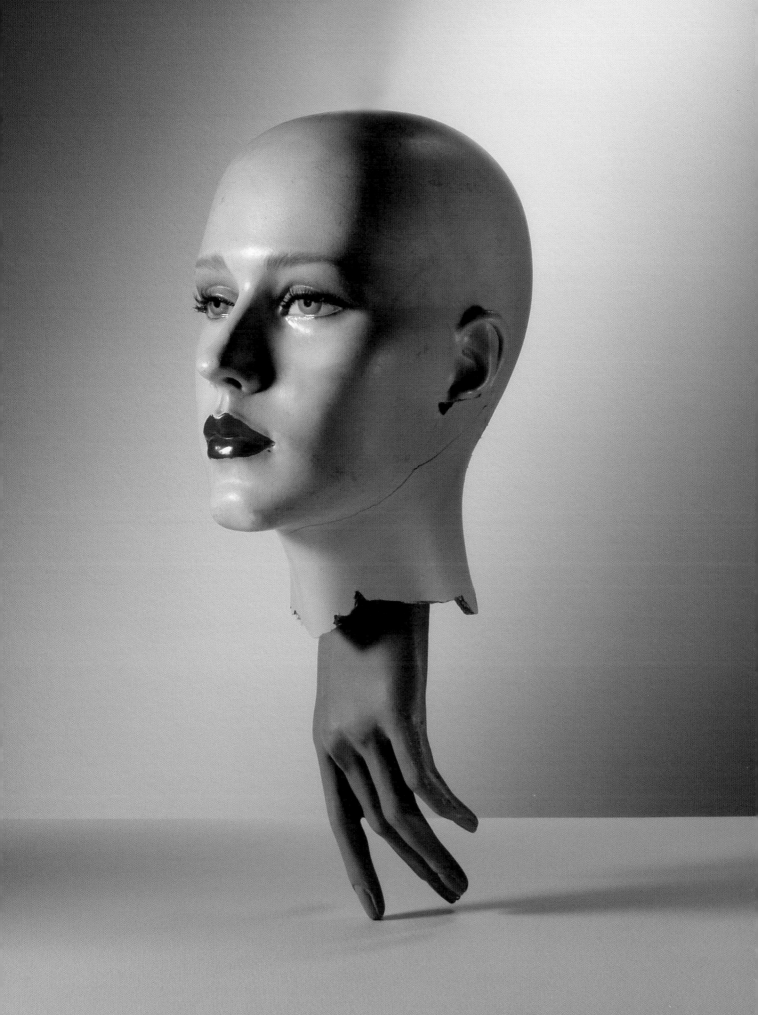

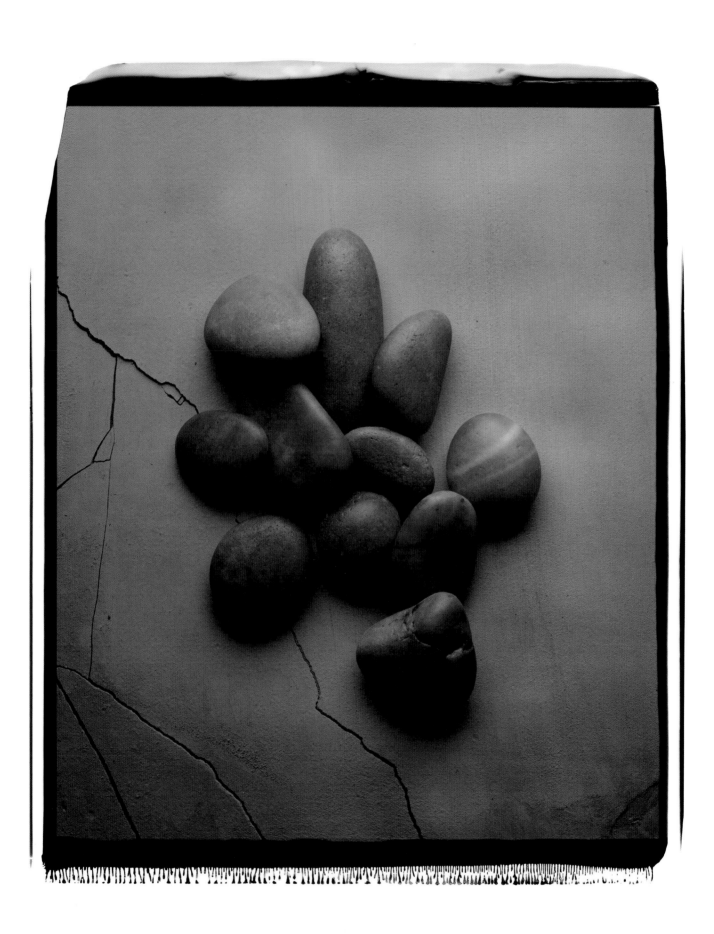

Mark Laita (this page), Ira Garber and Richard Fleischner (right page)

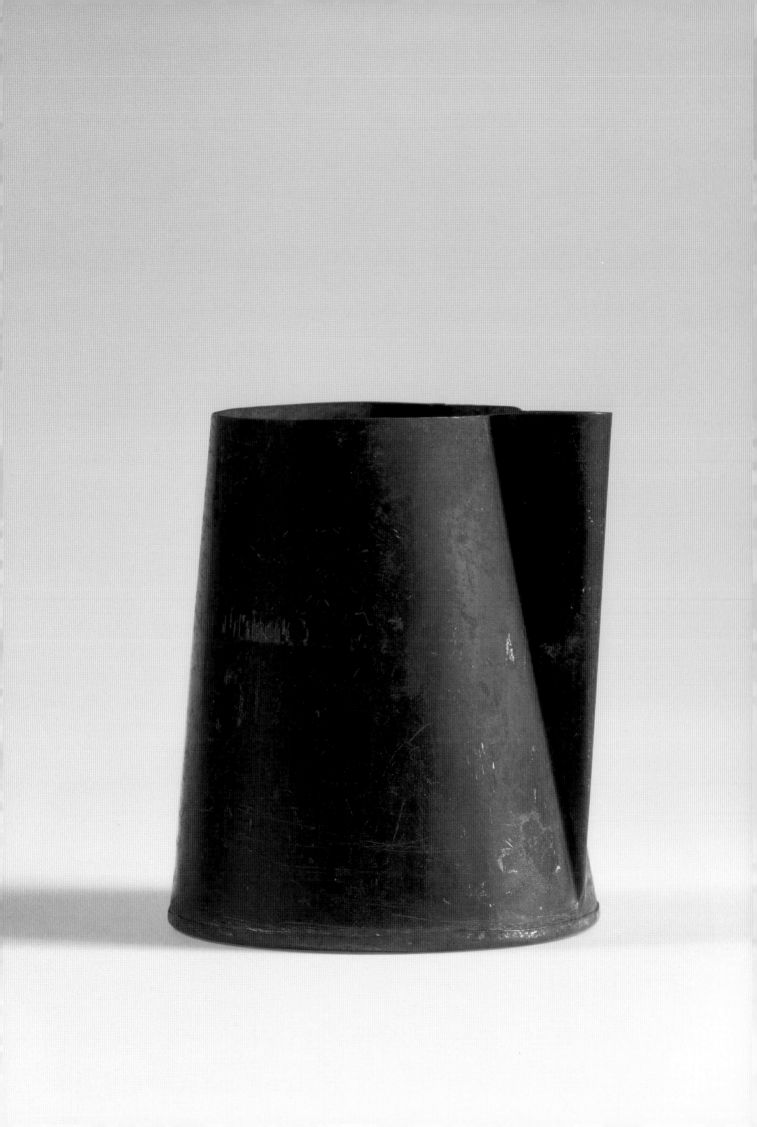

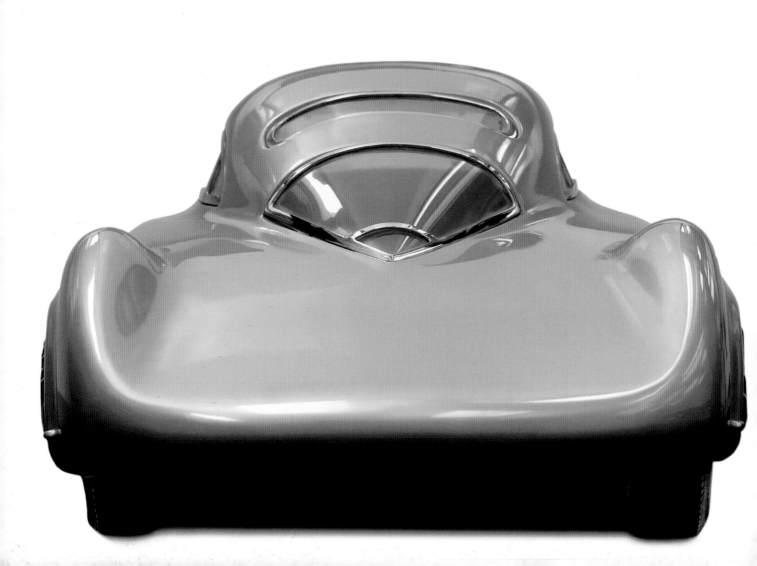

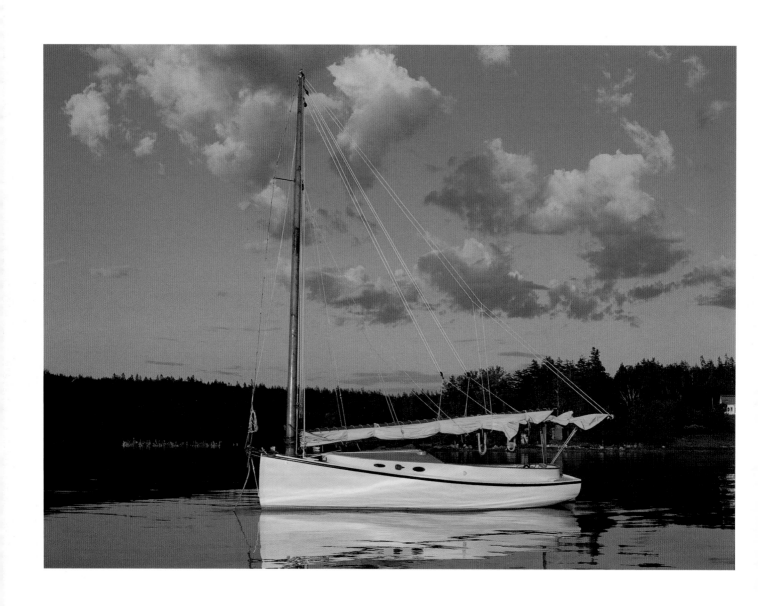

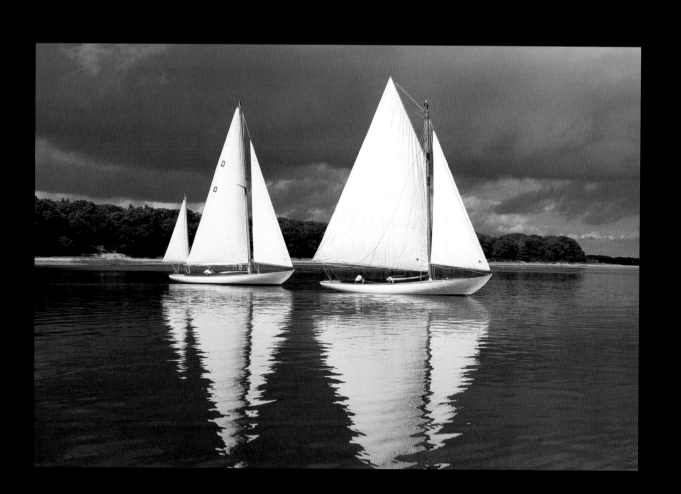

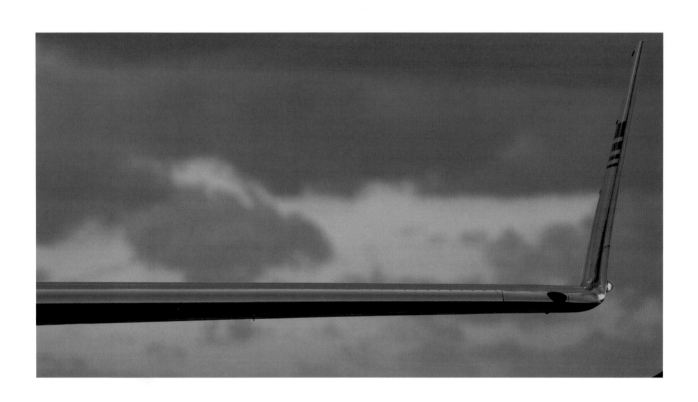

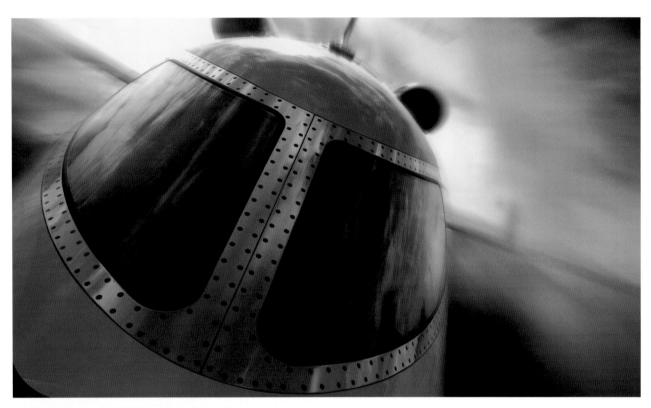

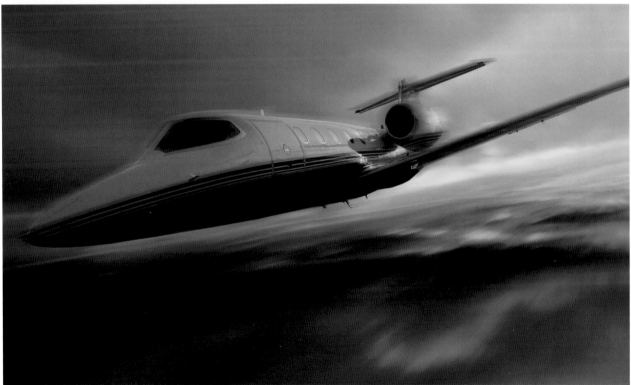

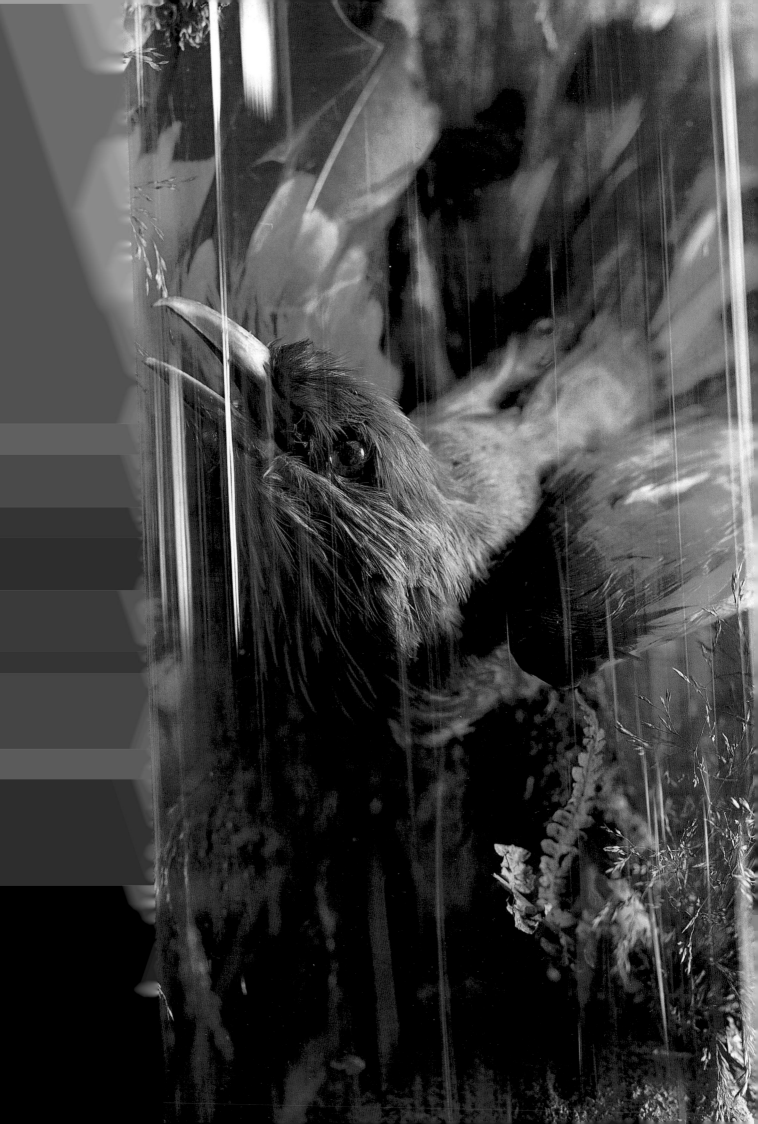

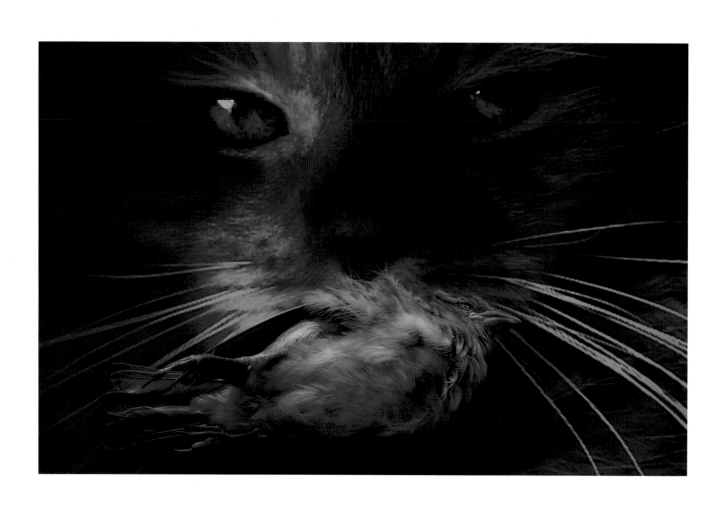

Stephan Abry (opening page), Phil Marco (this page)

Peter Dazeley

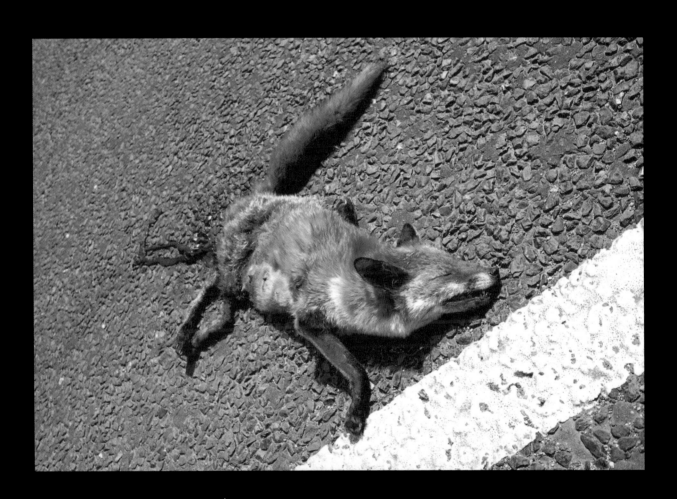

Peter Dazeley

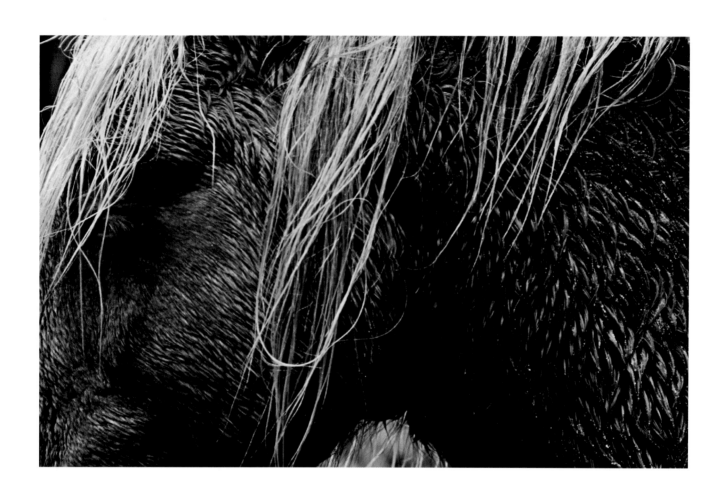

Rich Pomerantz

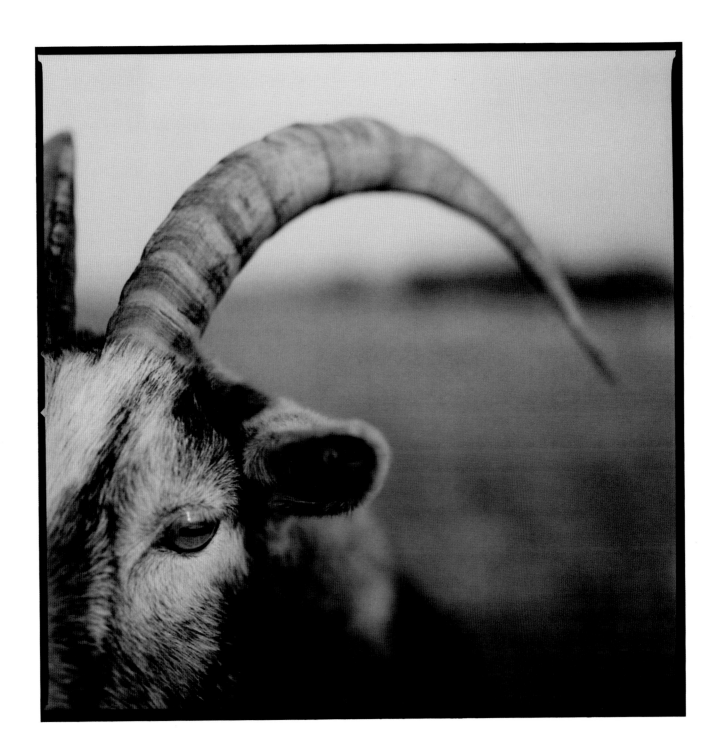

Paul Elledge

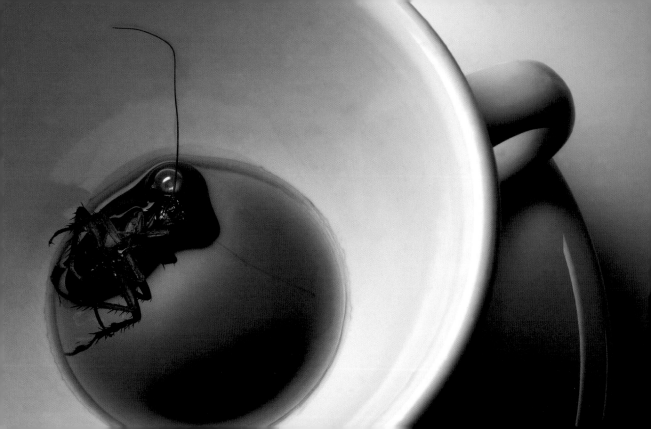

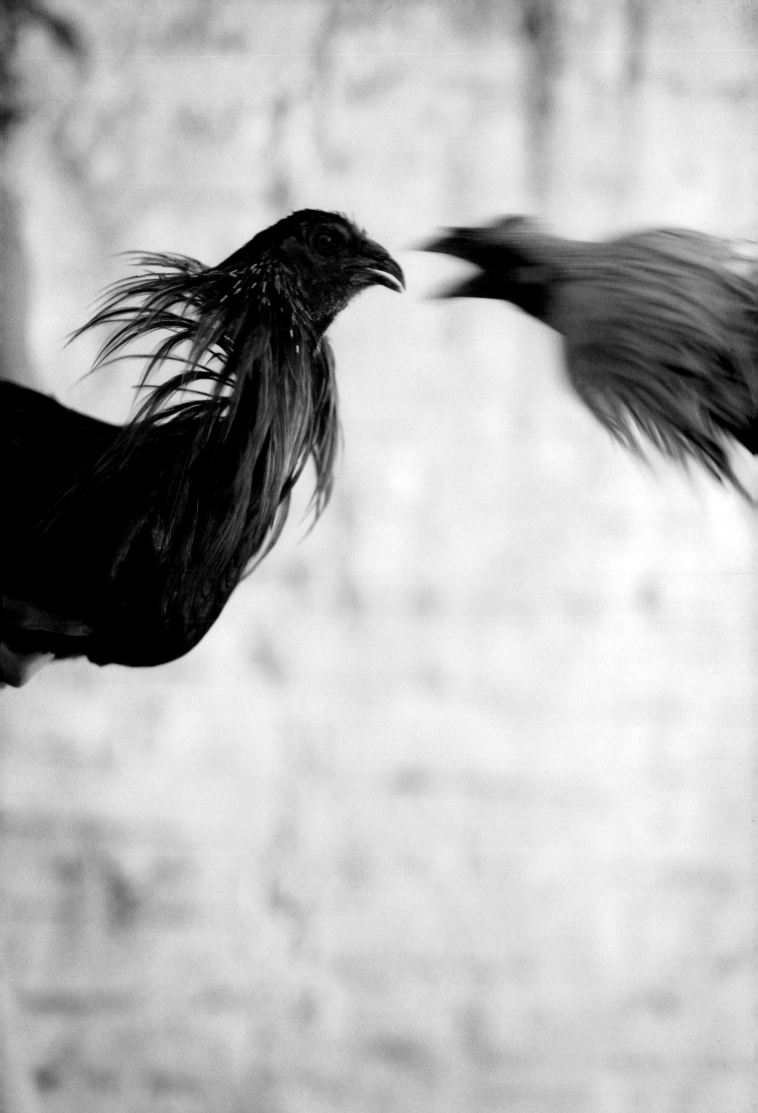

Page 102
'Legs and Poles'
Photographer: Claudia Goetzelmann
Art Director: Claudia Goetzelmann
Camera: Nikon F5
Film: Kodak EPP

Page 103
Photographer: Scott Montgomery
Representative: Kristianne Riddle
Art Director: Scott Montgomery
Camera: Mamiya RZ
Film: Fuji Astia

Page 104–105
'Aerial of a Glacier'
Photographer: Giorgio Karayiannis
Creative Director: Giorgio Karayiannis
Client: Essence of Life Publising

Page 106
'Pink Dunes'
Photographer: Charter Weeks
Client: Rain for the Sahal & Sahara
Camera: Nikon
Film: N8008

Page 107
'Rocks'
Photographer: Charter Weeks
Client: Rain for the Sahal & Sahara
Camera: Nikon
Film: N8008

Page 108
'Along the Moselle'
Photographer: Harvey Tulcensky
Representative: nonstock
Camera: Nikon F
Film: Kodak T-Max

Page 109
'White Bus'
Photographer: Scott Montgomery
Representative: Kristianne Riddle
Art Director: Scott Montgomery
Camera: Mamiya RZ
Film: Fuji Astia

Page 109
Photographer: Smari
Representative: Carol Alda Reps
Art Director: Will Murphy
Design Firm: Kingmahan Design Partners
Client: BASF
Camera: Fuji 68c
Film: Velvia

Page 110
'Among Trees'
Photographer: Sean Kernan
Representative: M. Birenbaum/JB Miller-Fox
Creative Director: Vivian Ghazarian
Designer: Nick Caruso
Design Firm: Artisan

Page 111–112
'Taos Series'
Photographer: Kent Barker
Representative: Independent Artists
Client: Meter Gallery
Camera: Contax 645
Film: T-Max 100

Page 113
'Watch Hill Light'
Photographer: Jody Dole
Representative: Robert Mead Associates
Creative Director: Bill Sisson
Design Firm: Soundings
Camera: Nikon D1X
Film: Digital

Page 114
'Flying Crow'
'Border #2'
'TV'
Photographer: Richard Schultz

Page 115
'Four Rocks'
Photographer: Richard Schultz

Page 116
'Silence = Death'
Photographer: Phil Bekker
Creative Director: Phil Bekker
Art Director: Phil Bekker
Designer: Phil Bekker
Design Firm: Bekker Productions
Client: Bekker Photography
Camera: Pentax 6 x 7
Film: Kodak 100 S

Page 117
'Bull Ring, Spain'
'Red Bicycle'
'Blue Loos'
'Business Car'
Photographer: Phil Bekker
Creative Director: Phil Bekker
Art Director: Phil Bekker
Designer: Phil Bekker
Design Firm: Bekker Productions
Client: Bekker Photography

Page 118
'Gymnast Dajon Sawyer, Key West'
Photographer: Michael Grecco
Representative: M Represents

Page 119
Photographer: Michael Grecco
Representative: M Represents

Page 120
'Minirvana'
Photographer: Dopy Doplon
Creative Director: Dopy Doplon
Art Director: Dopy Doplon
Designer: Dani de Mesa
Client: eArt Philippines
Camera: Nikon Coolpix 5000

Page 122
'Ella, Sculptural'
Photographer: Parish Kohanim
Art Director: Parish Kohanim
Client: PKS
Camera: Contax 645
Film: Tri-X

Page 123
'Roxanna Against Curved Wall'
Photographer: Parish Kohanim
Art Director: Parish Kohanim
Client: PKS

Page 124
Photographer: Parish Kohanim
Art Director: Parish Kohanim
Client: PKS

Page 125
Photographer: Parish Kohanim
Art Director: Parish Kohanim
Client: PKS

Page 126
'Male Series'
Photographer: John Bernhard
Representative: JJ Brookings Gallery

Page 127
'Model Minority Project'
Photographer: joSon
Representative: Alex Ely
Art Director: joSon
Client: joSon Photography

Page 128
'Yuba River hoh rainforest'
Photographer: Andy Freeberg

Page 129
'Katie'
Photographer: Derek Dudek
Client: Derek Dudek
Camera: Sinar 4 x 5
Film: Polaroid Type 55

Page 130
Photographer: Ron Baxter Smith
Representative: Teri Walderman

Page 131
Photographer: Joseph E. Reid

Page 132
'Ashly Bound'
Photographer: Michael McRae
Representative: David Montagano
Camera: 4 x 5 Toyo
Film: Aristatone

Page 133
'Laurie In Water'
Photographer: Michael McRae
Representative: David Montagano

Page 134
'Dr. Miles'
Photographer: Michael Warren
Representative: Carol Alda Reps
Art Director: Adam Goff
Client: New Scientist Magazine

Page 136
'Dr. Miles close-up'
Photographer: Michael Warren
Representative: Carol Alda Reps
Art Director: Adam Goff
Client: New Scientist Magazine

Page 137
'John Bray'
Photographer: Michael O'Brien

Page 138
'LeBron James'
Photographer: Michael O'Brien
Client: ESPN Magazine

Page 139
'Ballerina'
Photographer: Michael O'Brien

Page 140
'Kai'
Photographer: Paul Elledge
Representative: Sedgewick Road
Art Director: Zach Hitner
Client: Washington Mutual

Page 141
'Naja #2'
Photographer: Paul Elledge
Art Director: Zach Hitner
Advertising Agency: Sedgwick Road
Client: Washington Mutual

Page 142
'Al #2'
Photographer: Paul Elledge
Art Director: Paul Elledge
Client: Sanctuary Records

Page 143
'Coffee'
Photographer: Terry Vine
Representative: Schumann & Company
Art Director: Guy Kirkland
Advertising Agency: Lopez Negrete
Client: Bank of America

Page 144
'Miss Exotic 2002'
Photographer: Michael McRae
Representative: David Montagano
Camera: Wisner 20 x 24
Film: Polaroid 20 x 24

Page 145
'Philip Smart'
Photographer: Ringo Tang
Art Director: Pamela Lay
Client: Blanc De Chine

Page 146
Photographer: James Salzano
Representative: Marianne Campbell Assoc.

Page 147
'Portraits'
Photographer: Nick Ruechel
Representative: Arc Reps

Page 148
Photographer: Lennart Sjoberg
Representative: G.A.S.O.L.
Art Director: Paul Eneroth
Client: Gothenbourg Opera House

Page 149–152
Photographer: Sue Bennett

Page 153
'Al #3'
Photographer: Paul Elledge
Art Director: Paul Elledge
Client: Sanctuary Records

Page 154
'Robert'
Photographer: Michael McRae
Representative: David Montagano
Film: Wet Plate Ambrotype

Page 155
'Michael'
Photographer: Michael McRae
Representative: David Montagano
Film: Wet Plate Ambrotype

Page 156
Photographer: Terry Husebye
Art Director: Terry Husebye
Camera: Fuji 690
Film: Fuji Negative

Page 157
'Bucket on Head'
Photographer: Peter Dazeley
Representative: Sarah Ryder Richardson
Camera: Sinar 4 x 5
Film: Fuji Velvia

Page 158
'Erika'
Photographer: Richard Schultz

Page 159
Photographer: Michael Grecco

Page 160
'Tattoo'
Photographer: Ryu Mizuno
Camera: Hasselblad 503 CX
Film: Fuji 100F

Page 161
Photographer: Rodney Smith
Designer: David Meredith

Page 162
'Dad's Performance Review'
Photographer: Rodney Smith
Client: NY Times Magazine

Page 163
'Soap that doesn't wash off'
Photographer: Rodney Smith
Client: NY Times Magazine

Page 164
'Naomi Blur'
Photographer: Debra McClinton
Representative: Marianne Campbell Assoc.

Photographers

CreativeDirectorsArtDirectorsDesigners

Clients

Directory of Photo Reps

Anna Goodson
4 Cours des Primeveres
Verdun, Quebec Canada H3E 1W9
Tel: 1 514 983 9020
www.agoodson.com

Apostrophe
527 West 29th Street
New York, NY 10001
Tel: 1 212 279 2252
Fax: 1 212 279 7934
www.apostrophe.net

Arc Reps
140 West 22nd Street
New York, NY 10011
Tel: 1 212 206 8718
Fax: 1 212 206 8714
www.arcreps.com

Art & Commerce
755 Washington Street
New York, NY 10014
Tel: 1 212 206 0737
Fax: 1 212 463 7267
www.artandcommerce.com

Bernstein & Andrulli
58 West 40th Street
New York, NY
Tel: 1 212 682 1490
Fax: 1 212 286 1890
www.ba-reps.com

Beverly Ornstein
435 West Broadway, #2
New York, NY
Tel: 1 212 334 6667
Fax: 1 212 334 6669
www.howardschatz.com

Carol Alda Reps
8 Hurlburt Street, #1
Cambridge, MA 02138
Tel: 1 617 719 7595
Fax: 1 617 945 0399
www.carolalda.com

Creative Management
1180 Avenue of the Americas
New York, NY 70176
Tel: 1 212 655 6500
Fax: 1 212 271 7073
www.cmpnational.com

Danielle Malanson
2737 NE 10th Avenue
Portland, OR 97212
Tel: 1 503 288 6013
Fax: 1 503 281 0075

David Montagano
211 East Ohio Suite
Suite 2006
Chicago, IL 60601
Tel: 1 312 572 3283
Fax: 1 312 527 2081
www.davidmontagano.com

Independent Artists
3107 Cole Avenue
Dallas, TX 75204
Tel: 1 214 720 4496
Fax: 1 214 720 0702
www.iaagency.com

JJ Brookings Gallery
669 Mission Street
San Francisco, CA 94105
Tel: 1 415 546 1000
Fax: 1 415 357 1100

Judith Miller, Inc.
330 West 38th Street
Suite 801
New York, NY 10018
Tel: 1 212 564 0216
Fax: 1 212 564 0930
www.judithmillerinc.com

Judy Casey, Inc.
114 East 13th Street
New York, NY 10003
Tel: 1 212 228 7500
www.judycasey.com

M Represents
24 West 30th Street
New York, NY 10001
Tel: 1 212 840 8100
Fax: 1 212 251 1011

Marge Casey & Associates
20 West 22nd Street
New York, NY 10021
Tel: 1 212 929 3757
Fax: 1 212 929 3611
www.margecasey.com

Marianne Campbell Associates
840 Fell Street
San Francisco, CA 94117
Tel: 1 415 433 0353
Fax: 1 415 433 0351
www.mariannecampbell.com

Michael Ash Creative Management
1180 Avenue of the Americas
New York, NY 10036
Tel: 1 212 655 6500
Fax: 1 212 271 7073

Norman Maslov
608 York Street
San Francisco, CA 94110
Tel: 1 415 641 4376
Fax: 1 415 641 5500
www.maslov.com

Paula Gren
20 West Shore Drive
Marblehead, MA 01945
Tel: 1 781 639 7868
Fax: 1 781 639 2131
www.paulagrenreps.com

Sarah Ryder Richardson
The Studios
5 Heathmans Road
London, England SW6 4TJ
Tel: 44 207 736 2999
Fax: 44 207 371 8876
www.peterdazeley.com

Sedgewick Road
1741 First Avenue South
Seattle, WA 98134
Tel: 1 206 971 4200
Fax: 1 206 971 4299

Sharpe & Associates
7536 Ogelsby Avenue
Los Angeles, CA 90045
Tel: 1 310 641 8556 (West Coast)
1 212 595 1125 (East Coast)
www.sharpeonline.com

Tide Pool Reps
1459 18th Street, #108
San Francisco, CA 94107
Tel: 1 415 643 1231
Fax: 1 415 449 3545
www.tidepoolreps.com

Vernon Jolly, Inc.
225 Lafayette Street, Suite 906
New York, NY 10012
Tel: 1 212 431 4545
Fax: 1 212 431 2400
www.vernonjolly.com

Alex Bee Photography
1425 Rock Quarry Road, #115
Raleigh, NC 27610
Tel: 1 919 821 1661
Fax: 1 919 821 4115
www.alexbee.com

Art Brewer Photography
25262 Main Sail Drive
Dana Point, CA 92629
Tel: 1 949 661 8930
Fax: 1 949 248 2835
www.artbrewer.com

Art One Design
19/F Paspng Tamo Tower
2210 Don Chino Roces Avenue
Makati City, Manila
Philippines 1200
Tel: 632 817 7273
Fax: 632 813 5731

Artlighting Productions
178 East 124th Street, 3rd Floor
New York, NY
Tel: 1 212 289 1021
Fax: 1 212 289 0396

Bernhard Associates
218 Westcott Street
Houston, TX 77007
Tel: 1 713 869 2345
www.bernhardpub.com

Beverly Abramson Photography
22 Lowther Avenue
Toronto, Ontario Canada 5R1C6
Tel: 1 416 960 9044
Fax: 1 416 960 9040
www.beverlyabramson.com

Bill Diodato Photography
433 West 34th Street, #17B
New York, NY 10001
Tel: 1 212 563 1724
Fax: 1 212 594 3603
www.billdiodato.com

Clint Clemens Productions
PO Box 2439
199 Depot Street
Duxbury, MA 02331
Tel: 1 781 934 9410
Fax: 1 781 934 9409

Craig Cutler Studio
15 East 32nd Street
New York, NY 10016
Tel: 1 212 779 9755
Fax: 1 212 779 9780
www.craigcutler.com

David Allan Brandt Studios Inc.
1015 Cahuenga Boulevard
Los Angeles, CA 90038
Tel: 1 323 469 1399
Fax: 1 323 469 0522
www.davidallanbrandt.com

David Foster Photography
840 Summer Street
Boston, MA 2127
Tel: 1 617 464 2295
Fax: 1 617 464 2495
www.davidfosterphotography.com

Debra McClinton Photography
1375 Harrison St 2
San Francisco, CA 94103
Tel: 1 415 864 3188
Fax: 1 415 431 4868
www.debramcclinton.com

Derek Dudek Studio
Starr Mill Beverly Heights
Middletown, Ct 6457
Tel: 1 860 347 3609
Fax: 1 413 410 9382
www.derekdudek.com

Don Carstens Photography
1021 Cathedral Street
Baltimore, MD 21201
Tel: 1 410 385 3049
Fax: 1 410 659 0036
www.doncarstens.com

Elisabeth O'Donnell
3 Orange Street
Salem, MA
Tel: 1 978 745 7331
Fax: 1 978 741 4011
www.elisabethodonnell.com

Erickson Productions
3 English Street
Petaluma, CA 94952
Tel: 1 707 789 0405
Fax: 1 707 789 0459
www.jimerickson.com

Fotogret Lennart Sjoberg AB
Ostra Hamngatan 39
Gothenbourg, Sweden 411 10
Tel: 46 31 13 4010
Fax: 43 31 13 4016
www.lennart.se

Giorgio Photography
22 Robert Street
Melbourne, Victoria
Australia 3151
Tel: 1 61 3 9803 7604
Fax: 1 61 3 9803 3287
www.giorgioimages.au

Harrington Studio
2775 Kurtz Street Suite 2
San Diego, CA 92110
Tel: 1 619 291 2775
Fax: 1 619 291 8466
www.marshallharrington.com

Harry Sargous Photographs
1022 Greenhills Drive
Ann Arbor, MI 48105
Tel: 1 734 663 1769

Hennessy Photography
10 Lynn Street
Boston, Ma 2113
Tel: 6172693312
Fax: 6173677736
www.hennessystudio.Com

Holborn Studios
49-50 Eagle Wharf Road
London, England N1-7ED
Tel: 44 207 490 7857
Fax: 44 207 490 3034
www.frankherholdt.com

Ira Garber Photography
150 Chestnut Street
Providence, RI
Tel: 1 401 274 3723
Fax: 1 401 274 3727
www.iragarber.com

Isinglass Marketing
PO Box 203
Barrington, NH 03825
Tel: 1 603 664 7654

Jamey Stillings Photography
83 Placita de Oro, #7
Santa Fe, NM 87501
Tel: 1 505 984 9999
Fax: 1 505 984 9997
www.jameystillings.com

Jody Dole Studio
PO Box 374
Chester, CT 06412
Tel: 1 860 526 8602
Fax: 1 860 536 8604
www.jodydole.com

Jon Shireman Photography
15 East 32nd Street, 4th Floor
New York, NY 10016
Tel: 1 212 779 9823
www.jonshireman.com

Jonathan Knowles Photography
48A Chancellors Road
London, England W6 9RS
Tel: 44 20 8741 7577
Fax: 44 20 8748 9927
www.jknowles.co.uk

joSon Photo
350 Turk Street 302
San Francisco, CA 94102
Tel: 1 415 447 6011
Joson@Josonphoto.Com

Kent Barker Studio
1337 Gusdorf Road, Studio 1
Taos, NM 87571
Tel: 1 505 758 0970
Fax: 1 505 758 0975
barker@newmex.com

Klik
1478 Sandpiper Road
Oakville, Ontario Canada L6M 3R8
Tel: 1 905 825 0918
www.photokilk.com

Lanoreth Studios
2020 Airport Way S.
Seattle, WA 98134
Tel: 1 206 343 7118
Fax: 1 206 343 9487
www.lanorethstudios.com

Lars Topelmann Photography
2626 SE Ankeny Street
Portland, OR 97214
Tel: 1 503 234 1963
Fax: 1 503 232 6851
www.larsmann.com

Michael Grecco Photography Inc.
1701 Pier Avenue
Santa Monica, CA 90405
Tel: 1 310 452 4461
Fax: 1 310 452 4462
www.michaelgrecco.com

Michael Seidl Photography
116-Elliot Avenue West
Seattle, WA
Tel: 1 206 443 4317
Fax: 1 206 443 4317

Michael Warren Photography
110 K Street
Boston, MA 02127
Tel: 1 617 464 0011
Fax: 1 617 464 0066
www.warrenphotography.com

Montgomery Productions
204 North Waverly Street
Orange, CA 92866
Tel: 1 714 538 5130
Fax: 1 714 538 8696
www.smontgomery.com

Paul Elledge Photography
1808 West Grand Avenue
Chicago, IL 60622
Tel: 1 312 733 8021
Fax: 1 312 733 3547
www.paulelledge.com

Per Breiehagen Photography
708 North First Street, Suite 314
Minneapolis, MN
Tel: 1 612 338 2581
Fax: 1 612 330 2596
www.breiehagen.com

Peter Dazeley Photography
The Studios 5 Heathmans Road
Parsons Green, London SW6 4TJ
Tel: 44 20 7736 3171
Fax: 44 20 7371 8876
www.peterdazeley.com

Phil Bekker Photography
8205 Landing South
Atlanta, GA 30350
Tel: 1 404 210 8207
Fax: 1 770 992 5151
www.bekker.com

PKS
1130 West Peachtree Street
Atlanta, GA 30309
Tel: 1 404 892 0099
Fax: 1 404 892 0156
www.parishkohanim.com

Rich Pomerantz Photography
10 Church Hill Road
Washington Depot, CT 06794
Tel: 1 860 355 3356
www.richpomerantz.com

Richard Schults Photography
259 A Street
Boston, MA 02210
Tel: 1 617 439 3456
Fax: 1 617 439 6081
www.rschultz.com

Rick English Pictures
1162 El Camino Roa
Menlo Park, CA 94025
Tel: 1 650 322 1984
Fax: 1 650 322 1986
www.rickenglish.com

Ringo Tang Photo Workship
702 Cornell Centre 50 Wing 7a1 Road
Chai Wan, Hong Kong
Tel: 1 852 2521 5939
Fax: 1 852 2521 5186
www.ringtang.com

Robert Mizono Photography
150 Mississippi
San Francisco, CA
Tel: 1 415 575 3933
Fax: 1 415 575 3934
www.robertmizono.com

Robert Schoen
185 Parker Street
Acton, MA
Tel: 1 978 897 3242
www.schoenphoto.com

Rodney Smith Ltd.
7 Lawrence Lane
PO Box 697
Snedens Landing
Palisades, NY 10964
Tel: 1 845 359 3814
Fax: 1 845 389 8404
www.rodneysmith.com

Ryu Photographics
101 1-3-2 Itoyamach Chuo-ku
Osaka, Japan
Tel: 06 6944 1139
Fax: 06 6944 002

Salzano Studio
29 West 15 Street
New York, NY 10011
Tel: 1 212 242 4820
Fax: 1 212 463 0584
www.salzanophoto.com

Schatz Ornstein Studio
435 West Broadway 2
New York, NY 10012
Tel: 1 212 334 6667
Fax: 1 212 334 6669

Sean Kernan Studio
28 School Street
Stony Creek, CT 06405
Tel: 1 203 481 0213
Fax: 1 203 488 6164
www.seankernan.com

Smari Productions
4 Field Road
Arlington, MA 2476
Tel: 1 781 646 0148
Fax: 1 781 646 3504
www.smari:productions.com

Studio Dirk Karsten
Keienbergweg 57
Amsterdam, The Netherlands 1101GA
Tel: 31 20 697 2141
Fax: 31 20 691 1451
www.dirkkarsten.com

Sue Bennett Photography Inc.
107 North San Francisco Street
Suite 3
Flagstaff, AZ 86001
Tel: 1 928 774 2544
Fax: 1 928 774 5562
www.suebennett.com

(t)here media
410 West 14th Street
New York, NY 10014
Tel: 1 212 366 4140
Fax: 1 212 202 4791
www.t-here.com

Terry Husebye Photography
228 Mount Shasta Drive
San Rafael, CA 94903
Tel: 1 415 444 5844
Fax: 1 415 444 5840
www.husebyephoto.com

Terry Vine Photography
2417 Bartlett Street
Houston, TX 77098
Tel: 1 713 528 6788
Fax: 1 713 528 6852
www.tvine.com

Tibor Nemeth Photography
3 Orange Street
Salem, MA 01970
Tel: 1 978 741 2555
Fax: 1 978 741 4011
www.tibornemeth.com

Timothy Hogan Inc.
336 W 37th St 12e
New York, NY 10018
Tel: 1 212 967 1029
Fax: 1 212 967 5052

Tom Atwood Photography
341 West 71st Street #15
New York, NY 10023
Tel: 1 212 712 2523

Westside Studio
70 Ward Street
Toronto, Ontario
Canada M6H 4A6
Tel: 1 416 535 1955
Fax: 1 416 535 0118
www.westsidestudio.com

CHECKOUT >> www.graphis.com

{ ORDER FROM ANYWHERE IN THE WORLD.
Yes, even from Christmas Island.

DESIGN>> JON CANNELL DESIGN & BALANCE PROGRAMMING>> SYSTEMS CATALYST FLASH DESIGN>> GARN CREATIVE

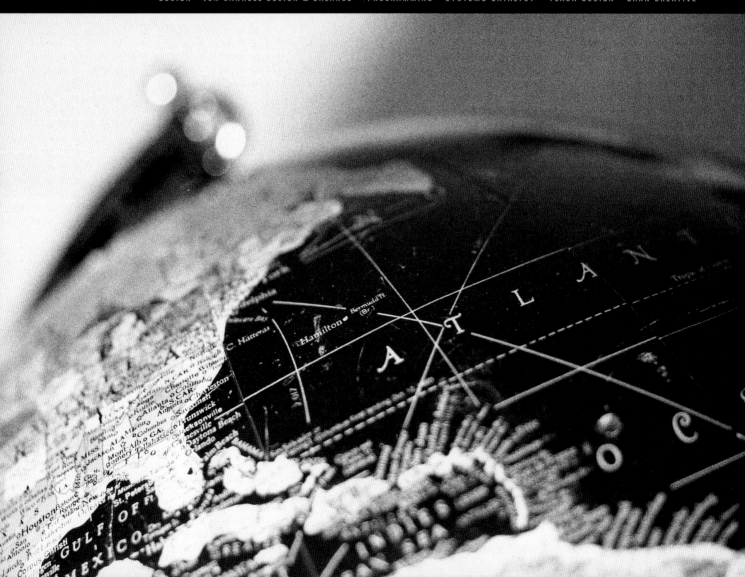